EAST GERMAN MODERN

Hans Engels

EAST GERMAN MODERN

Photographs Hans Engels

Essay Frank Peter Jäger

Captions Ben Kaden

PRESTEL

Munich · London · New York

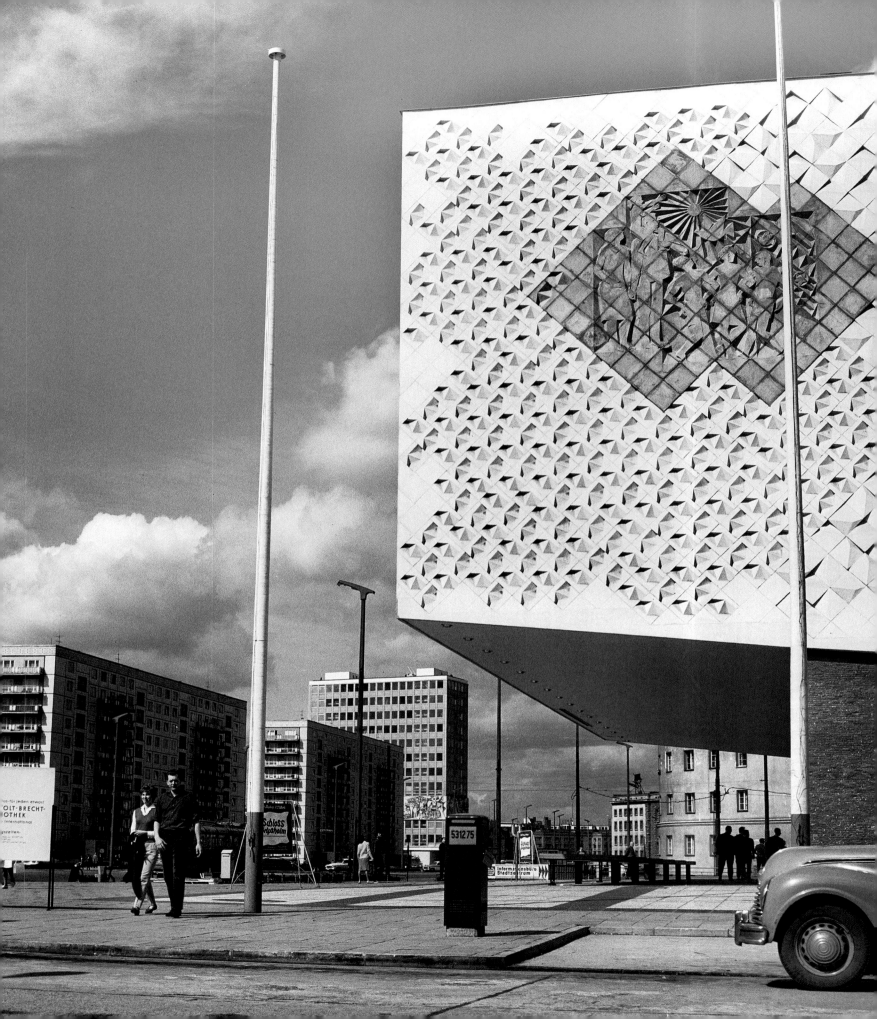

Rooms Bathed in Light for the New Human

Architecture in the GDR was a balancing act between political symbolism, planning requirements, luxurious interiors and the decay of old urban quarters – a dazzlingly paradoxical chapter in European modernism.

Lasting interest in the architectural heritage of the GDR is manifested in the constant appearance of new books, exhibitions and conferences – and it is reasonable to conclude that the buildings and urban ensembles constructed in the forty years[1] of the GDR amount to more than a mere footnote in architectural history.

Even thirty years after German unification, however, on many sides there is still no consensus about the architectural value of buildings in the style of GDR modernism. Citizens and political decision-makers are still polarised when the value of such buildings is called into question and therefore their destruction is often under discussion. In January 2019, for example, plans to demolish the Terrassenrestaurant Minsk, a work by the architect Karl-Heinz Birkholz on the Brauhausberg in Potsdam, were foiled only at the last minute when a procedure to involve citizens led to a new majority on the building committee. By then, however, the neighbouring indoor swimming pool with its vigorously curving concave roof, also designed by Birkholz, had already fallen victim to the wrecking ball.

Although East German architectural historians and architects accuse people from the former West Germany, sometimes sweepingly, of "treating GDR modernism as something to be discarded",[2] and claim that by razing the buildings of the GDR the West wants to erase the material and cultural evidence of its identity and its past, in the *Süddeutsche Zeitung*, Peter Richter, with reference to the debate in Potsdam, emphasises: "in truth, the battlefronts have been drawn in a more complicated way … and long-standing Potsdamers too have reasons to be enthusiastic about reconstructed baroque – and those who move in from West Germany to support the retention of GDR modernism."[3] It is also noticeable that young architects and planners, regardless of their origin, approach these buildings with less prejudice than those who grew up with them: in the former East Germany, too, it was not until about the year 2000 that protest arose against disrespectful treatment of the GDR's architectural legacy.[4]

What could be beautiful about the buildings of a dictatorship?

On the other hand, for a long time many politicians and decision-makers from the West regarded the GDR almost exclusively as a repressive, unjust state, a dictatorship. They found it hard to imagine that the architectural remains of this state could suddenly be of cultural value. "Did not the Party's claim to total power restrict any development whatever of open thought and design in such a way that all that could result was, at best, a stage set for the latest formal standards?"[5] This question is legitimate, and plays a key role in approaching this architectural heritage: In the legacy of a dictatorship, what is worth preserving or even to be considered attractive?

The answer is simple: it is necessary to live with the paradox that an anti-democratic system can produce architecturally outstanding achievements. Architecture does not necessarily follow political ethics. Just as the reality of life in the GDR was multifaceted, the buildings it produced were multifaceted too – with regard to their range, the timeline of their development and not least to the motives of its architects and the latitude available to them.

Stylistic phases of GDR architecture

The following description distinguishes the five principal phases that marked the development of architecture in the GDR:[6]

In the immediate post-war period (from 1946 to about 1950), the emphasis lay on the most urgent task, reconstruction. The architectural and urban ideals of the international architectural avant-garde, for example the Athens Charter, were the guiding principles of reconstruction in both West and East. The essential decisions were taken by the Soviet military administration. The second phase was the Stalin era (from 1951 to 1957), when the debate about formalism in art, initiated by Soviet cultural

Karl-Marx-Allee in Berlin, looking towards Alexanderplatz: on the right, Kino International; in the background, the Haus des Lehrers (1964)

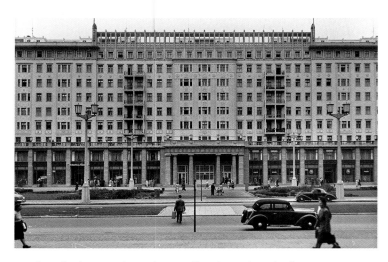

Residential palaces on the Karl-Marx-Allee, formerly Stalinallee

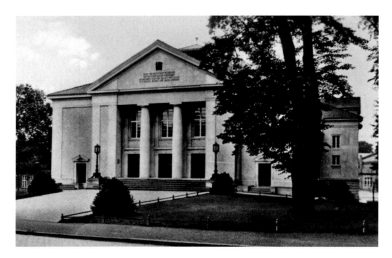

Theatre in Neustrelitz that was rebuilt in 1954 in the style of the time

officers, produced far-reaching consequences for architecture. This led, on the one hand, to "designs of historical pomp"[7] situated between Soviet-influenced neo-baroque, so-called wedding-cake architecture, and neoclassicism. For more everyday construction projects, the no less anti-modern *Heimatstil* (homeland style) predominated. A modernist manner of any kind whatever was frowned upon.

After Stalin's death in 1953 it was a few years before the political thaw reached architecture, and a reversion to the International Modern style was sought. The return to soberness from 1957 to the early 1970s may be regarded as the golden period of architecture in the GDR. Impulses from both West and East were adopted and led to the formation of an autonomous Ostmoderne (Eastern modernism) that delighted in experiment.

The fourth phase relates to the 1970s. With modular construction methods and the establishment of types, politically willed industrial construction was definitively implemented for all standard tasks in the shape of the *Plattenbau*, a structure made from prefabricated concrete slabs.

After 1980, in the fifth phase, the perfecting of industrial construction continued. Alongside this, in the spirit of reflective modernism, postmodern influences became apparent in the GDR too. At the same time a renewed appreciation of the value of pre-modern building fabric and old town centres set in.

"Risen from ruins"

The hardships of the phase of reconstruction after 1945 shaped the identity of the newly founded state and its citizens. Young people, many of whom had just returned from the war, built up a new country. One of the very first reconstruction projects, on the orders of the Soviet military administration, was the Volksbühne (People's Theatre) on Rosa-Luxemburg-Platz in Berlin (p.145). Few people are aware that this theatre, so influential today in the German-speaking drama scene, is essentially a post-war building. From 1948 onwards Hermann Fehling and Gustav

Müller rebuilt the theatre dating from 1913 designed by the architect Oskar Kaufmann, which was reduced to its outer walls in the Second World War, and added two salons to its sides. These were intended as places where theatregoers could meet after the performance to discuss the work. The decisive intervention consisted in transforming the side windows to long vertical and horizontal bands of windows and in building the semicircular upper part of the façade, which gave the theatre a Neue Sachlichkeit (New Objectivity) character.[8]

Stalinist baroque classicism

For one long decade this was to be the last time that such a plain, modern building was erected in the eastern part of Germany. From 1950, in accordance with influences from Moscow, architecture in the National Tradition style was dominant. This "baroque classicism of the Stalinists"[9] is seen in exemplary manner in the newly built Friedrich-Wolf-Theater in Neustrelitz with its columned portico and in the Kulturhaus at the Maxhütte steelworks in Unterwellenborn in Thuringia, where no fewer than three awe-evoking temple façades were built. Stalinstadt, later called Eisenhüttenstadt, newly founded near the Polish border in Brandenburg, still presents a coherent ensemble from this period, one great museum of early GDR architecture (pp. 52–55).

For housing in villages and small towns, the homeland style with gable roofs, simple volumes and façades with regular door and window openings represents a kind of timeless modesty. For public buildings, however, architects' efforts to dispense with any kind of architectural esprit are most obvious: no cuboid forms, no continuous bands of windows, no unsupported projecting roofs of reinforced concrete, no dynamically rounded façades. As soon as these buildings had been completed, a feeling of yesterday, of being left behind by the times, clung to them. Only industrial and university buildings manifested a certain freedom. The verdict

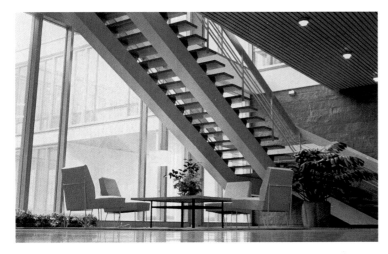

In the lobby of Restaurant Moskau, Berlin

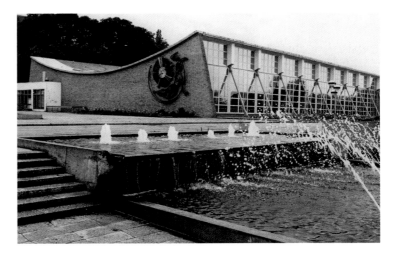

The now demolished swimming pool in Potsdam

of formalism hangs perceptibly like a sword of Damocles over the heads of those who designed these buildings, especially with regard to what this architecture does not display.[10] At the same time, the extent of what was reconstructed and newly built in only a few years is impressive, especially in view of the high reparations that were owed by the Soviet Occupation Zone and later GDR to the Soviet Union: entire railways and factories were dismantled and taken to the Soviet Union.

The cities, above all, severely damaged by war, are marked even today by the wedding-cake style, including the centres of Magdeburg, Nordhausen and Rostock. In Lange Strasse in Rostock, the façades were built with exposed brick, interrupted by patches of plasterwork. These nods to the north German style of brick Gothic are a welcome regional variation on tame eclecticism. However, in small towns and villages, too, the intention was to put a new, socialist face on everyday life. Here architecture was given the task of imparting physical expression to the achievements of the new system.

Palaces for workers

From late 1949 a political campaign initiated by, among others, the Soviet culture officials Alexander Dymschitz[11] and Vladimir Semyonov led to a far-reaching rejection of all positions of Western art and architecture that were regarded as bourgeois and decadent or subjective. Until that time, reconstruction in East Germany had largely followed the guiding examples of International Modernism. The accusation of formalism was aimed especially at the emerging International Modern style and manifestations of Neues Bauen (New Building) such as the Bauhaus style – or what was taken to be this style. The high-rise completed on Weberwiese in 1951 to designs by Hermann Henselmann marks the beginning of this phase. What was now demanded were palaces for workers, part of ceremoniously staged urban spaces that gave spatial expression to the achievements of socialism. In a mere two and a half years, on the two kilometres

between Strausberger Platz and Frankfurter Tor in Berlin, the ensemble of Stalinallee (today Karl-Marx-Allee, pp. 108–115) was constructed with its eight- to twelve-storey housing in the National Tradition style, which in effect meant an interpretation of the Soviet wedding-cake style with added local variations. On the inner ring road in Leipzig, the housing on Rossplatz constructed at the same time was a similarly elaborate, monumental residential palace.

The unbelievably short construction period of Stalinallee in Berlin, which was motivated by propaganda purposes, necessitated compromises in craftsmanship that soon took their toll: within a few years the first ceramic tiles and pieces of masonry fell from the façade. By 1990 this had happened to 50 per cent of the cladding.[12]

On the west side of Strausberger Platz, the ensemble of this showpiece boulevard terminates in two higher structures that enclose the oval-shaped space. This is a lasting caesura, as the final section of the street up to Alexanderplatz is flanked by several eight- and ten-storey slab-like residential blocks of large prefabricated elements, placed at right-angles to the street (p. 108). These austere slabs were built a decade later and express an entirely transformed view of architecture and city planning. The change from architecture that shapes the urban space to open stand-alone buildings is evident.

The prefabricated blocks (Plattenbauten) are flanked by a series of public buildings that are among the highlights of GDR architecture of those years: the Kino International cinema, Restaurant Moskau (now known as Café Moskau) opposite it, and an element linking them to the residential slab blocks, two-storey pavilion buildings with large areas of glazing for shops and services such as the former Babette beauty salon, which was used as a bar until 2018 (pp. 120–127). This second section of Karl-Marx-Allee represents the third phase of building in the GDR. The spirit of the National Tradition and Soviet models had been cast off, and with the "reappropriation of avant-garde design concepts by the left, East German

architects returned to the international arena".[13] Even the published architectural drawings of the new quarters emanated a new spirit: whereas a few years before female workers with earnest looks wearing headscarves and plain work smocks populated the views of Stalinallee, on pictures of the second construction phase suddenly young couples, clad in skirt, blouse and wide-cut summer trousers, stroll past busy street cafés – the enjoyment of life instead of the spartan pathos of reconstruction.

No one in the GDR would have described the imaginative architecture of those years, freed from all ideological bonds, as the International Modern style, as this term was too closely identified with America and capitalism.[14] However, these buildings with curving roofs of pre-stressed concrete and ornamented grid façades, poised between elegance and soberness, clearly correspond to the International Modern style of about 1960 in the West.[15] From the point of view of the ruling SED party and those responsible for construction in the GDR, the design of Karl-Marx-Allee was the urban answer to the Interbau construction exhibition of 1957 in West Berlin, with which the Federal Republic had demonstrated its ideal of contemporary urban development. This is one reason why Andreas Butter and Ulrich Hartung argue that the Ostmoderne style should not be judged only by the standards of global modernism but seen "as an independent contribution to the discussion of these standards".[16] According to this view, its aims in social policy subtly entered buildings and urban spaces.

Lavish spatial design

A fine example of the combination, typical for the GDR, of lavish spatial design with egalitarian luxury is the above-mentioned cinema, Kino International on Karl-Marx-Allee, designed by Josef Kaiser and Heinz Aust (pp. 124–125). It may be Berlin's most beautiful cinema. Conceived as a venue for premieres, it presents its show façade confidently to the street. Beyond the spacious entrance hall, stairs lead upwards at the side. The showpiece of the building, however, is the lobby on the upper floor facing the street. This wood-panelled foyer next to the auditorium with its striking folded ceiling is five metres tall and thirty-five metres long, more a banqueting hall than a cinema foyer. Its south side, overlooking the street, is a metres-high glass façade engraved with the figure of a bear, the heraldic animal of Berlin. Where the refreshment bar stands on the window side of the foyer, a wall surface for large-format film posters – which, by the way, are made by hand to this day – interrupts the glass façade.

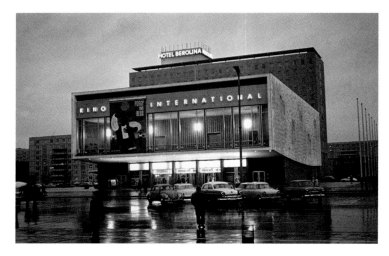

Kino International in Berlin, built in 1963

The grandeur of this foyer with its dark parquet floor is overwhelming. It is furnished with club armchairs, and gives cinemagoers a direct view of the evening traffic flowing along the city artery. Occupants of vehicles outside can see, as they pass, guests at a premiere chatting expectantly behind the glass façade of the upper foyer. The decisive point is that this architecture gains its effect entirely from the design of the space itself – a combination of generous dimensions, careful treatment of materials and thought-out details. With the exception of three cylindrical chandeliers and the wooden relief of the wall panelling, the foyer dispenses with ornament. A year earlier, Josef Kaiser and Heinz Aust had completed the Filmtheater Kosmos (p. 128), two subway stops further out from the city centre.[17] It is larger and a shade less exclusive but in no way inferior to the International in the care devoted to its fittings. Skilfully combined materials and guiding sequences of rooms in a highly similar form can be found in the large Restaurant Moskau by Josef Kaiser and Horst Bauer. Its eye-catching feature is a metres-high mosaic next to the entrance (pp. 126–127). The Kongresshalle on Alexanderplatz (pp. 120–121), too, is a spatial creation of great distinction. In its foyer, two oval spiral stairs twist upwards to the first floor in a gentle curve. Here, as in the circular room with its shallow-vaulted dome, the inspiration of the works of the Brazilian architect Oscar Niemeyer is unmistakable. This series of splendid buildings for the arts also includes the Kulturpalast in Dresden with its austere yet transparent grid façade (p. 184).

The double promise

Buildings like this express a double promise: the promise that socialism will create an equal society of solidarity and improve the lives of its citizens in large and small ways, and the promise that architectural modernism will lead them into airy spaces bathed in light and liberate them from the burdens and sclerotic structures of the past. For this reason, buildings for the community, for the arts and leisure, appeared to be the noblest

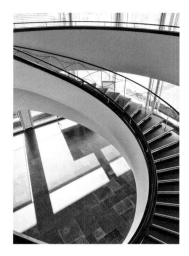
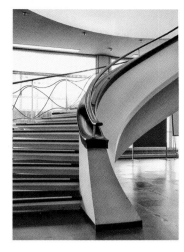

The staircase in the lobby of the Kongresshalle on Alexanderplatz in Berlin

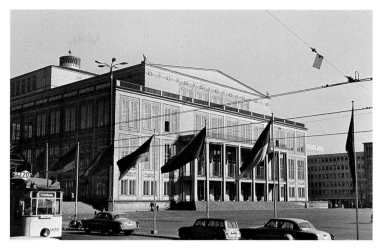

The new opera house on Augustusplatz in Leipzig

architectural task, to be the highest-ranking branch of GDR architecture, because "there was undoubtedly a place for creativity and indulgence in the collectivist view of humanity held by SED party officials."[18]

Seen against this background, a zoo, too, is not merely an assembly of functional buildings. The cafeteria of the newly established zoo in Berlin-Friedrichsfelde, completed in 1963, is a large-scale restaurant, striking for its spacious sequence of rooms arranged in a semicircle around the attached outdoor terrace. Small aquariums were set into the walls of these rooms. The plans derived from Heinz Graffunder and his architectural collective. The original furnishings have survived in part.

The kings of the animal world were accommodated in the Alfred-Brehm-Haus, which was also designed by Graffunder and his collective. In a masterly manner, this house for big cats, composed on two levels and generously illuminated by skylights, encloses landscape dioramas and an outdoor compound. More modest, but of equal quality in its planning of open space, is the iga garden exhibition site in Erfurt with its halls for plants and café pavilions (pp. 91–93).

It is instructive to take a closer look at buildings that were constructed in the transitional phase between the National Tradition style and re-engagement with international avant-garde architecture – for example the opera house in Leipzig, newly built on Augustusplatz between 1956 and 1960 on the site of a predecessor that was destroyed in the war. The symmetrical pediment of its main façade (excerpt on p. 18) still reveals the neoclassicism of the Stalin era, but striking vertical elements of composition are lacking in the façade as it was finally executed. It is structured instead by slender, upright window formats, linking the forms of classical dignity, which are only hinted at, with a positively graphic sobriety. Historical decorative elements had been suppressed further and further in the course of revision of the designs.[19]

In the case of the Müggelturm (Müggel Tower), a popular café for day trippers with a viewing platform on the Müggelberg hill in the wooded south of Berlin, the neoclassical manner had been entirely superseded. This thirty-metre-tall structure with a steel skeleton, completed in 1961, is finely proportioned with a rectangular plan, and undoubtedly a milestone of GDR modernism. The winning entry among the thirty-two submissions to the Berlin city government for the architectural competition was, significantly, a proposal by a group of students at the Weissensee Kunsthochschule Berlin who were studying under the architect Selman Selmanagić, a graduate of the Bauhaus.[20]

The reconstruction of this destination for excursions was largely facilitated by donations from citizens and 3,700 hours of work by volunteers. This unpaid participation, which was especially common in the years of reconstruction, illustrates the emotional association of GDR citizens with buildings of this kind, which lasted into the period after German reunification.

The Ahornblatt dispute

As the demolition of the large Berlin restaurant Ahornblatt in 2000 shows, even then the front lines in the controversy about the value of GDR architecture could not simply be explained on East-West lines.[21] This building, designed by the engineer Ulrich Müther and the architects Gerhard Lehmann and Rüdiger Plaethe, already had the status of a protected monument. Both the Berlin Chamber of Architects and architectural experts in East and West campaigned for its preservation. However, the Berlin tax office had already sold the site to an investor. The director of building of the Berlin Senate, Hans Stimmann, wanted to re-establish the historic ground plan of the city on this site by means of block perimeter development. It was thus a combination of opposing principles of urban planning, clumsy real-estate policy and ignorance that led to the loss, certainly avoidable, of this emblematic building. Furthermore, there

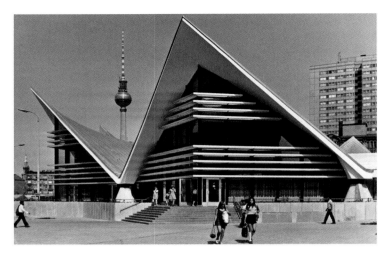

Ahornblatt restaurant by Ulrich Müther, completed in 1973

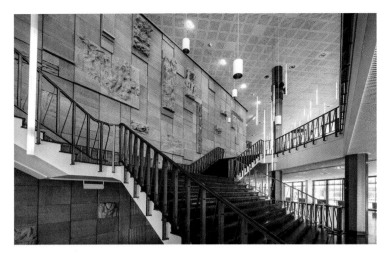

The relief *Lied des Lebens* in the lobby of the Haus der Kultur in Gera

were financial reasons: the Ahornblatt self-service restaurant had seating for 880 diners, intended in part for providing lunch for the employees in nearby ministries and companies.

Even when tenants were found who believed that they could run such a large establishment at a profit, they frequently resigned in the face of the huge running costs of the building. Architecture from the GDR period is often no longer compatible with forms of use in the Federal Republic, partly because, in many cases, the institutions associated with the buildings no longer exist. When construction work is needed, the operators are confronted with numerous regulations about fire safety, energy and conservation. In this way, more than one renaissance of an architectural gem from the days of the GDR was lost in the labyrinth of standards. The list of these problem children is long. They were and are found throughout the former GDR, from the Erzgebirge mountains to the shores of the Baltic Sea. Even in the case of Ulrich Müther's Inselparadies, a restaurant pavilion with all-round glazing in the dunes of Baabe on Rügen (p. 163), restoration and revitalisation succeeded only at the last minute after fifteen agonising years.[22]

Paradoxically, as a result of the debate about Ahornblatt, Müther's oeuvre came to wider public attention for the first time, raising the level of interest in the whole of GDR modernism. Ulrich Müther, not an architect but a graduate in civil engineering, thus retrospectively became a kind of pop star of GDR architecture. Books, numerous newspaper articles and television reports subsequently appeared about his bold concrete-shell structures. The Baltic Sea coast, Rügen and Rostock were main areas of his work (pp. 62–63, 74–75, 86–87, 104–105). The buildings that he designed in collaboration with architects include several churches (pp. 58–59). In Potsdam (p. 89) and near Erfurt, as also in Finland and the Federal Republic, concrete-shell buildings bear the unmistakable signature of this engineer. Müther's work is a textbook example of a characteristic quality often found in the GDR: the merging of ambitious construction with architectural design, which points to consistent teamwork by architects and planners of support structures.

The bus station in Chemnitz (p. 85), an experimental building by the Deutsche Bauakademie (German Building Academy), also seems to have emerged from cooperation of this kind. The 1,200-square-metre roof of the waiting hall, without internal supports, is held up by cables attached to anchors in the ground via sloping pylons. This is nothing less than a showcase presentation of the load-bearing structure.

Paintings for everyday life – building with art

To express the comprehensive enhancement of everyday life, art related to architecture was a feature of public construction work in the GDR from the very beginning. Until about 1960, the images executed on façades and in the foyers and stairwells of public buildings were dominated by motifs of the class struggle in the manner of Socialist Realism – tractor drivers, female agricultural workers holding aloft the hammer and sickle, the heads of communists and resolute Red Army soldiers. At the start of the Sputnik era, horizons widened: from 1958 the conquest of the Earth's orbit by the Soviet space programme became a popular subject for many mosaics and paintings. In his book *DDR. Baubezogene Kunst* (GDR: Art for Architecture), the architect Martin Maleschka has published a detailed documentation on the artistic furnishing of GDR buildings, showing that in the early 1960s both the range of artistic techniques and the themes of the images were broadened.[23] Non-political everyday motifs from the socialist world increasingly replaced propaganda images. Maleschka's co-author Peer Pasternack made a close examination of Halle-Neustadt, a town built from the drawing board in 1964, and discovered the considerable total of 184 works of art of all kinds, scattered across the area of the town. Only 23 per cent of them were devoted at that time to unambiguously political topics.[24] Abstract art-for-architecture, too, was now possible

again, as Rudolf Sitte's concrete relief at Technische Universität Ilmenau and many other cases demonstrate.[25] Examples of the high-quality late phase of this art on buildings are the limestone relief *Lied des Lebens* (Song of Life), dating from 1981, in the Haus der Kultur in Gera and, also drawing on musical inspiration, the ceiling painting *Gesang vom Leben* (Song of Life) by Sighard Gille. This 712-square-metre painting adorns the foyer of the Gewandhaus in Leipzig (pp. 18–19) and was suggested by Gustav Mahler's *Lied von der Erde* (Song of the Earth).[26] The striking hexagonal building opens to Augustusplatz with a three-storey glass façade, enabling the monumental painting behind it to radiate far into the urban environment.

But art could be even bigger. Probably the most idiosyncratic combination of architecture and the visual arts is manifested in the Peasants' War Panorama, above Bad Frankenhausen in Thuringia (p. 17). Here the GDR, taking its cue from the views of Karl Marx, commemorated the German Peasants' Wars of the sixteenth century as part of an early bourgeois revolution. For almost twelve years, the East German "painter prince" Werner Tübke collaborated with five other painters on a monumental circular work showing scenes from the Peasants' War and the Renaissance, completing it in 1987. With its surface area of 1,722 square metres, this panorama, situated where a decisive battle was fought in 1525, is among the largest paintings in the world.[27] In this case the art does not complement the building, but vice versa: the exterior of the enormous round structure, visible from a great distance, is reminiscent of a gasometer or water tower.

A leap in urban scale: Prager Strasse

After 1960, reconstruction of cities that had been severely hit by air raids in the Second World War was by no means complete. Among the most ambitious urban building projects of the 1960s was the recreation of Prager Strasse in Dresden, which was wholly destroyed in February 1945. Before the war it had been the most splendid shopping street in Saxony. As the result of a competition held in 1962,[28] the street was to be rebuilt in thorough-going contemporary design as a wide artery for pedestrians. Seen from the train station, three slab-like towers rise on its north side, while the south side is flanked by a monumental apartment building, 240 metres long. This twelve-storey block contains 614 small apartments.[29] In its modernist radicality, the project recalls a design for a city of the future produced in 1924 by the architect Ludwig Hilberseimer, in which residential high-rises linked by pedestrian bridges stretch to the horizon.[30]

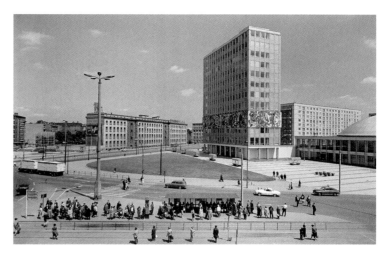

Alexanderplatz, Berlin, with the Haus des Lehrers and the Kongresshalle (right), around 1965

Nowhere in the GDR other than in Berlin-Mitte and Karl-Marx-Stadt (now called Chemnitz) was a break with the scale and structure of the previous urban nexus carried out so consistently. Towards the station, four towers on an approximately square ground plan and the fifteen-storey Interhotel Newa flank the quarter, which was designed by several architects' collectives. Importance was attached here to attractive open spaces.[31] Today the effect is diluted by new buildings from the post-unification period that lack a relationship to the ensemble.

The elements forming a spatial connection to the pedestrian avenue with its fountains and geometrical planting are pavilion-like shops, large restaurants and the famous Rundkino, a circular cinema at the eastern margin of the ensemble, planned by the collective of Gerhard Landgraf and Waltraud Heischkel. Its external appearance is a cylinder, twenty metres in height and fifty metres in diameter, accentuated with black vertical stripes. A conspicuous feature of the façade at the first floor is the cladding of white enamelled bands of metal that form square and vertical patterns. This is a further building that stands out for its synthesis of form, innovative architectural adornment and careful detail. Opposite the Rundkino, the Centrum department store constituted the eastern termination of the street for many years. Its sculptural, structured façade of anodised aluminium elements lent a "crystalline character"[32] to the building. The department store, designed by the Hungarian architects Ferenc Simon and Ivan Fokvari, was demolished in 2006, but the honeycomb-shaped façade elements were saved.[33] The architect Peter Kulka wanted to reuse these original honeycomb elements for a new department store on the same site, but ultimately had new ones made based on the originals, which were in poor condition. Though the loss of the original structure is regrettable, here attempts are nevertheless evident to preserve for the urban environment a façade design typical of post-war modernism. Rhythmic façades of metal elements and shaped pieces of concrete, known at the time as

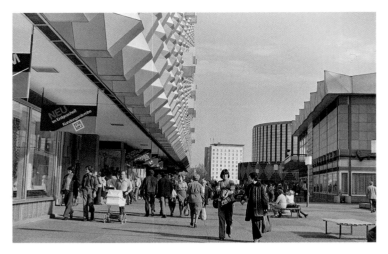

Prager Strasse, Dresden; to the left is the Centrum department store

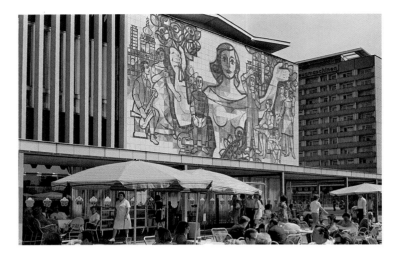

Restaurant Bastei on Prager Strasse; the mural is made of Meissen porcelain

"industrial sculpture", were a specific and varied feature of GDR modernism. These means of designing large surfaces, simple to manufacture but effective, enlivened gable walls and the boundaries of open spaces, and helped "to lend three-dimensional shaping to a building that had become a mass product".[34] The façade of the Stadthalle in Chemnitz conveys a lively impression of the potential of such abstractly structured façades.

In Leipzig, the other large city in Saxony, war damage was less severe than in Dresden. For the SED party, the trade-fair city of Leipzig ranked directly after Berlin as an urban showcase. In consequence of both of these factors, modernism in Leipzig in those years was manifested in dominant urban buildings rather than in large-scale ensembles. Alongside the Neues Gewandhaus, the opera house and trade-fair buildings, it is above all the 142-metre-high Universitätshochhaus (University Tower), built between 1968 and 1972 by a team associated with Hermann Henselmann, that comes to mind. This tower, curving steeply upwards on its eastern side, is a Leipzig landmark today.

Less spectacular but outstanding in its design is the 95-metre residential tower, topped by the trade-fair logo, on Wintergartenstrasse by Frieder Gebhardt and Georg Eichhorn (p. 21). This sculptural octagonal tower contains 208 apartments and is a fine symbol of optimism and the "faster – higher – stronger" spirit of the period around 1970.

Modern versus medieval: Halle-Neustadt
The conceptual opposite to Leipzig and Dresden, where modernism made its mark in the city, is Halle-Neustadt, where a completely new town for a population of 100,000 was juxtaposed with the old one. Following the decision by the Politburo of the SED in 1963 to construct a "socialist town of chemical workers" for employees in the chemical plants in Buna and Leuna, building began in 1964 under the direction of Richard Paulick, a

Bauhaus pupil. By 1980, 33,000 apartments had been built on an area of 1,000 hectares to the west of the old city of Halle. This extensive town of Plattenbau structures with its own municipal charter, rail station and shopping zone next to a thousand-year-old salt-makers' city on the river Saale prefigured in exemplary fashion the later development of architecture and urban development until the end of the GDR.

Since the late 1950s, the industrialisation of the construction industry, in other words, building with blocks and later with large slabs, had been pursued with great energy.[35] By 1985, this way of building had reached a share of 83 per cent of the total volume of residential construction.[36] In this way, according to the aims of the Party, the housing issue was to be solved by 1990. The new housing estates rose – like Halle-Neustadt – almost without exception on the edge of towns. This was in the spirit of the times, but was also a consequence of the space needed for the gantry cranes with which the prefabricated ceiling, wall and façade elements, delivered by low-loading trucks, were assembled on site. In 1990, almost one-third of the 6.35 million apartments had been built by industrial methods.[37]

Plattenbau policy and decay of historic quarters
Though the aims of the plan for constructing new housing were met, while this happened historic city centres and quarters dating from the late nineteenth century were falling into disrepair. The number of unoccupied properties increased. The GDR had no solution for handling the existing building stock. The rivalry between the modern and the old urban environment, which in Halle was settled at the level of whole towns, affected practically every town and city in the country on a smaller scale. In about 1980, under the influence of postmodernism and the associated rediscovery of old towns, a gradual change in thinking took place. Drawing on an ever-broader range of Plattenbau types and ways of varying them, the housing construction combines now increasingly developed individualised

variations of the Plattenbau with a low space requirement for use in city centres. However, this small-scale "adapted Platte", in some cases with a gable roof, pointed gables, fluting and mosaics, also required an open site for their assembly.[38] This meant that, as in Bernau, Greifswald and on the cathedral square in Halle (p. 150), neighbouring buildings were often demolished for the purposes of urban redevelopment. Thus, paradoxically, the wish to bring about a renaissance of town centres meant a fatal blow to ensembles, sometimes centuries old, which had survived until that time.

A first counter-stroke to this practice in urban development was the so-called complex reconstruction begun in 1970 around Arkonaplatz in Berlin. Under the direction of Lothar Arzt and Klaus Pönschk, a systematic renovation of the existing built fabric was attempted for the first time. Blocks were gutted, apartments fitted with bathrooms and gas heating, and participation by residents even took place.[39] From 1973 the architect Manfred Zache applied the concept that had been tried here on three blocks to the considerably larger quarter around Arnimplatz at the northern edge of Prenzlauer Berg. This became the first example of large-scale, careful urban renewal[40] in the GDR, but remained an exception – although Zache was able to demonstrate that renovation of the existing buildings also made sense financially.[41]

The ornamented Plattenbau and reconstruction

The Politburo and Ministry of Construction lacked not only the political will to make a decisive change of course; the almost complete orientation of the construction sector in the GDR to industrial-style building left hardly any scope for the repair of old building fabric, and there was a shortage of manual workers with the appropriate training. Thus the gap between aims and reality became larger and larger in the last decade of the GDR. With the above-mentioned Neues Gewandhaus in Leipzig (pp. 18–19), the Friedrichstadtpalast revue theatre (p. 141) and the Sport- und Erholungszentrum (SEZ) (p. 135) in Berlin, the GDR once more tackled major prestige projects. The occasion for the project in the capital was Berlin's 750th jubilee year in 1987. For these undertakings, which included the Zeiss-Grossplanetarium at the Ernst-Thälmann-Park (p. 137) and reconstruction of the Nikolaiviertel between the city hall and Museumsinsel (Museum Island), teams from the whole GDR were sent to Berlin. The technicians of the housing construction combines displayed great ambition in carrying out ever more refinements to the appearance of

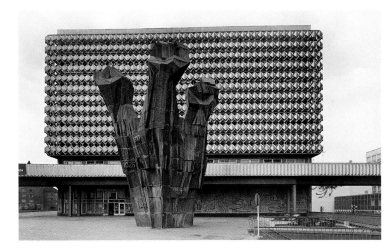

Monument to the revolutionary German workers' movement in Halle, 1969

the Plattenbau modules. On the east side of Gendarmenmarkt in Berlin, Art Nouveau decoration in the form of small mosaics was even integrated into the façades of Plattenbau structures in 1987.[42] In this way matters turned full circle, astonishingly, with a return to the architecture of the National Tradition in the 1980s: in manufacturing, construction was industrial, while in style it was historical once again. Yet priorities such as these accelerated the decay of the genuine old quarters. Moreover, the appearance of the buildings designed in contemporary style seems indecisive. They proclaim a process of architectural searching.

If East German postmodernism existed, then it was represented by the gable-house look of the prefabricated concrete structures in Berlin's Nikolaiviertel, the technified steel-framework construction of the SEZ sports and recreation centre and the façade of the Friedrichstadtpalast (p. 141). "In the sculptural and ornamental play of its concrete shapes with integrated coloured glass prisms, the building makes an idiosyncratic statement",[43] was the somewhat helpless comment of a GDR architectural journal on this new structure. The nickname that quickly spread for the revue theatre, the "Kazakhstan central station", is a very fitting expression of its aesthetic. The buildings of the late GDR do not live up to its era of splendour between 1958 and 1978.

The designer disappears in the collective?

Much has been discussed here about buildings, but little about architects.[44] This is mainly for reasons of space, because architecture in the socialist state by no means happened without authors, in spite of the practice of working in collectives and the general absence of private architecture offices. For every building and every technical plan, GDR architecture guides always name the persons responsible for the design. It even seems that the true authors of architectural achievements were recorded better than in the Federal Republic, where the heads of offices often claim sole credit for the work and ideas of their competition teams.

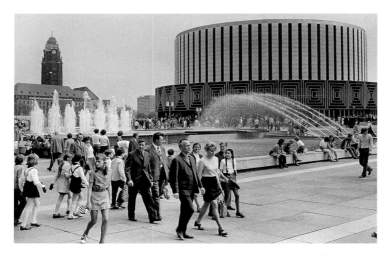

The Rundkino on Prager Strasse, Dresden

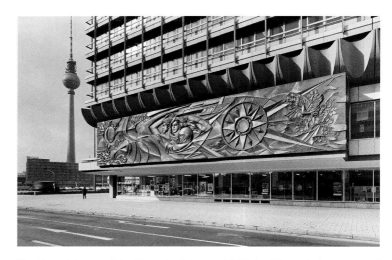

The Fernsehturm and the Haus des Reisens with Walter Womacka's copper wall relief *Der Mensch überwindet Zeit und Raum* (Man Conquers Time and Space)

However, few creators of architecture attained the recognition given to Richard Paulick, Heinz Graffunder, Josef Kaiser, Roland Korn and of course Hermann Henselmann, without whom the history of GDR architecture cannot be told. It is remarkable how this enabler and strategist of urban development, agile and conscious of a mission, succeeded throughout every phase of GDR construction policy in maintaining his active influence on the architectural face of the country.[45]

Henselmann's Signal Tower

In conclusion, there is one building that may not be omitted from a book about the architecture of the GDR. Although Henselmann did not plan it himself, only he made it possible in its present form. On superficial consideration, the Berlin Fernsehturm, the television tower, completed in 1969 to plans by Fritz Dieter and Günter Franke, is just one more example of the numerous prestige projects with which the leadership of the GDR wished to impress the West. Seen in a wider context, however, Europe's second-tallest building at 365 metres represents the vision of a crown for the city, realised after a delay of several decades. This idea and the term were coined by Bruno Taut during the Expressionist beginnings of Neue Sachlichkeit in 1919. Hermann Henselmann himself provided the first idea with his design for a Signal Tower in the urban planning competition for the centre of East Berlin, for which the government of the GDR invited submissions in 1958. However, he placed this tower on a site that was earmarked for a GDR government high-rise. This headstrong attitude cost Henselmann his position as the chief architect of Berlin. Nevertheless, he had made public the idea of marking the centre of Berlin, not with a gesture of political power, but with a universal symbol of technical progress. This was far-sighted: today the "most beautiful of all television towers"[46] comes immediately after the Brandenburg Gate as a symbol of the city.

Its proportions are perfect, and the huge metal sphere for the tower restaurant is almost a stroke of genius as a counterpoint to the shaft of the tower, which narrows gently as it rises. Its ball-shaped cladding of pyramidal sheets of stainless steel is a borrowing from the Sputnik space capsules of the Soviet pioneers, combining the space fever of those years with Bruno Taut's vision. And the tower is situated so ingeniously that it stands precisely in the line of view of many arterial roads: from whichever direction the centre of Berlin is approached, the direction is straight towards the tower with its gleaming silver sphere. It is the best-known work of GDR architecture and surely the lasting gift to the world of this now-vanished country.

Frank Peter Jäger

1 Here the phase of the Soviet Occupation Zone before the foundation of the German Democratic Republic in 1949 is included.

2 Andreas Butter and Ulrich Hartung, *Ostmoderne – Architektur in Berlin 1945–1965*, Berlin 2005, p. 15.

3 Richter, Peter, 'Zweiter Frühling zur Ostmoderne in Potsdam', *Süddeutsche Zeitung*, 1 July 2018.

4 The demolition of the Ahornblatt restaurant, a work by Ulrich Müther in Berlin, undoubtedly gave an initial impetus.

5 This question is also posed, though in a rhetorical sense, by Butter and Hartung, *Ostmoderne*, p. 10.

6 The division of GDR architecture into five phases undertaken here corresponds to the usual view in the literature for phases 1 to 3. Phases 4 and 5 (1970s and 1980s) is clearly justified by factual changes.

7 Butter and Hartung, *Ostmoderne*, p. 54.

8 The phase of stylistic change to the National Tradition explains why the interior, under the aegis of the Dresden architect Hans Richter from 1952, turned out considerably more imposing than the sober exterior of the building suggests. See here Butter and Hartung, *Ostmoderne*, p. 33.

9 Butter and Hartung, *Ostmoderne*, p. 11.

10 Significantly, the house for big cats (Alfred-Brehm-Haus) in the Berlin Tierpark, begun in 1956, was one of the first buildings to embody self-confident modernism once again.

11 Alexander Dymschitz was Moscow's cultural officer for Germany at that time.

12 Conversation with Prof. Dr. Markus Tubbesing, architect and conservation expert.

13 Butter and Hartung, *Ostmoderne*, p. 10.

14 In the Berlin architectural guide of 2005, GDR modernism is however explicitly categorised under the International Style. See Rainer Haubrich, Hans Wolfgang Hoffmann and Philipp Meuser, *Berlin – Der Architekturführer*, Berlin 2005.

15 Butter and Hartung, *Ostmoderne*, p. 10.

16 Ibid., p. 10.

17 Today, the former Filmtheater Kosmos is used as a congress centre. Café Moskau serves as an event location.

18 Butter and Hartung, *Ostmoderne*, p. 10.

19 Wolfgang Hocquél, *Leipzig Architektur. Von der Romantik bis zur Gegenwart*, Leipzig 2004, p. 119.

20 The members of the group were Jörg Streitparth, Siegfried Wagner and Klaus Weisshaupt. Source: Martin Wörner, Doris Mollenschott, Karl-Heinz Hüter et al., *Architekturführer Berlin*, Berlin 2001.

21 The name Ahornblatt (Maple Leaf) derives from the five hyperbolic paraboloid shells that form the roof support structure of the semicircular projecting building.

22 See Rahel Lämmler and Michael Wagner, *Ulrich Müther: Shell Structures in Mecklenburg-Western Pomerania*, Sulgen and Zurich 2010. A further example of the difficulties of repurposing GDR buildings under the conditions of the West is the above-mentioned Müggelturm. Here it took sixteen years and three failed attempts at privatisation before a sustainable concept for its use was found.

23 Martin Maleschka, *GDR. Baubezogene Kunst. Kunst im öffentlichen Raum 1950 bis 1990*, Berlin 2018.

24 Peer Pasternack, in ibid., p. 31.

25 Maleschka, *GDR. Baubezogene Kunst*, p. 434.

26 Hocquél, *Leipzig Architektur*, p. 121.

27 See 'Bauernkriegspanorama', *Wikipedia, Die freie Enzyklopädie*, https://de.wikipedia.org/wiki/Bauernkriegspanorama.

28 The winning proposal for the competition was submitted by the collective of P. Sniegon, K. Röthig and H. Konrad. See *Architekturführer DDR, Bezirk Dresden*, Berlin 1981, p. 18.

29 See 'Prager Strasse (Dresden)', *Wikipedia, Die freie Enzyklopädie*, https://de.wikipedia.org/wiki/Prager Strasse (Dresden).

30 This refers to the project "Hochhausstadt" or "Neubebauung der Friedrichstrasse", which was intended for Berlin. See Ruth Eaton, *Die ideale Stadt*, Berlin 2001, pp. 176–77.

31 The landscape architects were J. Pietsch and S. Kassberg. See *Architekturführer DDR*, p. 18.

32 Gilbert Lupfer, Bernhard Sterra and Martin Wörner, *Architekturführer Dresden*, Berlin 1997, p. 3.

33 The former Centrum department store in Suhl and the Konsument store in Leipzig were also demolished.

34 Pasternack, in Maleschka, *GDR. Baubezogene Kunst*, p. 32.

35 The older method of *Plattenbau* building known as *Blockbauweise* (block building method) and the method that was later increasingly adopted, called *Tafelbauweise* (slab method), differed essentially in the size and weight of the constructional elements that were used. See Christine Hannemann, *Die Platte*, Berlin 2000, p. 24.

36 Ibid.

37 Ibid., p. 23.

38 Among the few exceptions were the buildings on Gendarmenmarkt in Berlin constructed between 1986 and 1988, where building with prefabricated concrete slabs on individual plots was successful thanks to technical modifications.

39 Here, see Haubrich et al., *Berlin – Der Architekturführer*, p. 206.

40 The term *Stadterneuerung* (urban renewal), coined in West Berlin, was not in common currency in the GDR, but fits the conceptual approach.

41 Haubrich et al., *Berlin – Der Architekturführer*, p. 206.

42 Ibid., p. 233.

43 Article in *Architektur der DDR*, no. 10 (1984), cited in Joachim Schulz and Werner Gräbner, *Berlin Architektur von Pankow bis Köpenick*, Berlin 1987.

44 In the GDR, a comparatively large number of women architects were named as early as the 1960s as the authors of designs or responsible employees.

45 Thomas Flierl, *Der Architekt, die Macht und die Baukunst. Hermann Henselmann in seiner Berliner Zeit 1949–1995*, Berlin 2018.

46 An assessment by Gabi Dolff-Bonekämpers, which the author is pleased to support, in Adrian von Buttlar, Kerstin Wittmann-Englert and Gabi Dolff-Bonekämper, *Baukunst der Nachkriegsmoderne, Berlin 1949–1979*, Berlin 2013, p. 230.

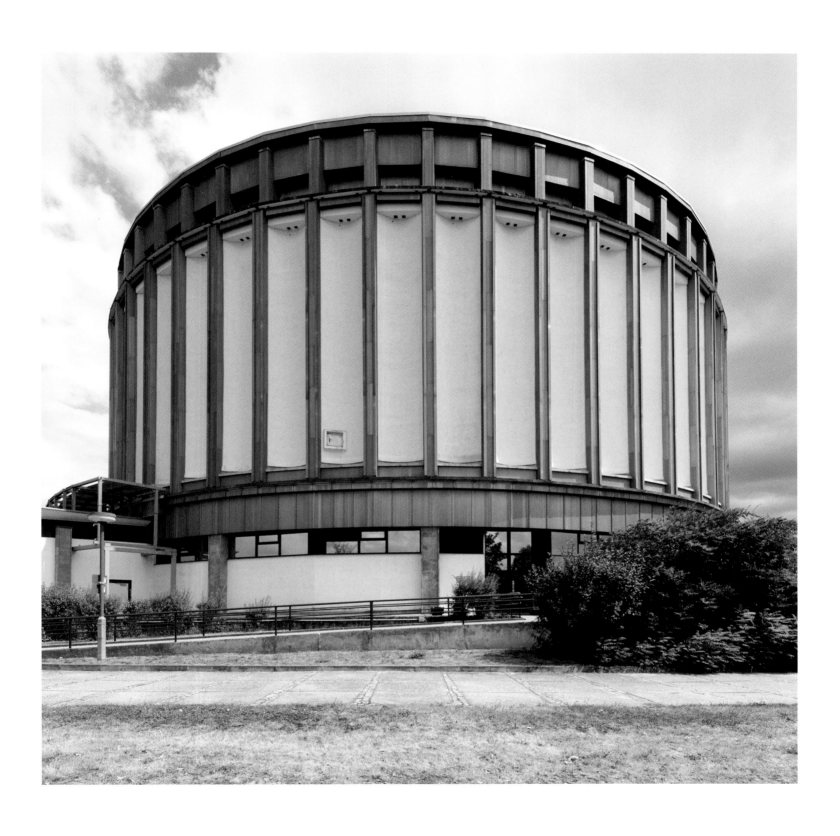

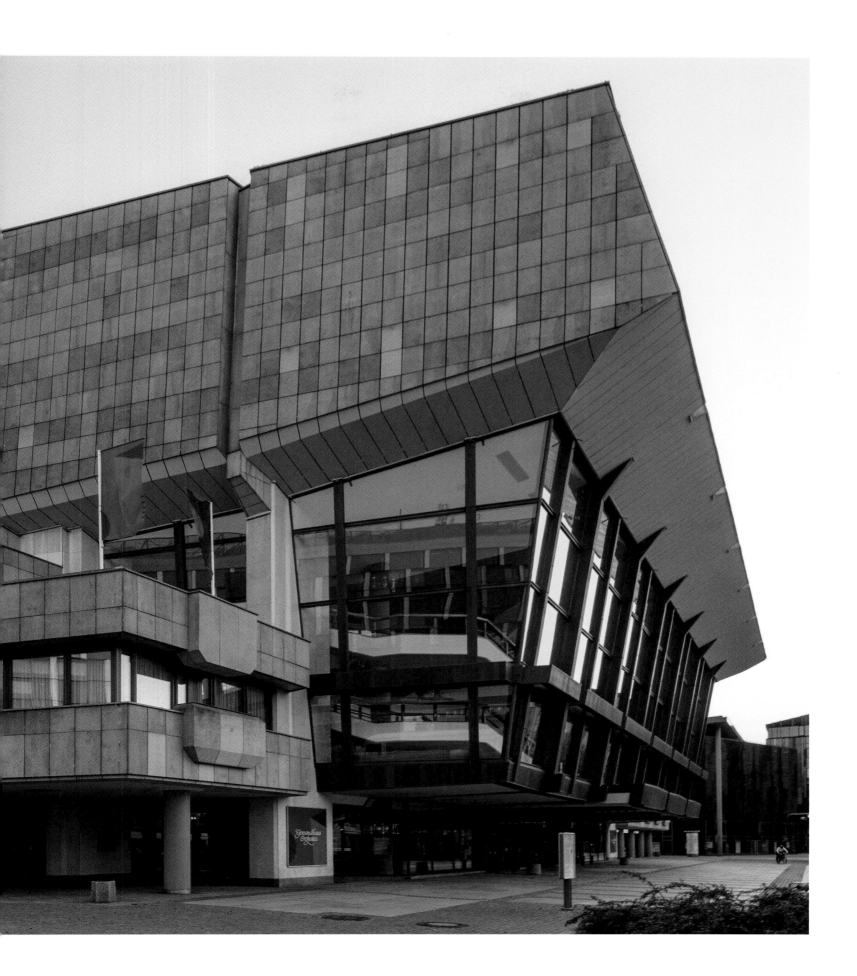

20 Opera house, Leipzig

right: Wintergartenhochhaus, Leipzig

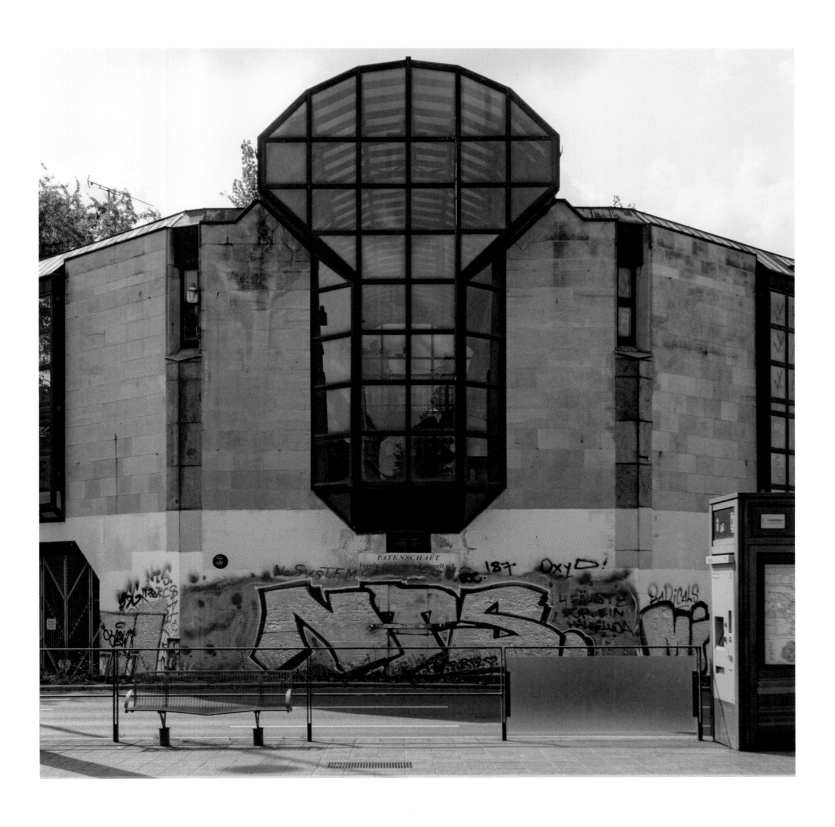

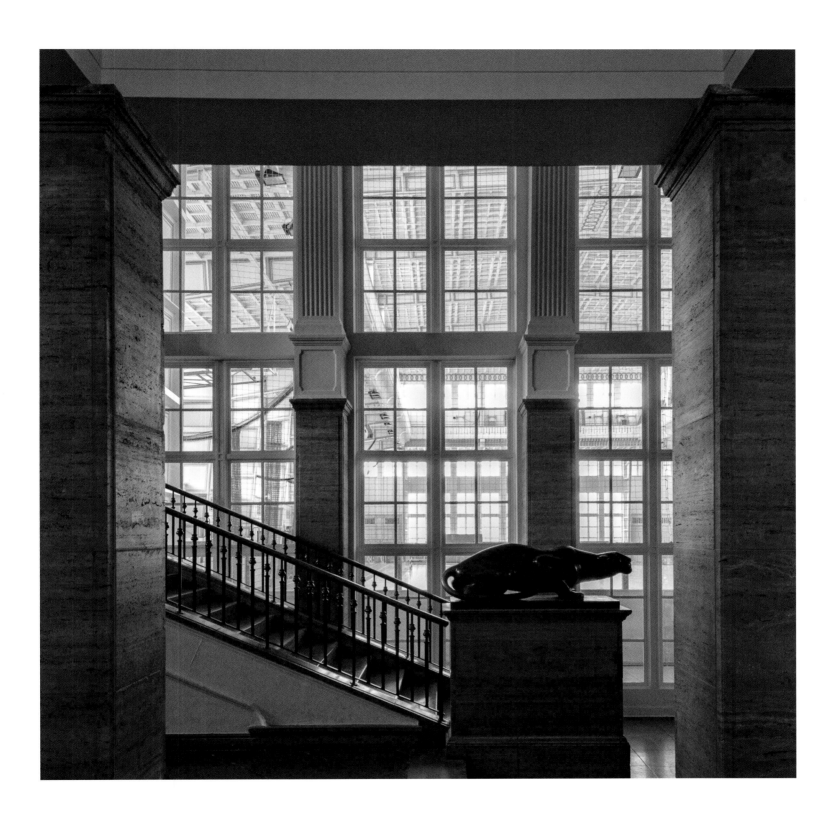

Ernst-Grube-Halle, DHfK, Leipzig **27**

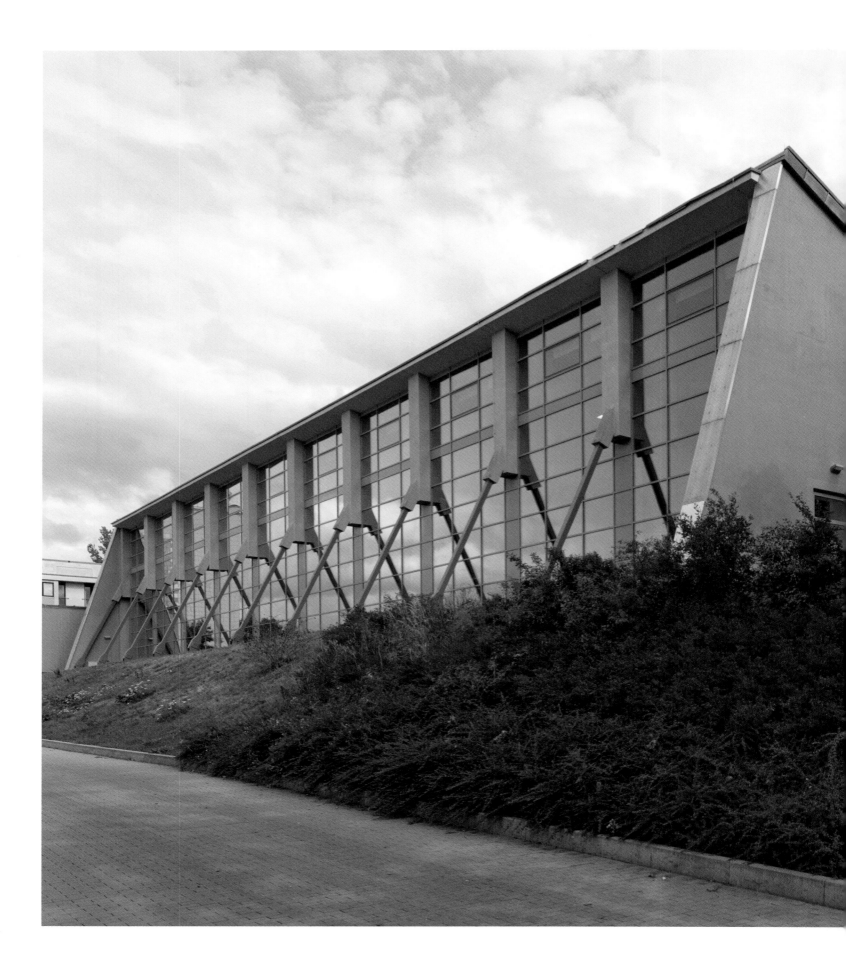

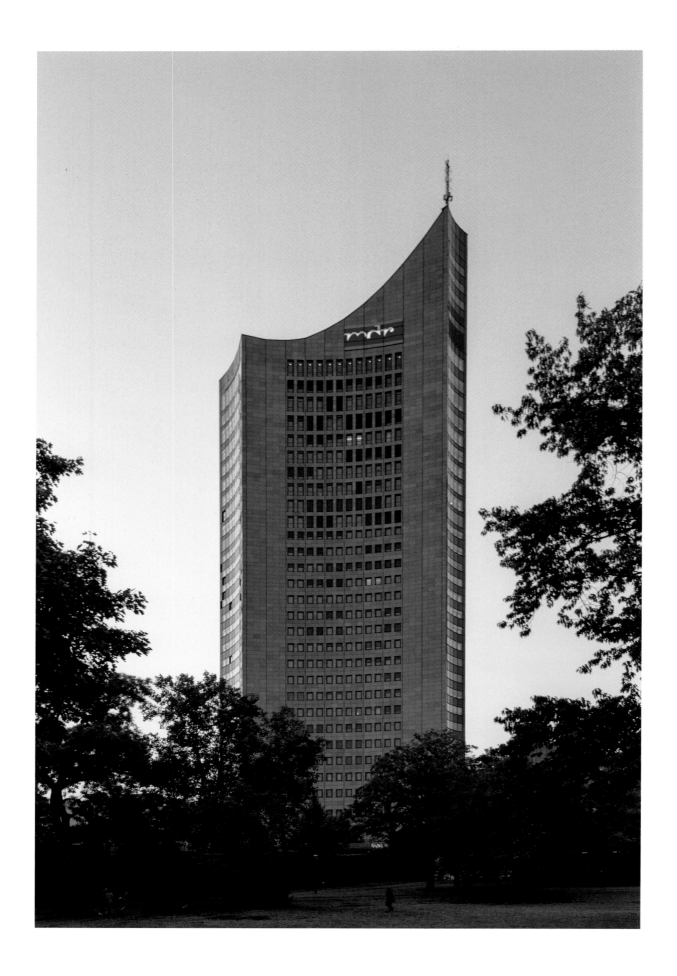

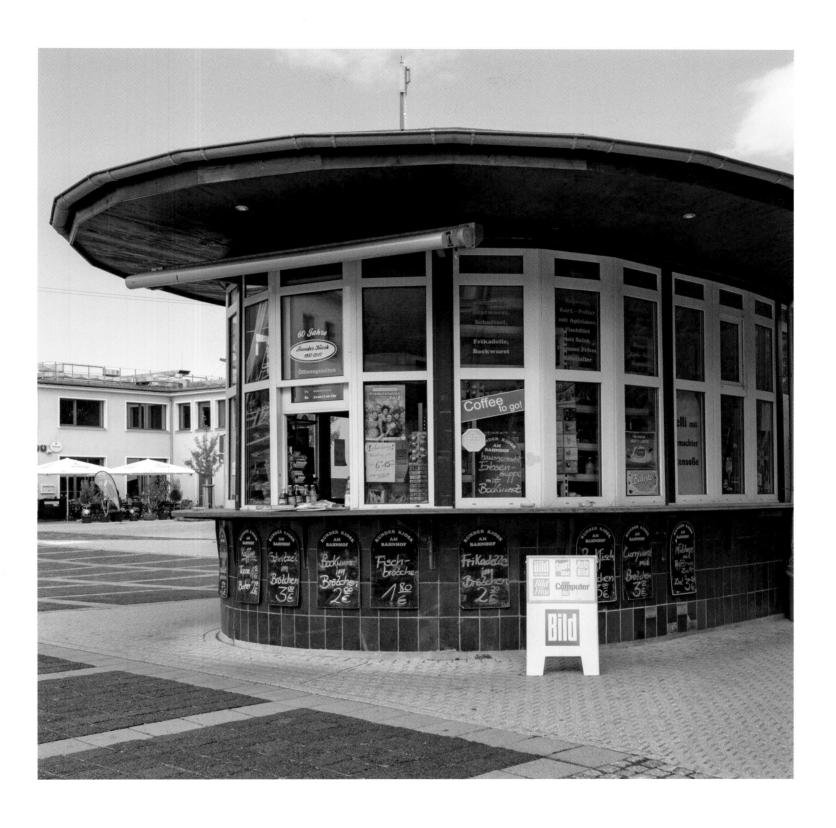

Round station kiosk, Sangerhausen **31**

left: Universitätshochhaus, Leipzig

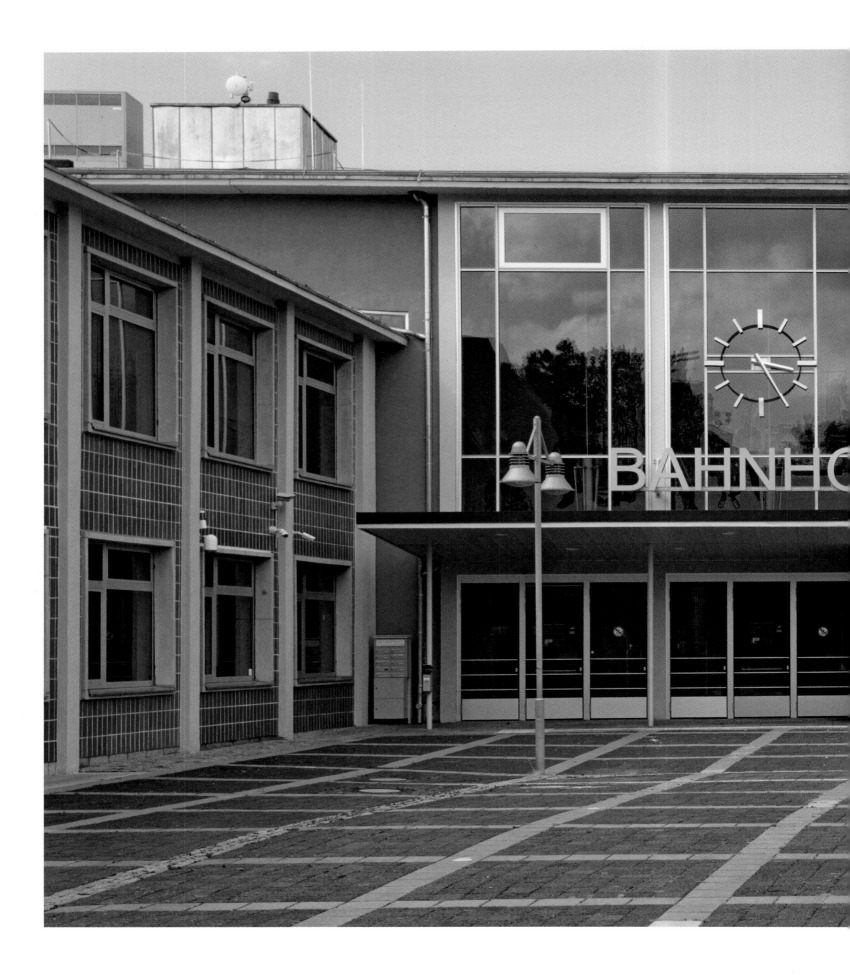

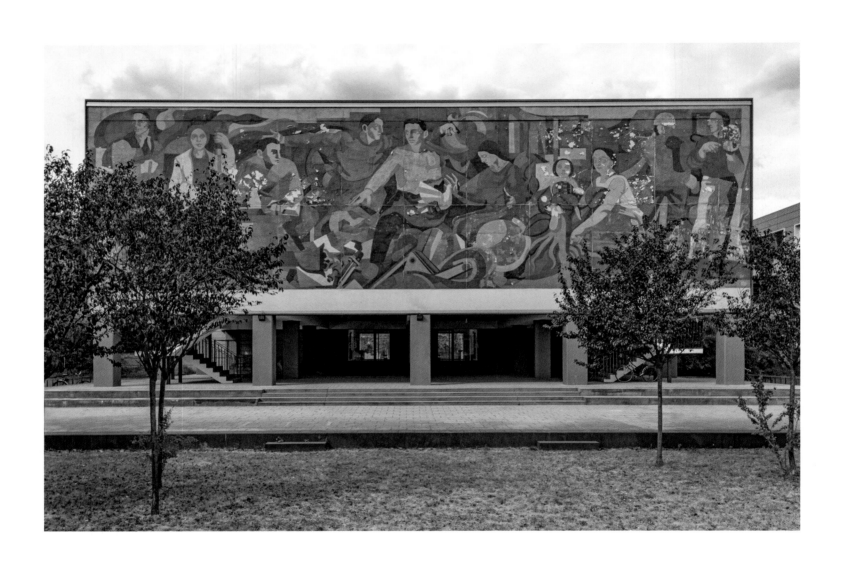

34 Teaching building of the Brandenburgische Technische Universität Cottbus

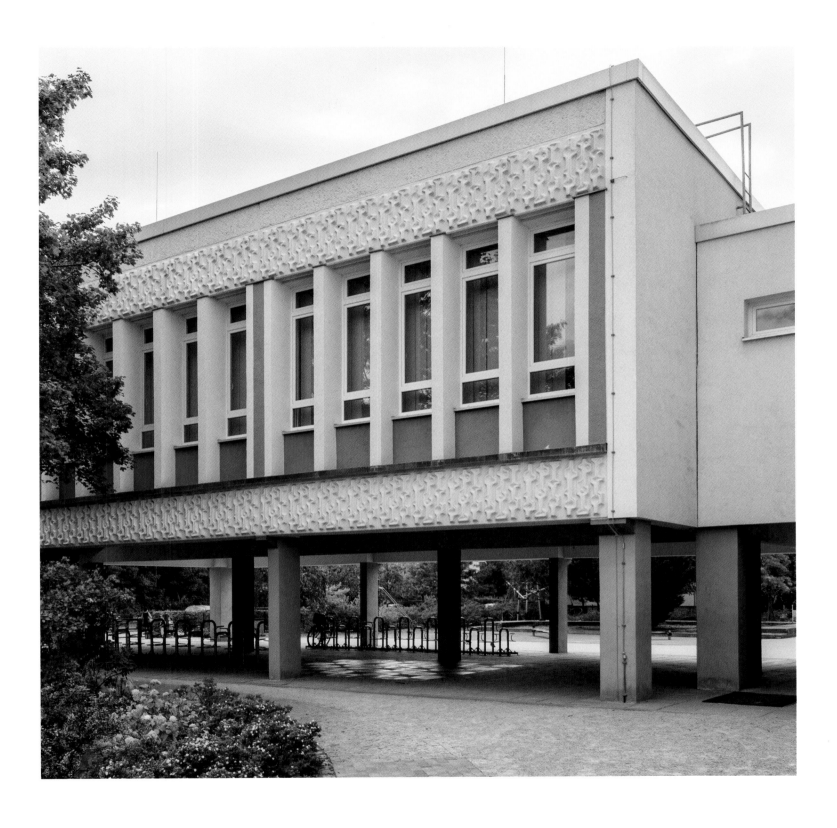

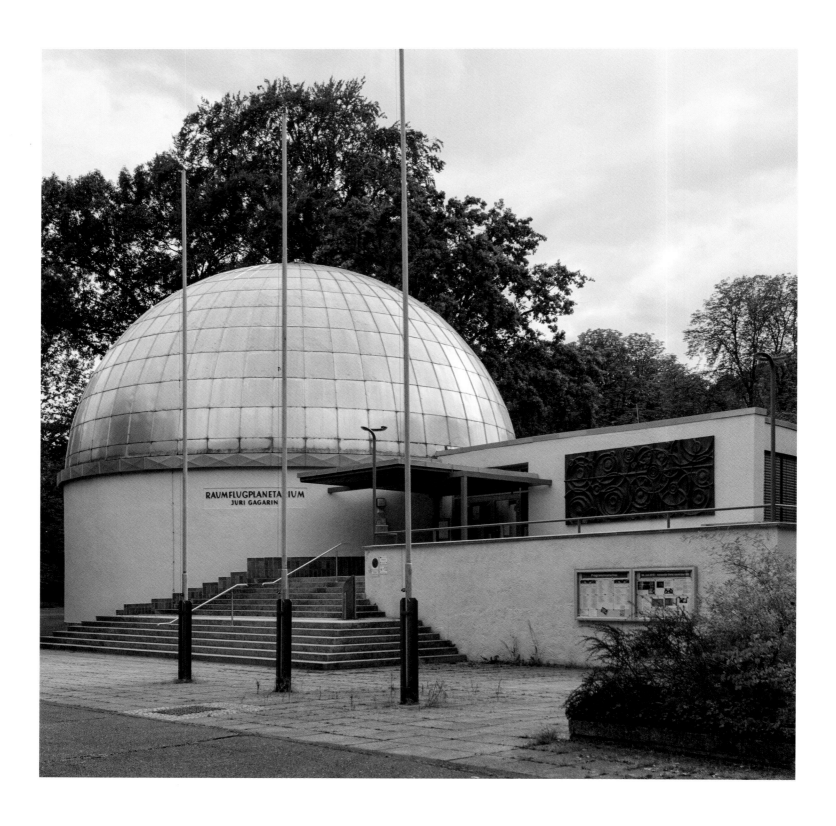

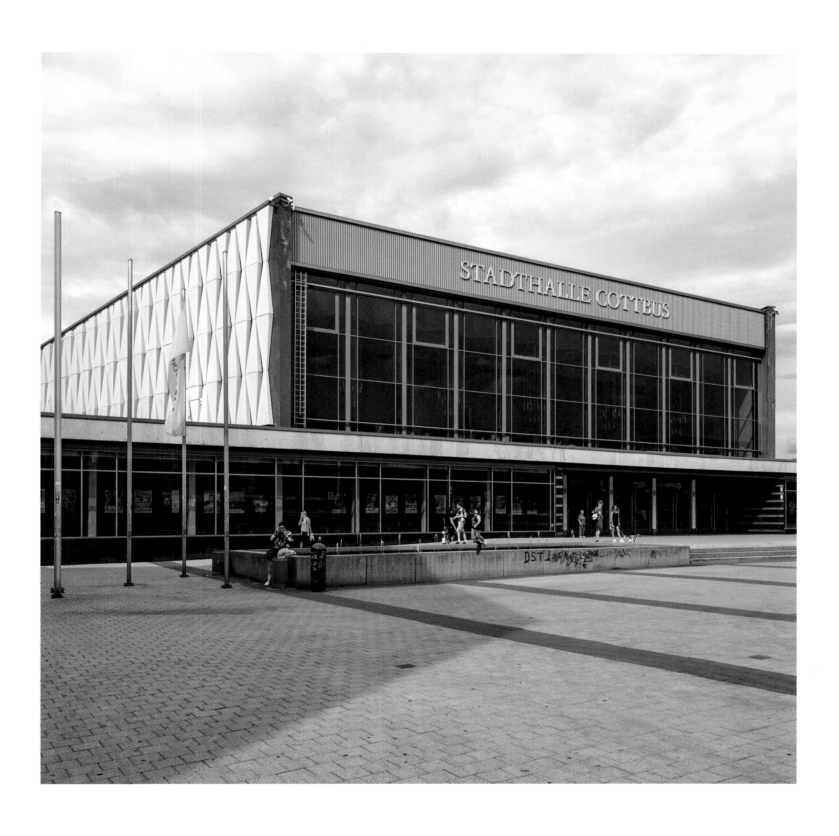

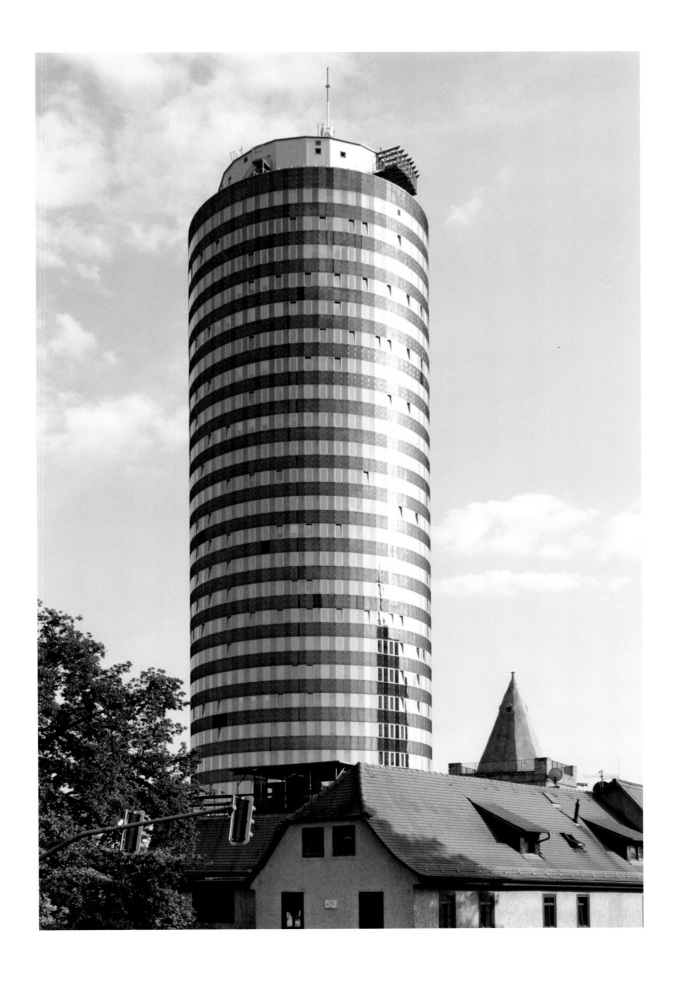

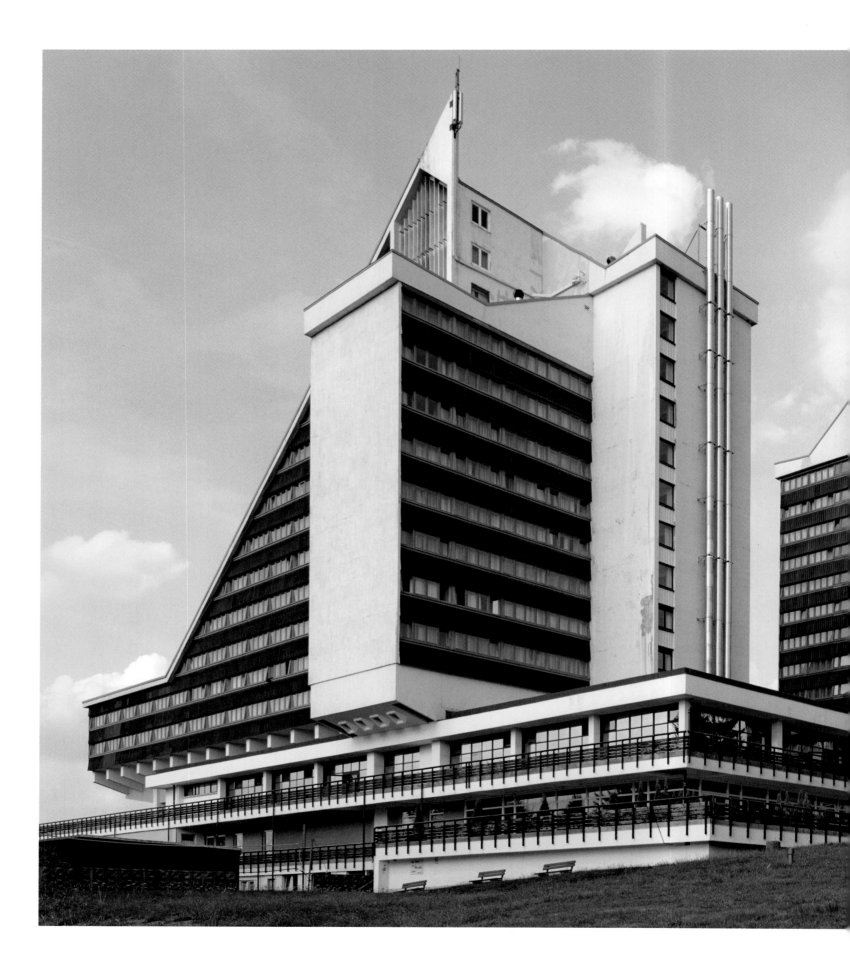

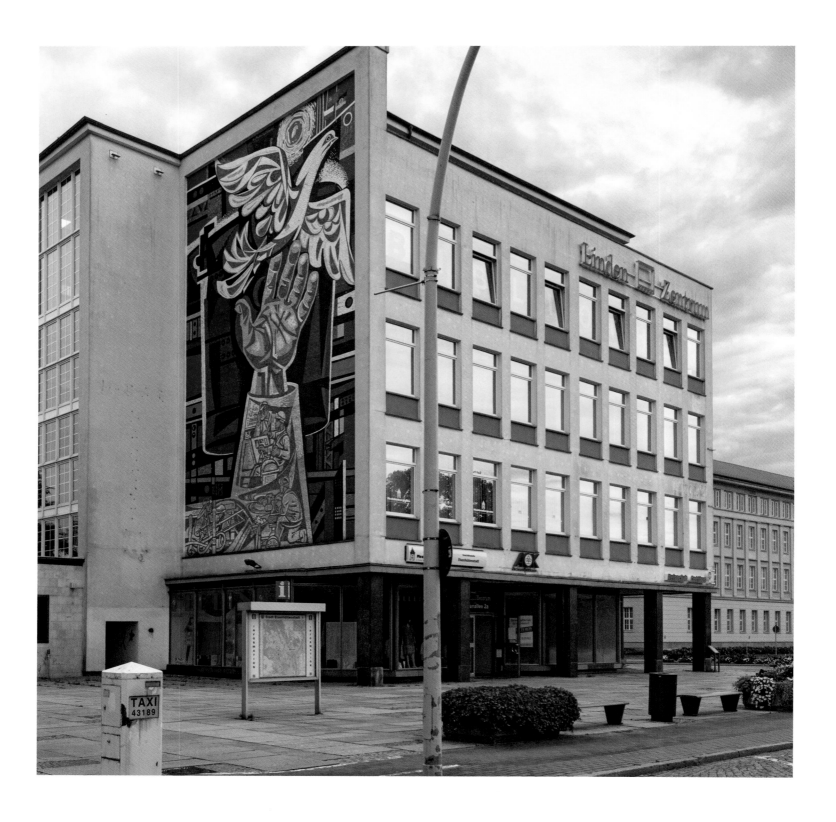

44 Magnet department store, Eisenhüttenstadt

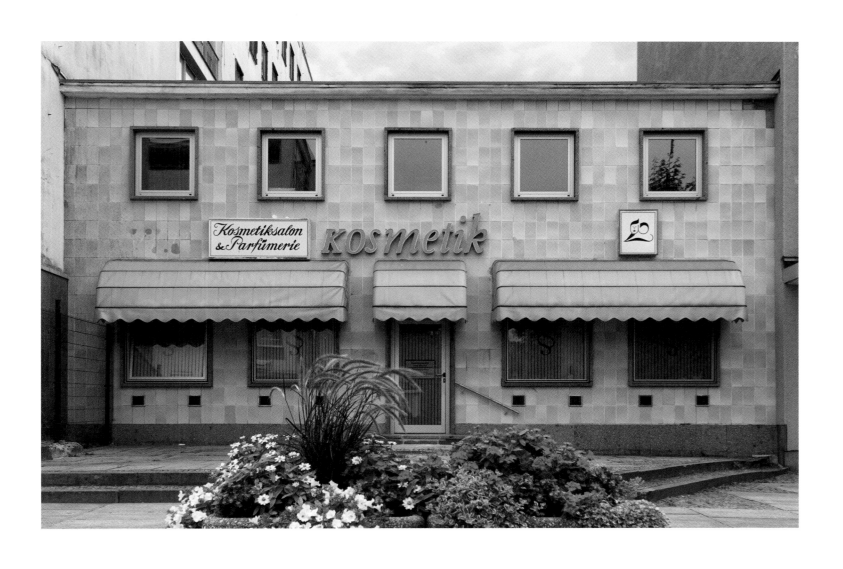

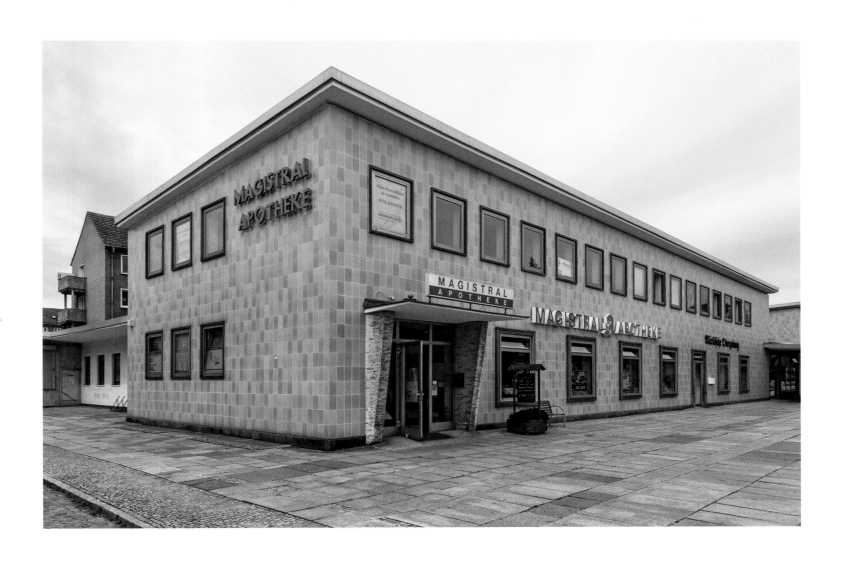

48 Kaufhalle Fix, Eisenhüttenstadt

Nursery school on Erich-Weinert-Allee, Eisenhüttenstadt **53**

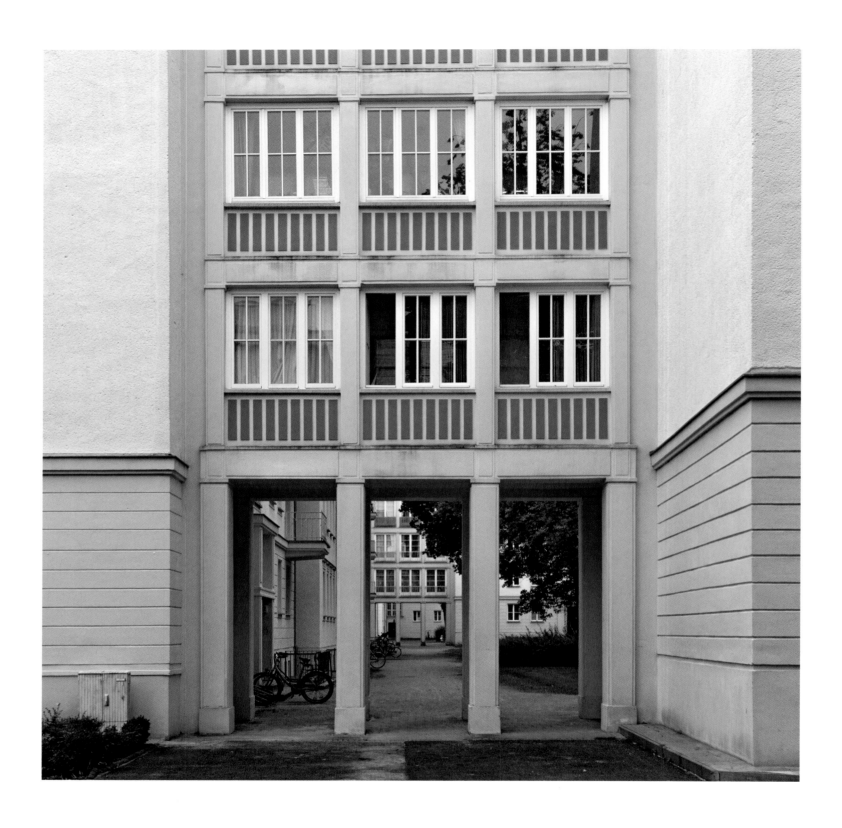

54 Housing Complex II, Pawlowallee, Eisenhüttenstadt

right: Housing Complex II, Block 51/53, Eisenhüttenstadt

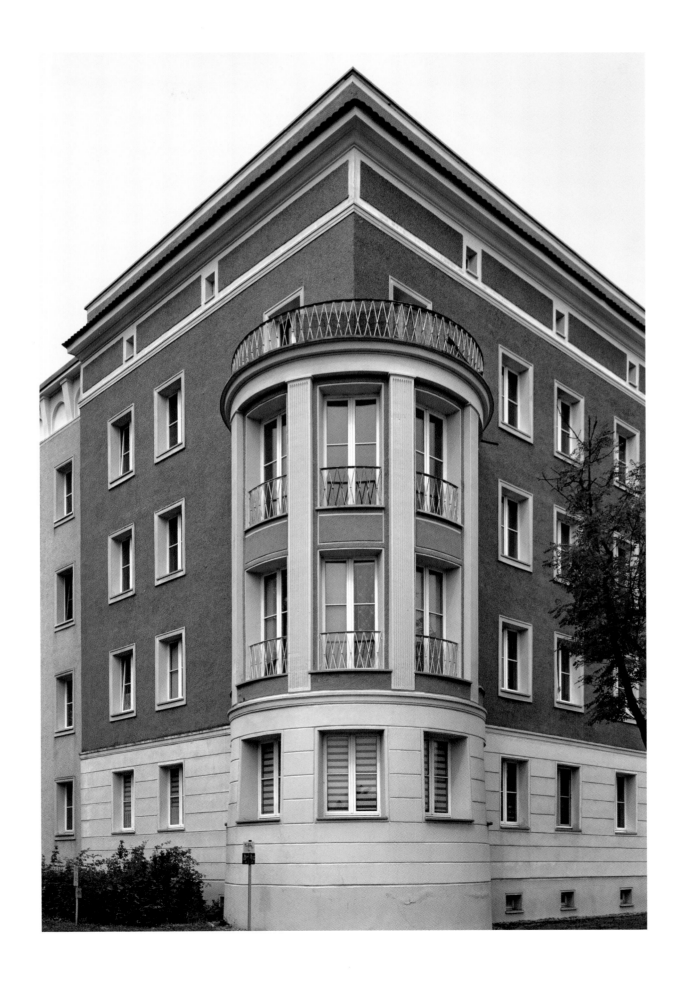

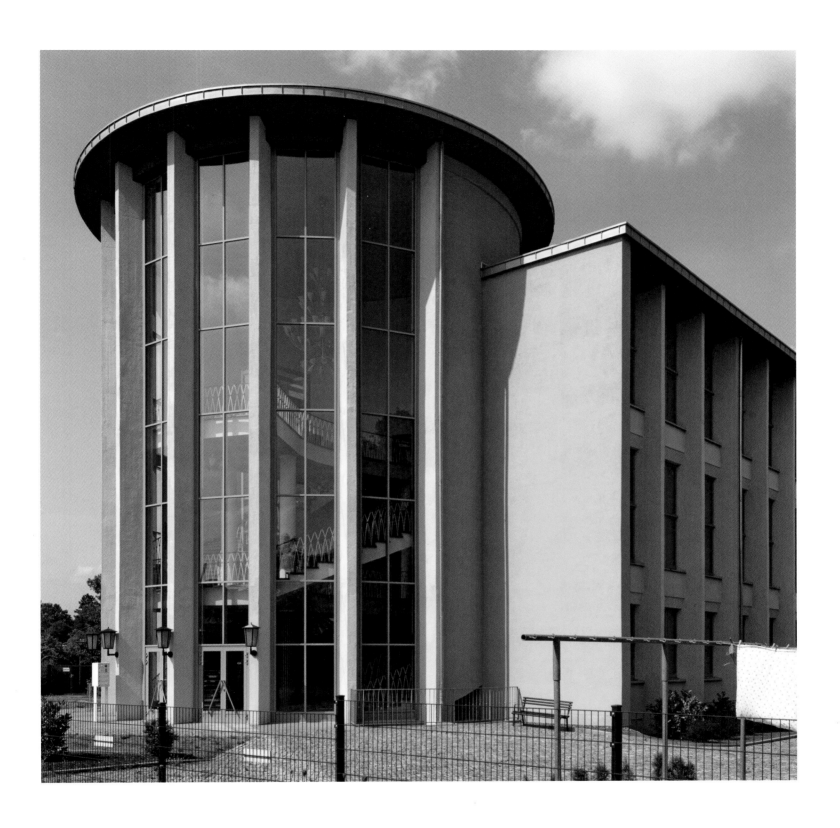

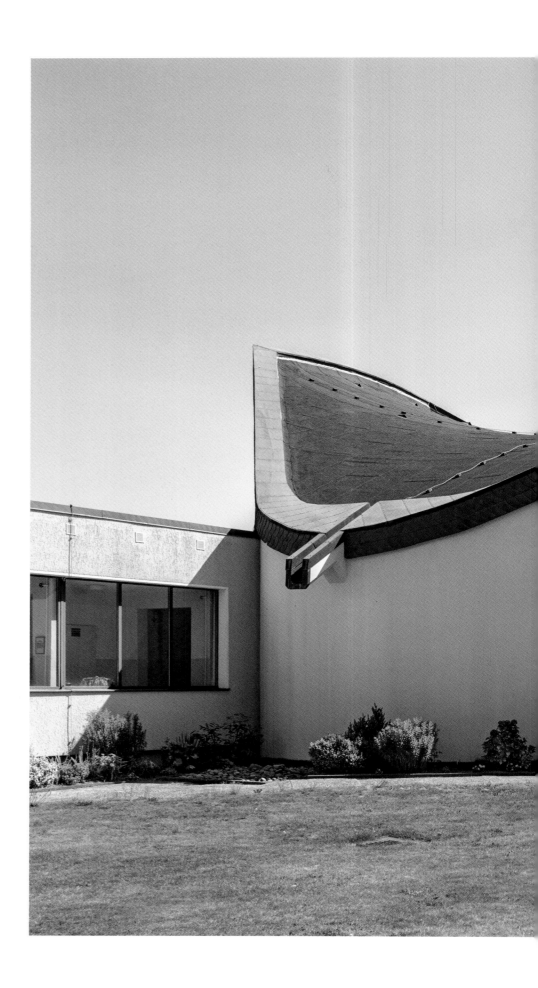

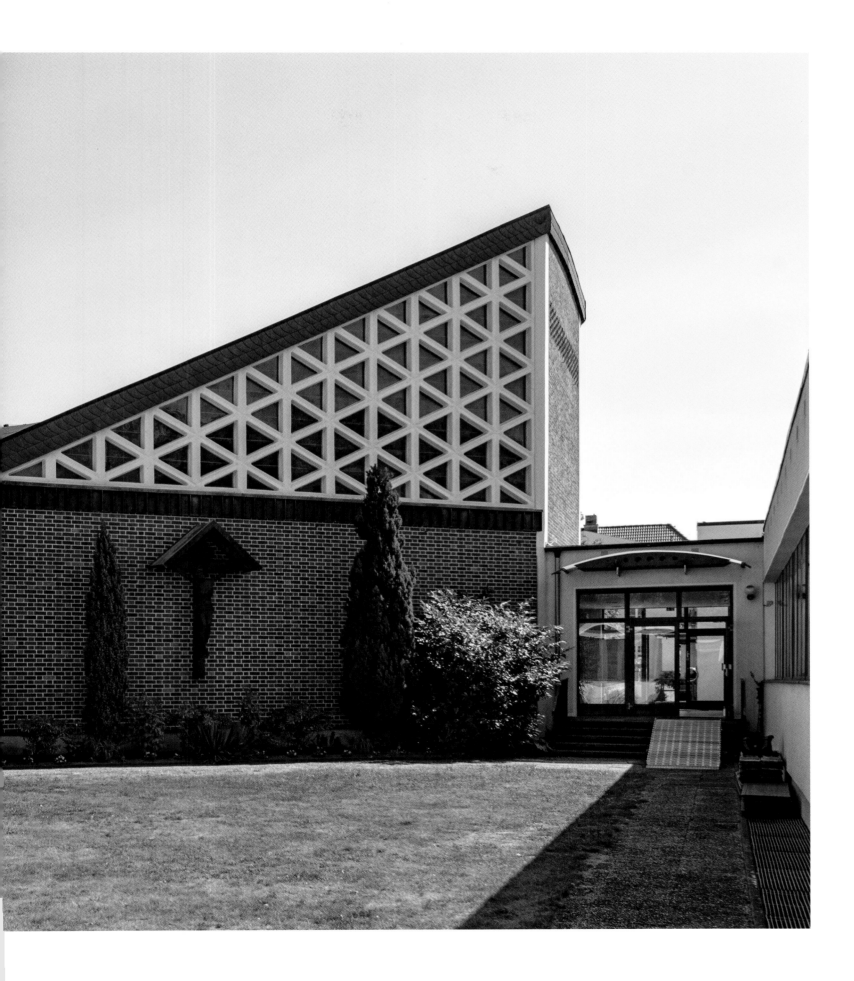

60 Möwenhaus with Warnow pharmacy, Rostock

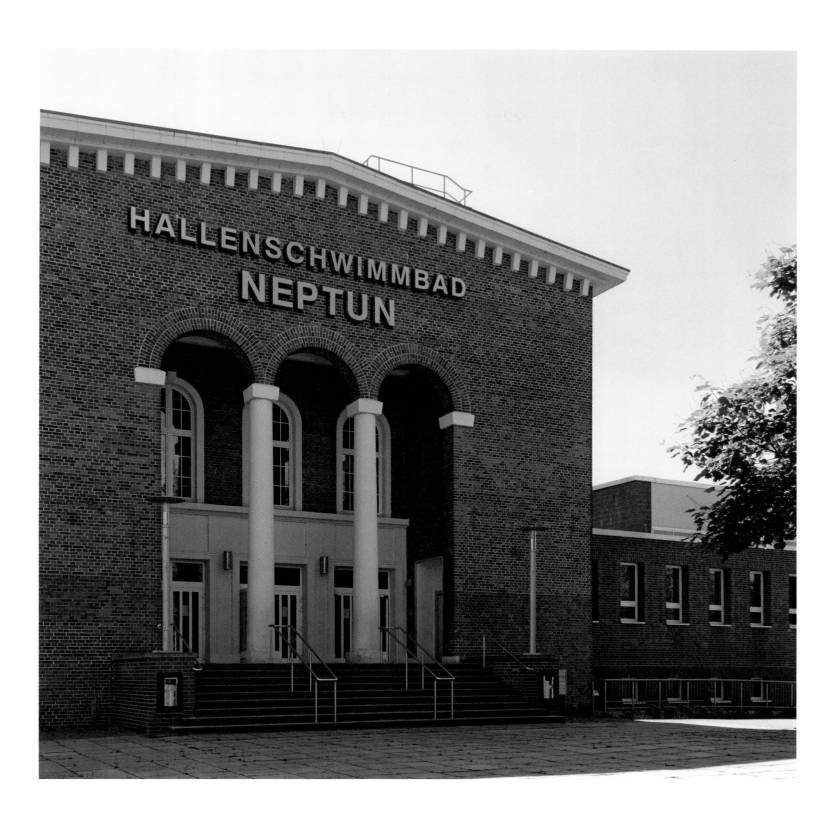

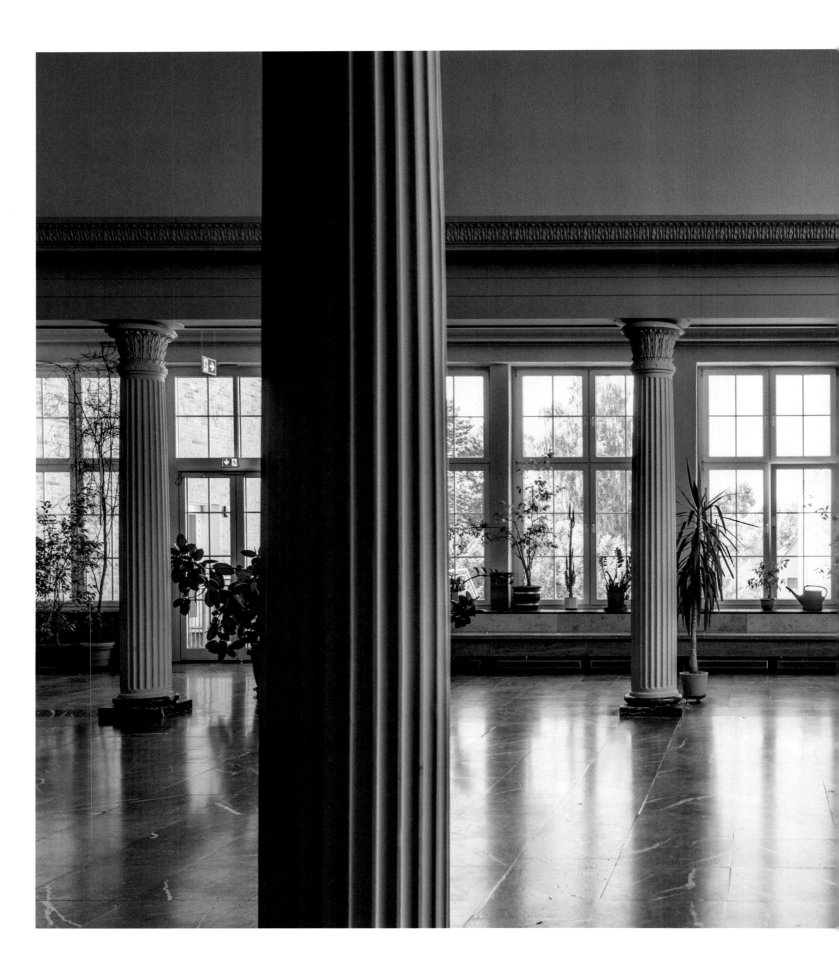

Marble hall, Neptun swimming pool complex, Rostock **67**

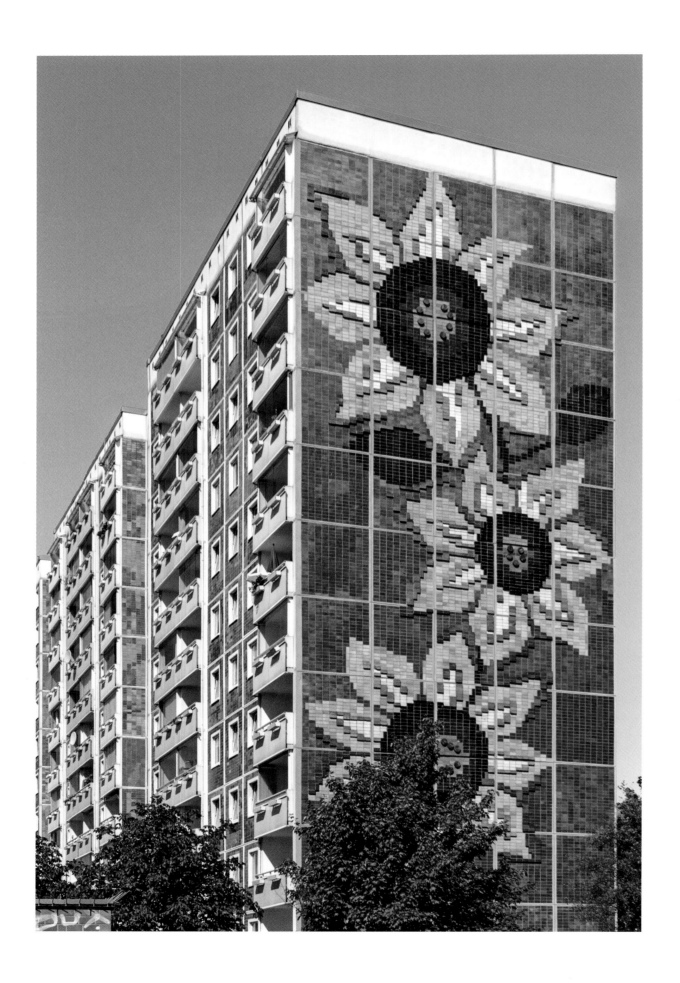

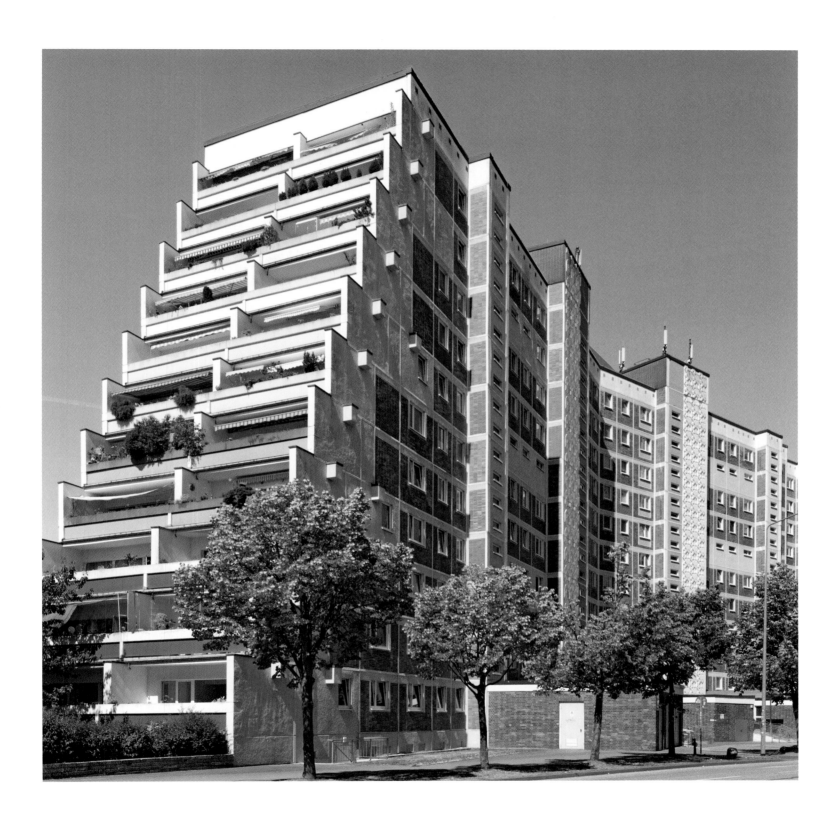

left: Sonnenblumenhaus, Rostock-Lichtenhagen

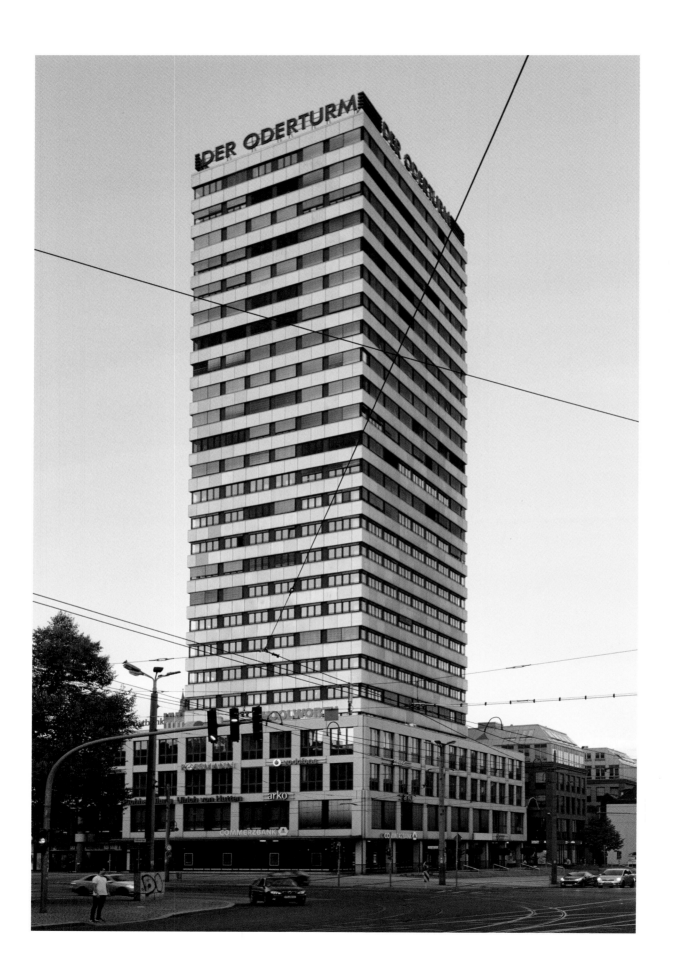

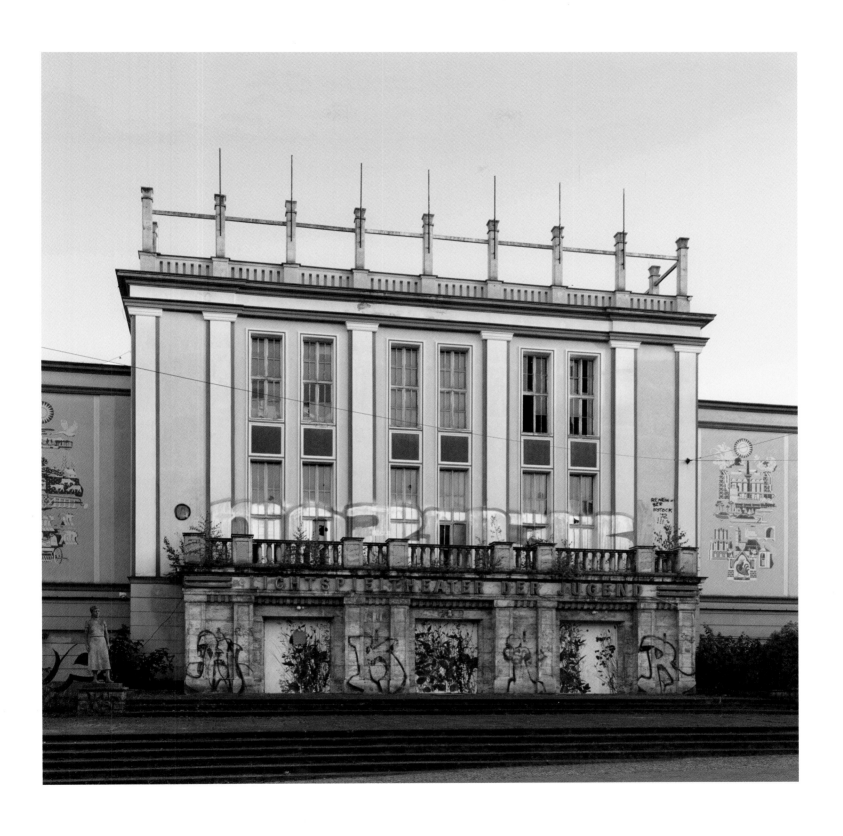

Filmtheater der Jugend, Frankfurt (Oder) **73**

left: Oderturm, Frankfurt (Oder)

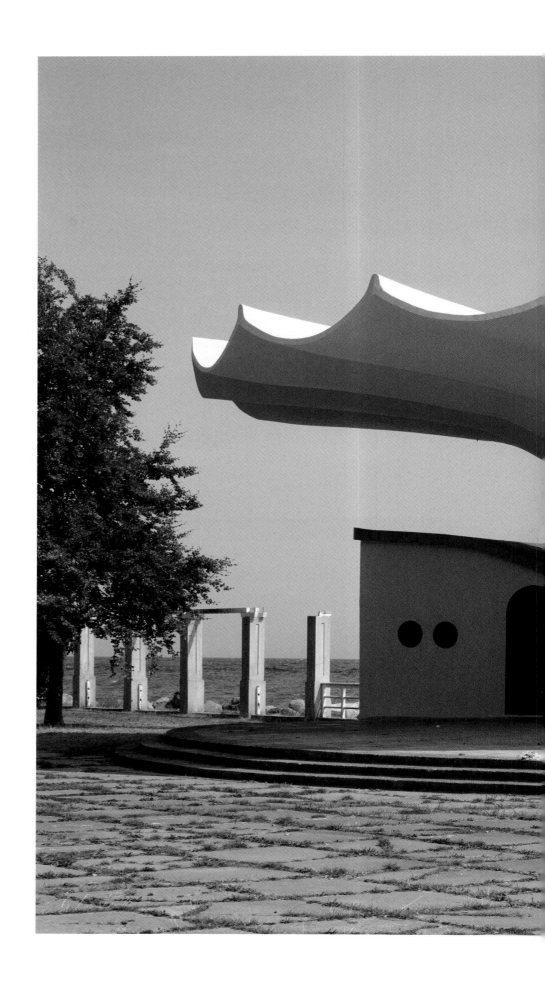

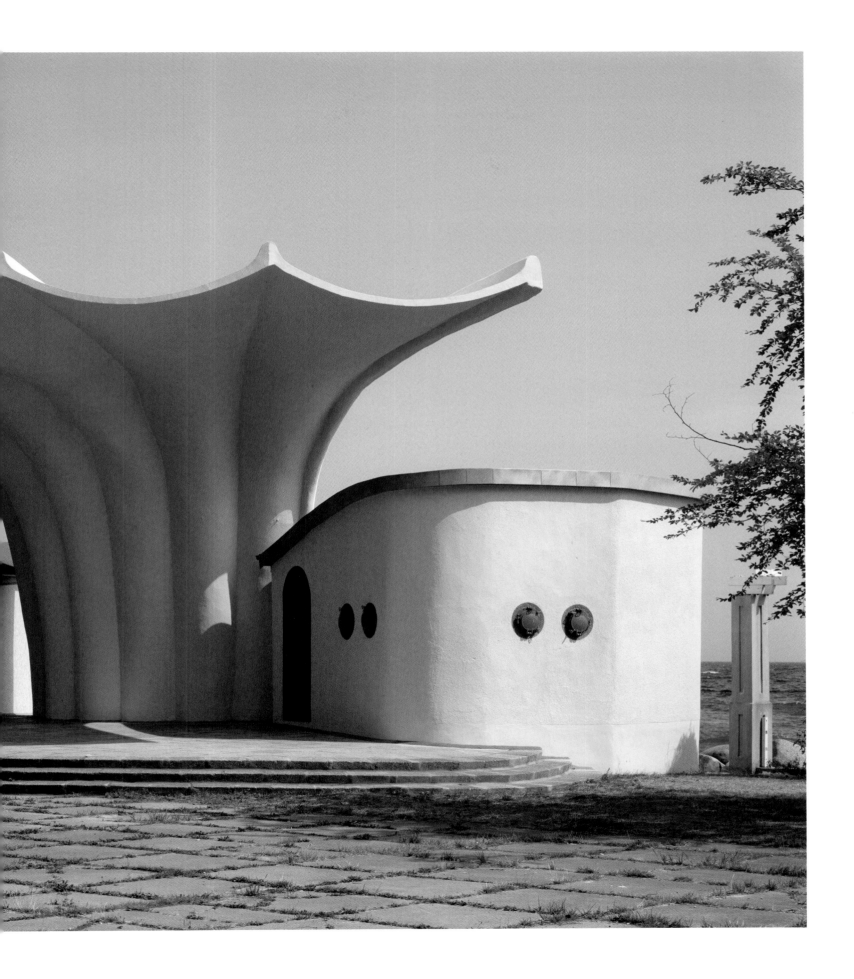

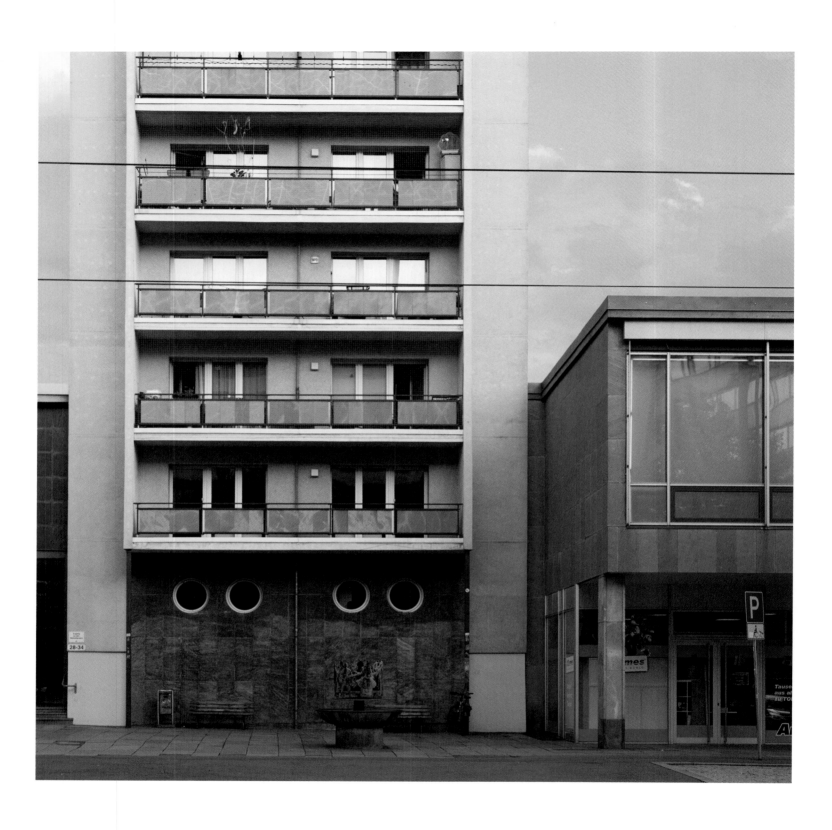

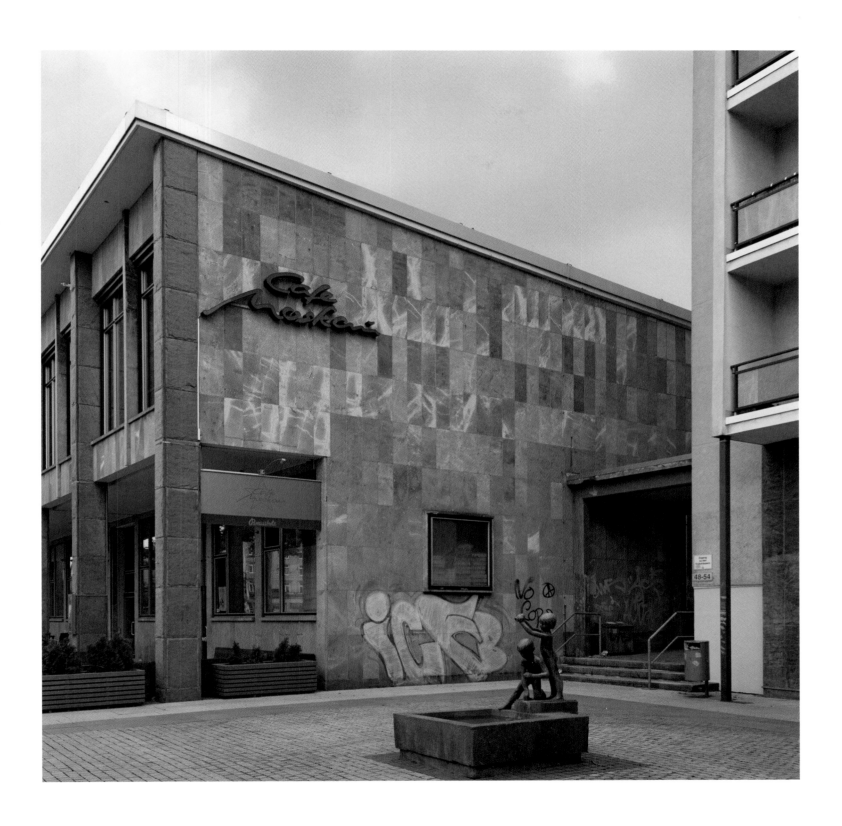

here and opposite: Buildings on Strasse der Nationen, Chemnitz **77**

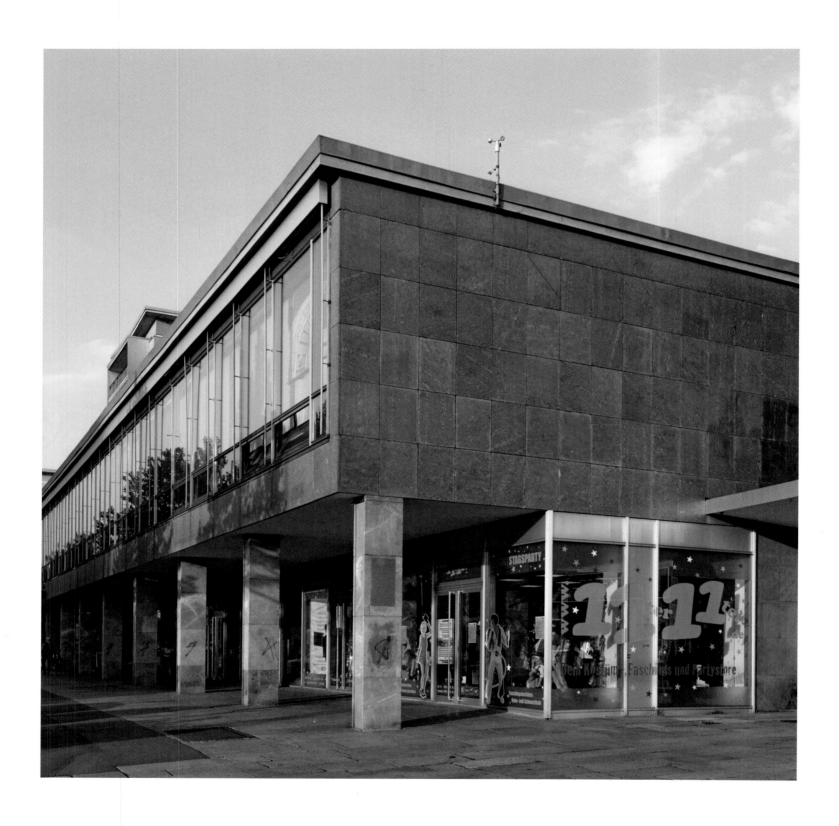

here and opposite: Buildings on Strasse der Nationen, Chemnitz

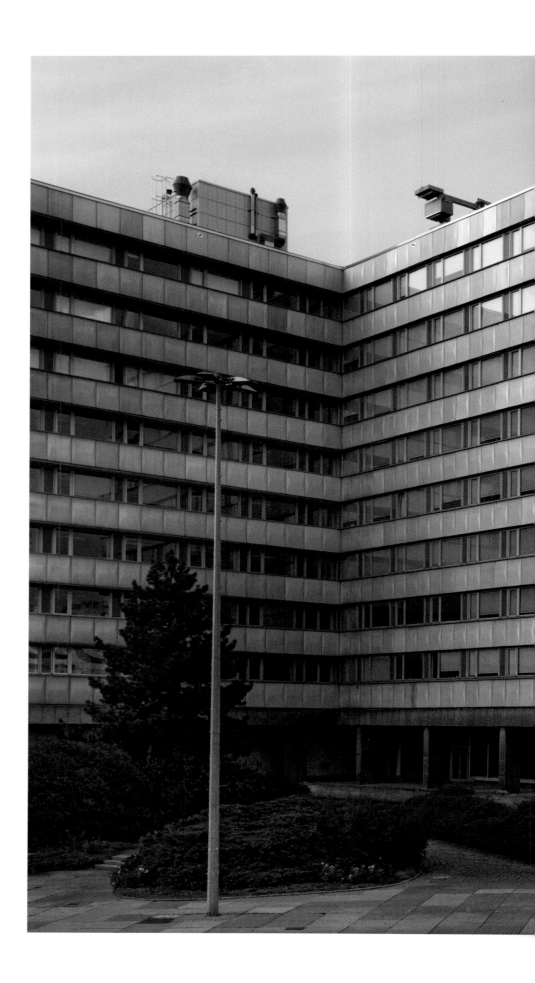

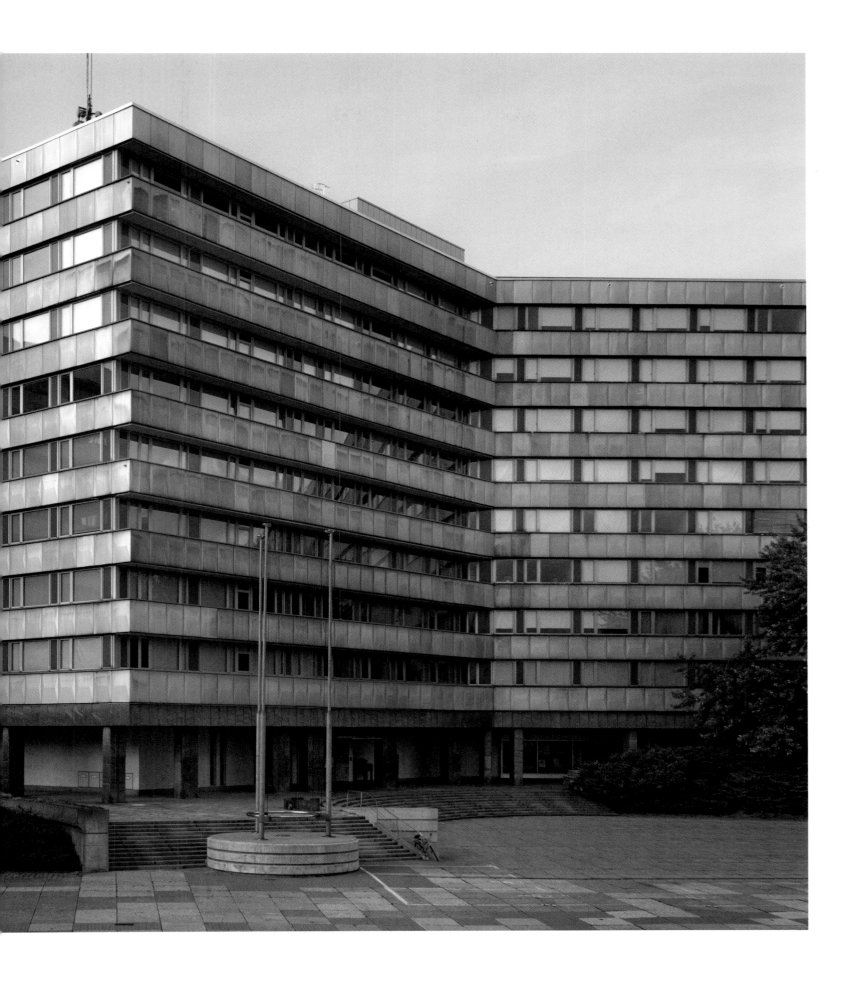

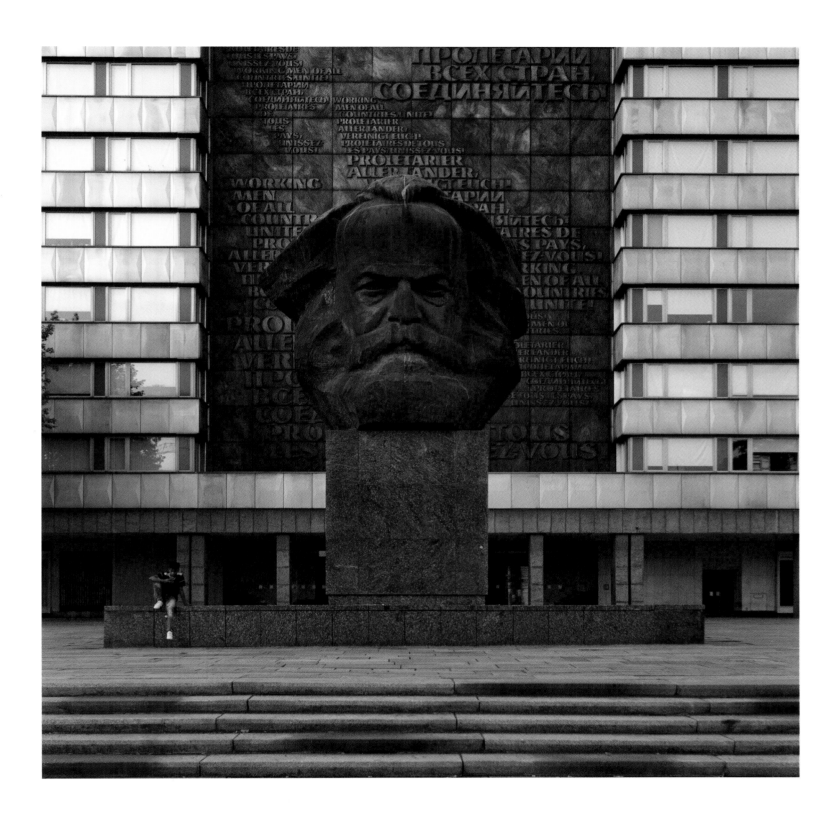

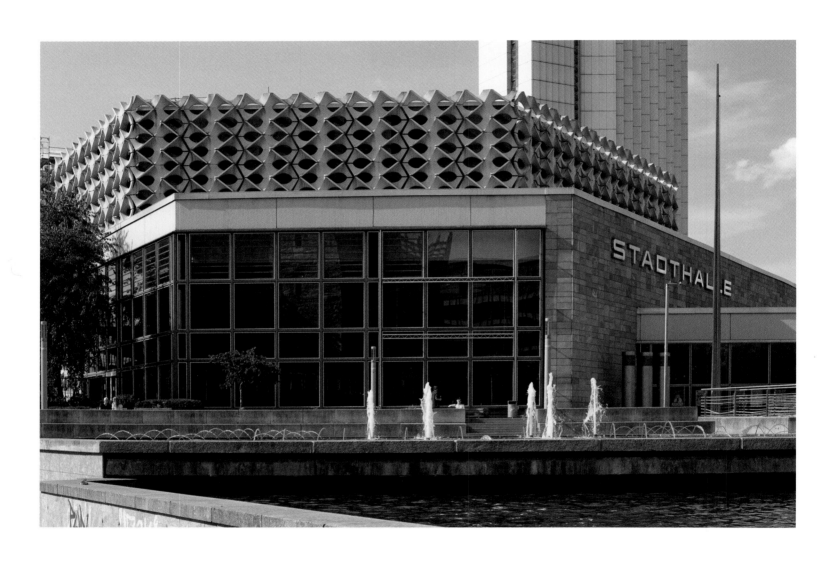

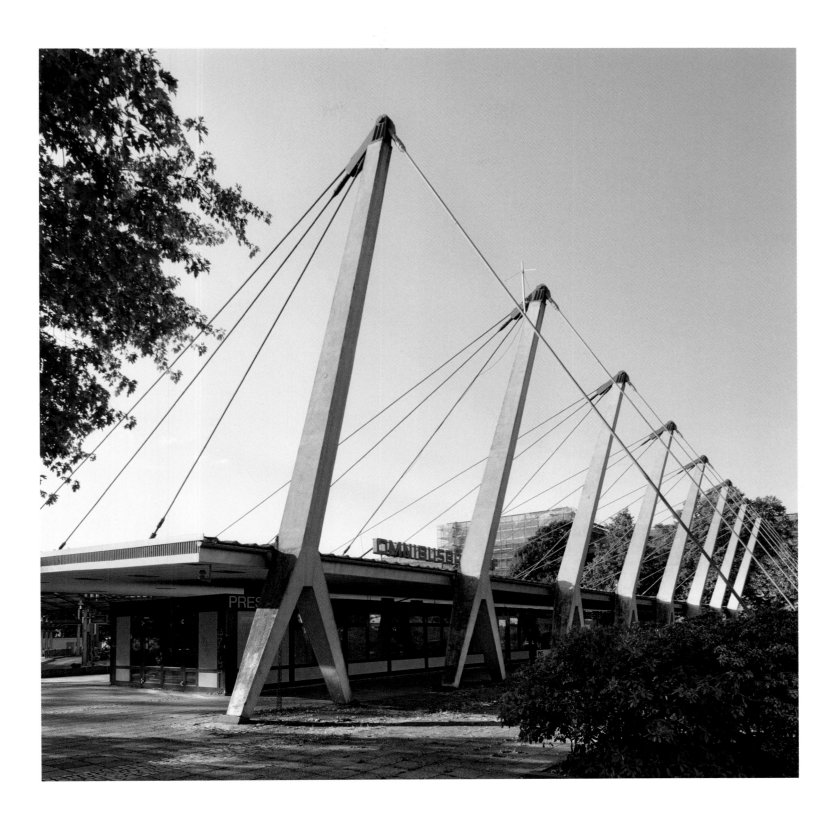

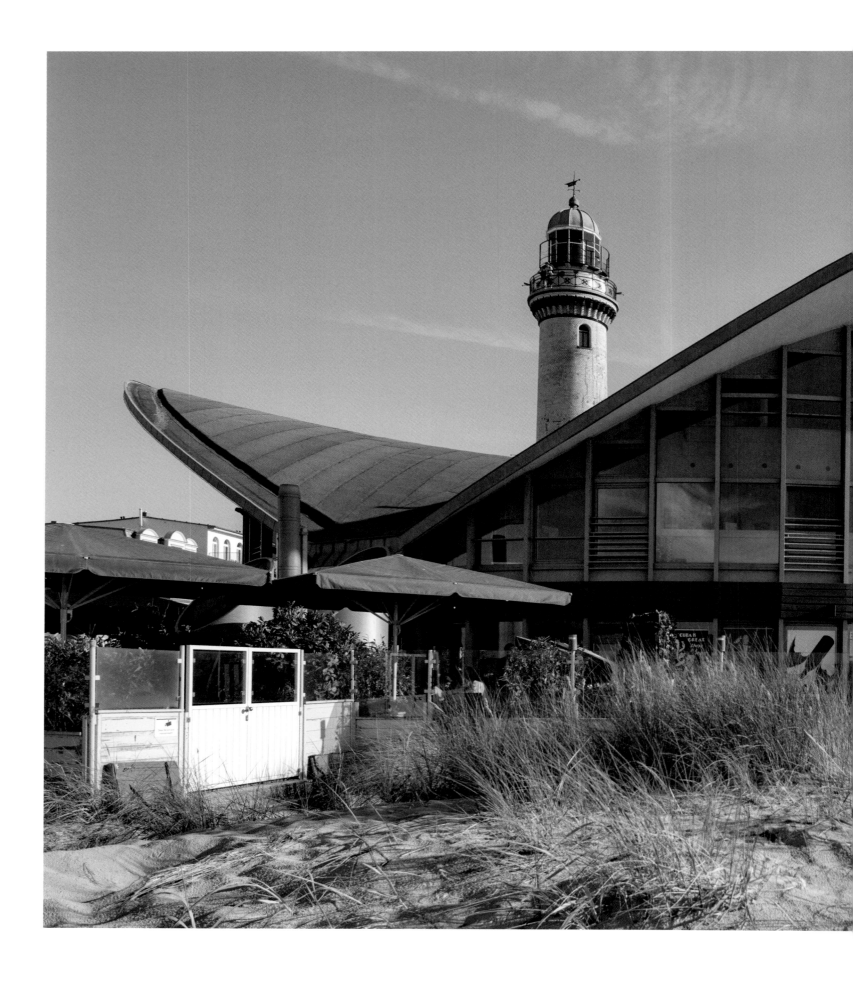

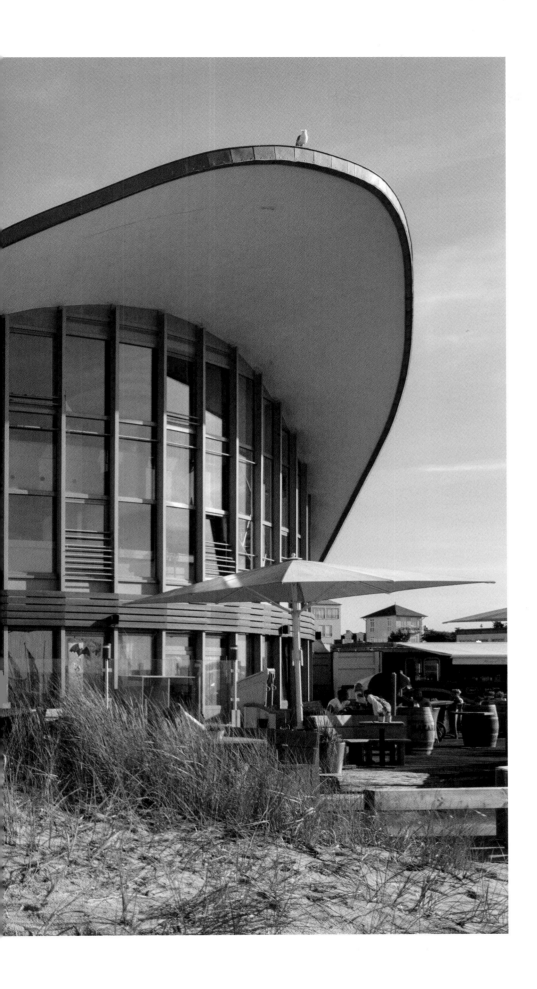

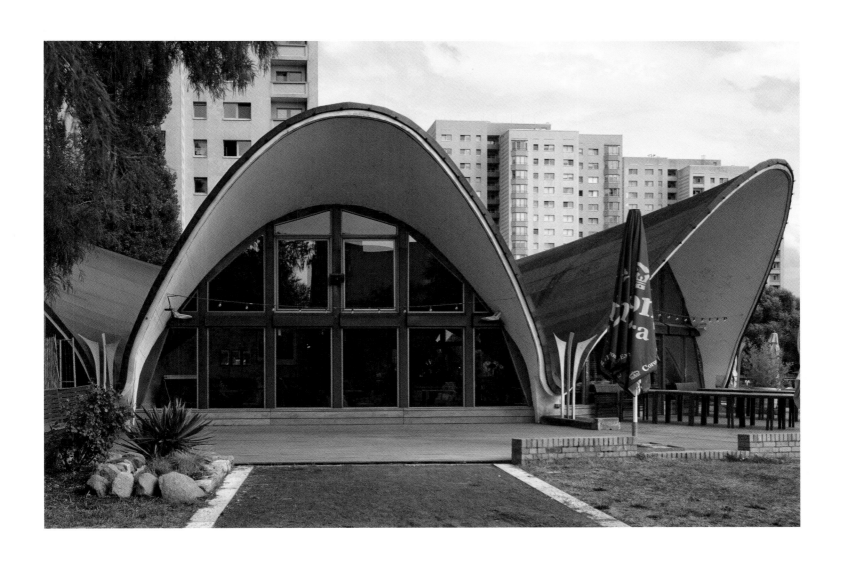

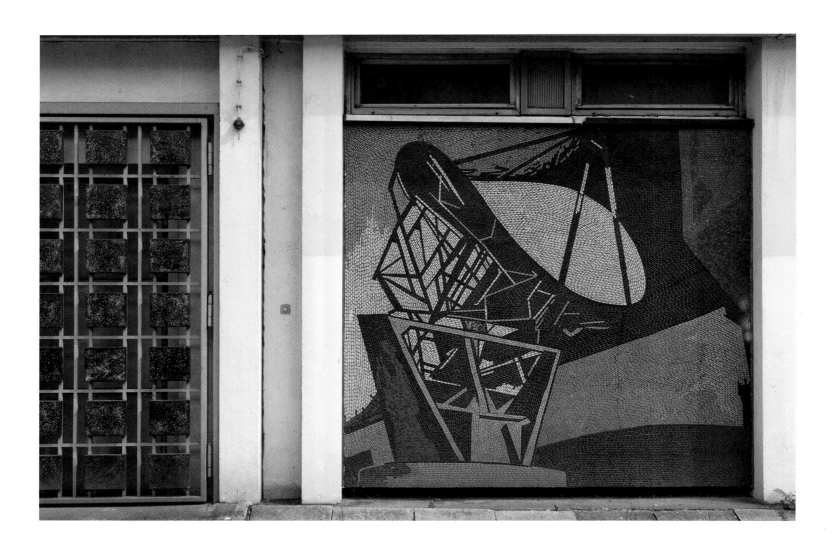

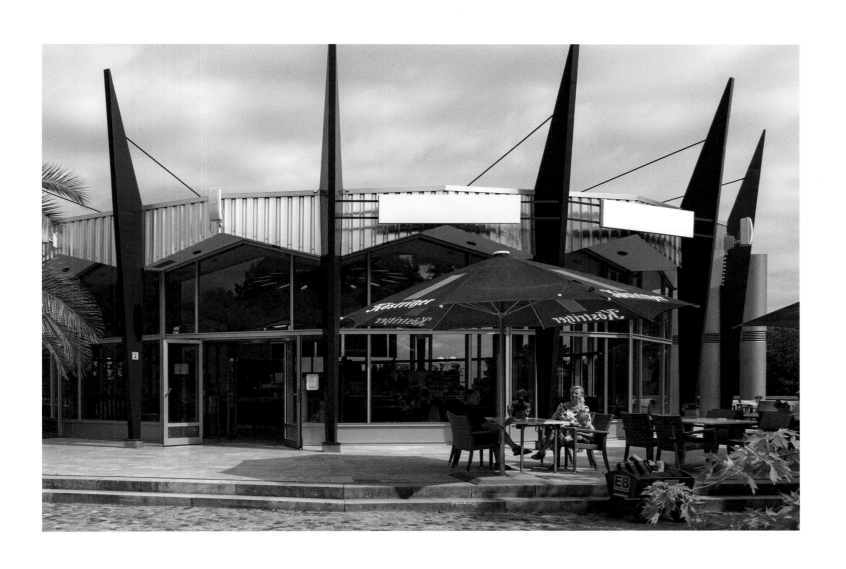

94 Fritz Gremer's sculpture *Aufbauhelfer*, iga 61, Erfurt

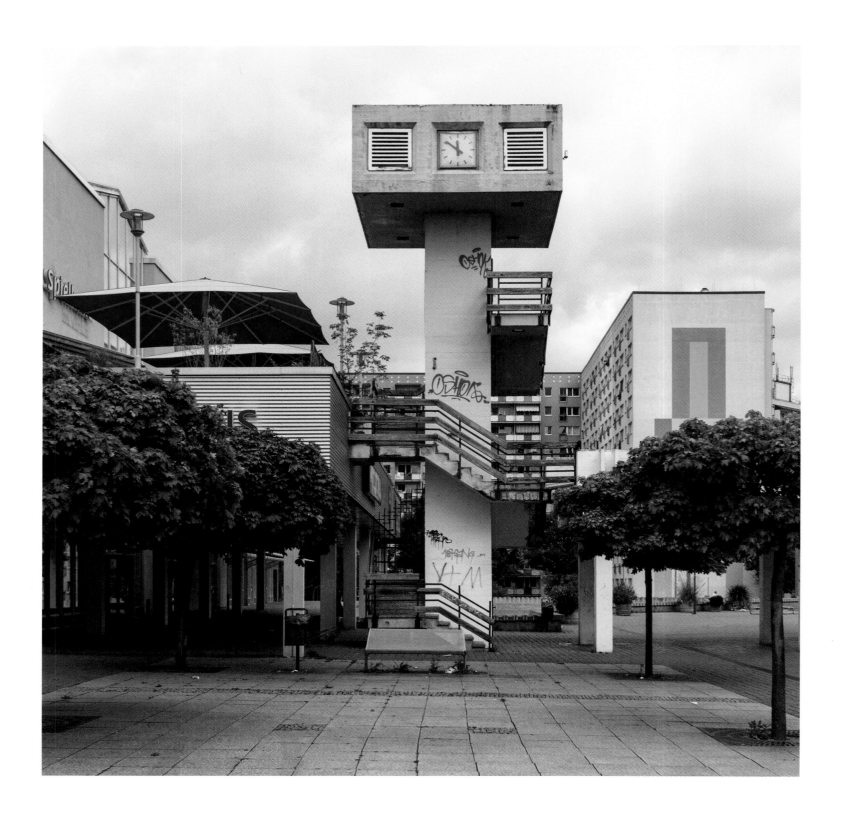

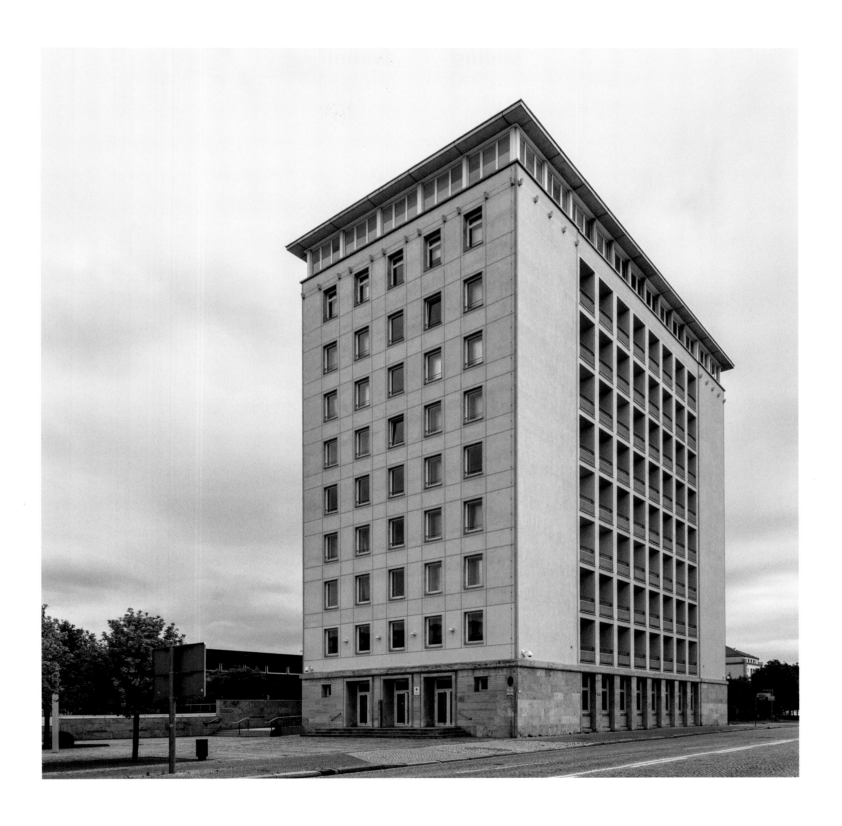

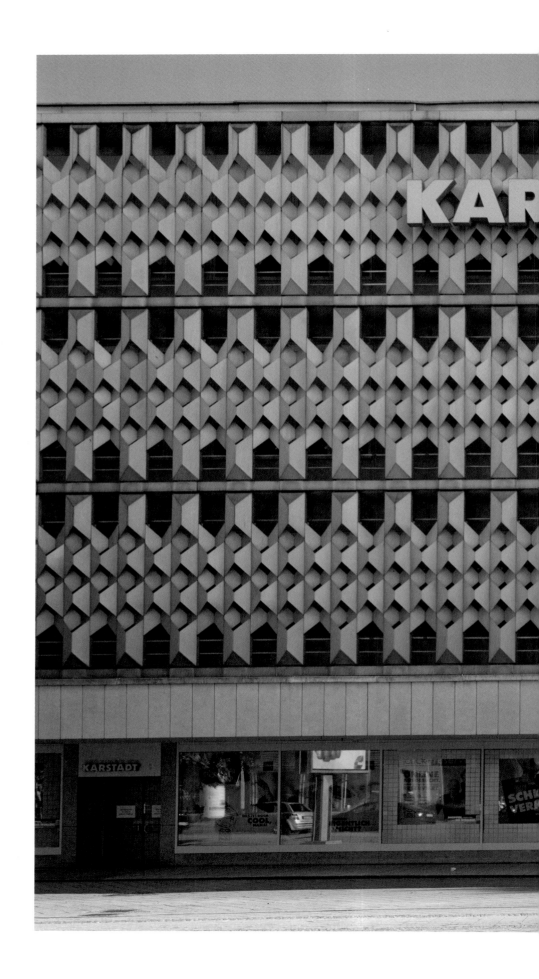

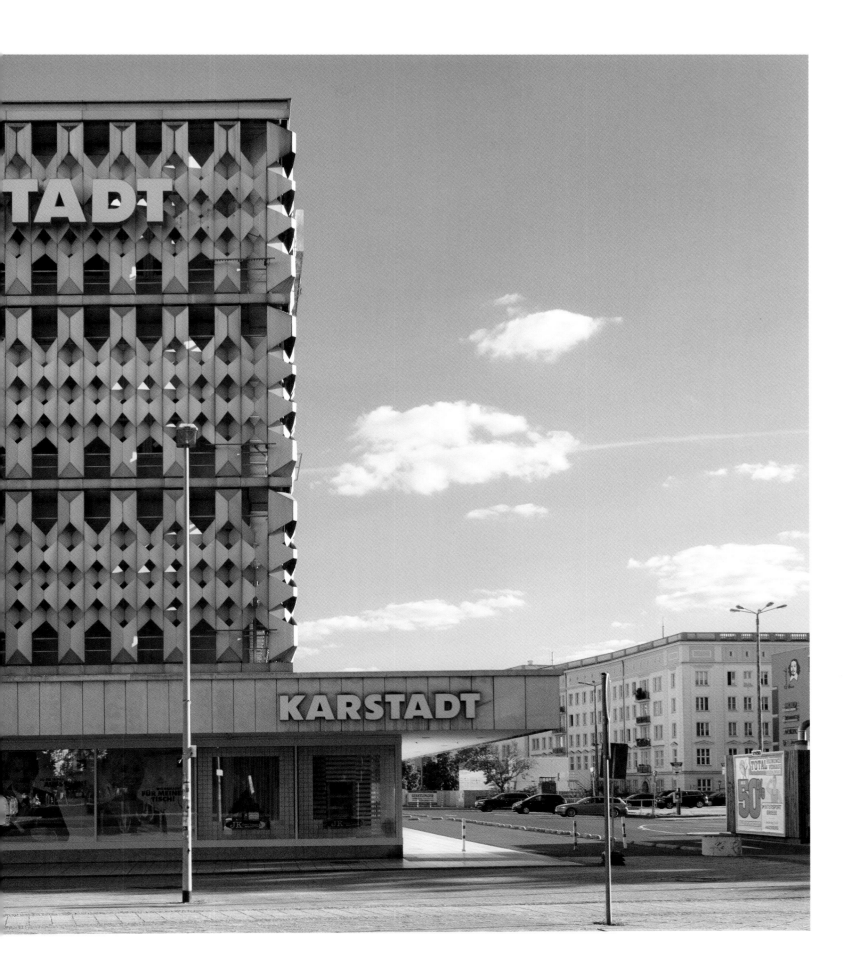

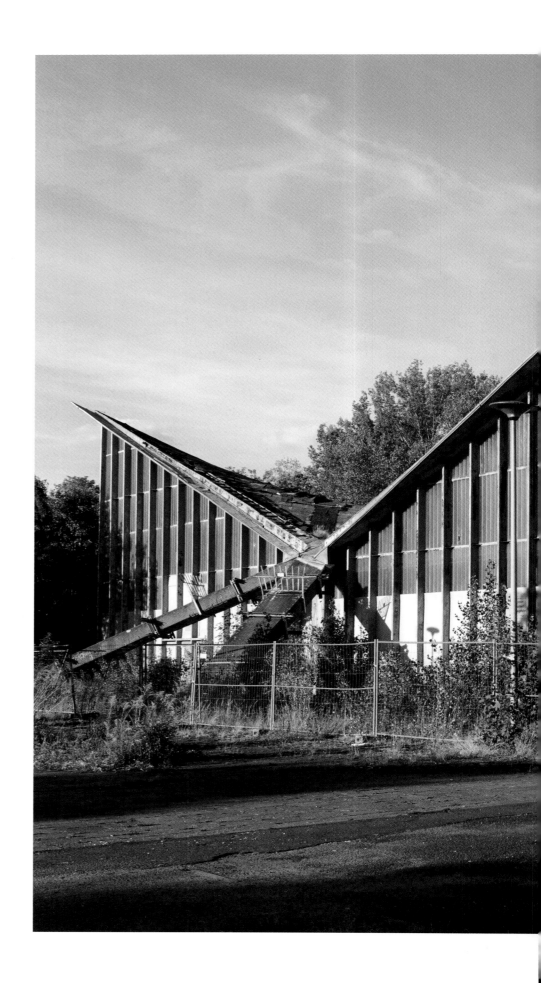

Rotehornpark multipurpose hall, Magdeburg

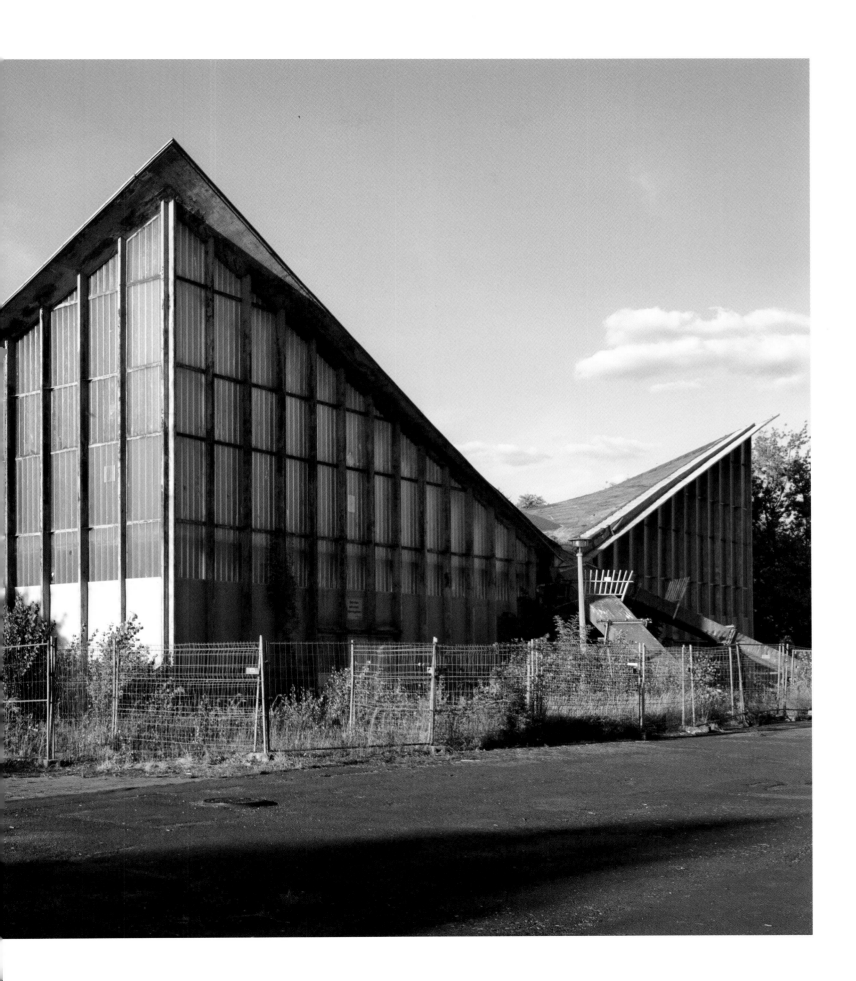

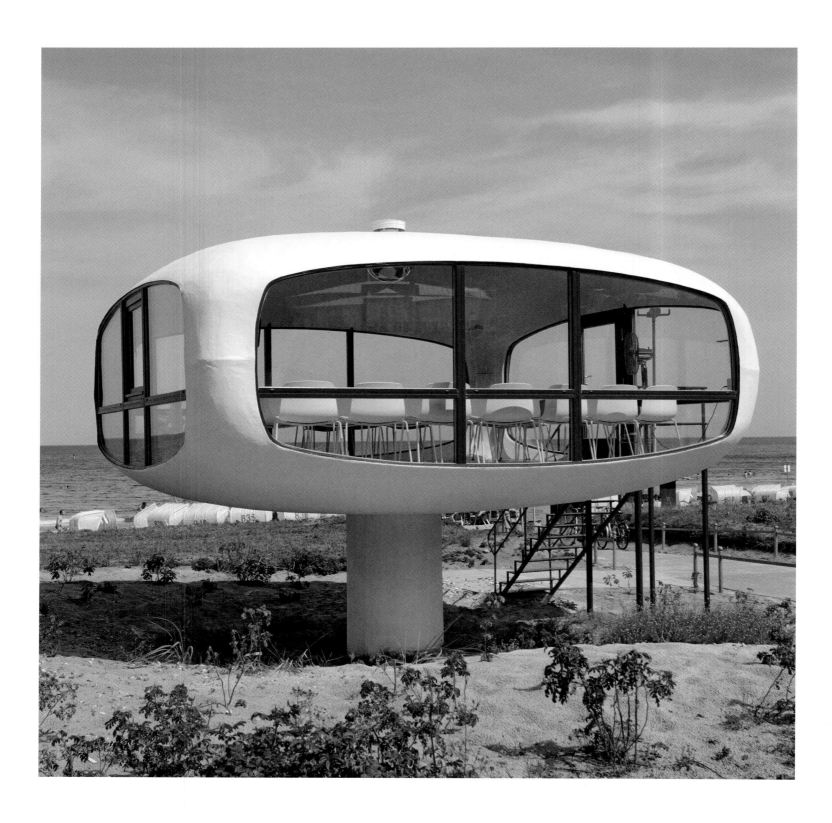

106 Coastguard tower, Binz

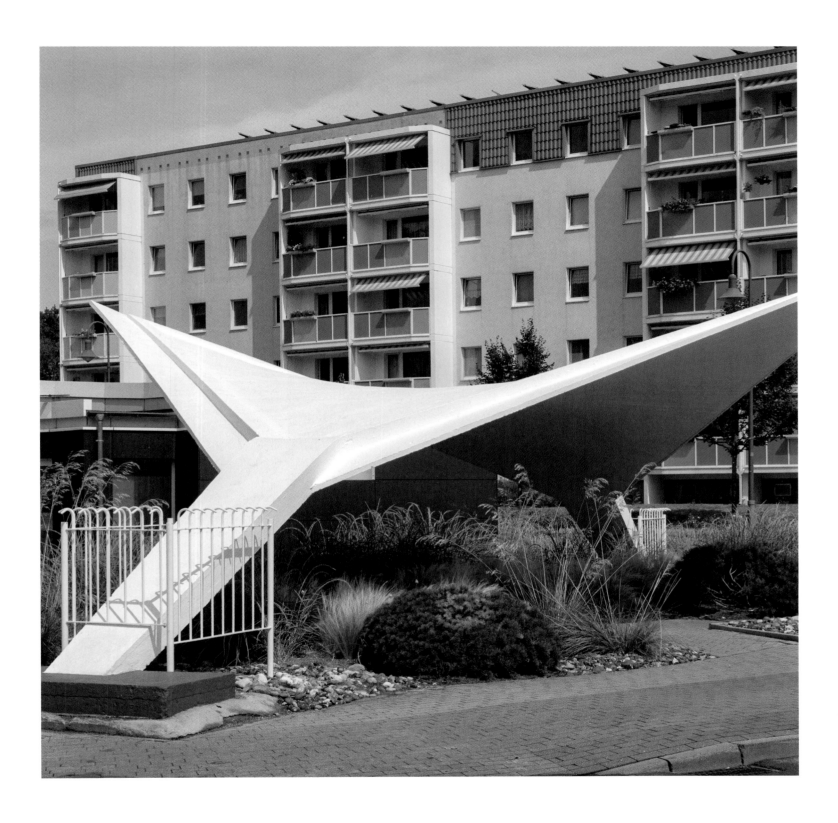

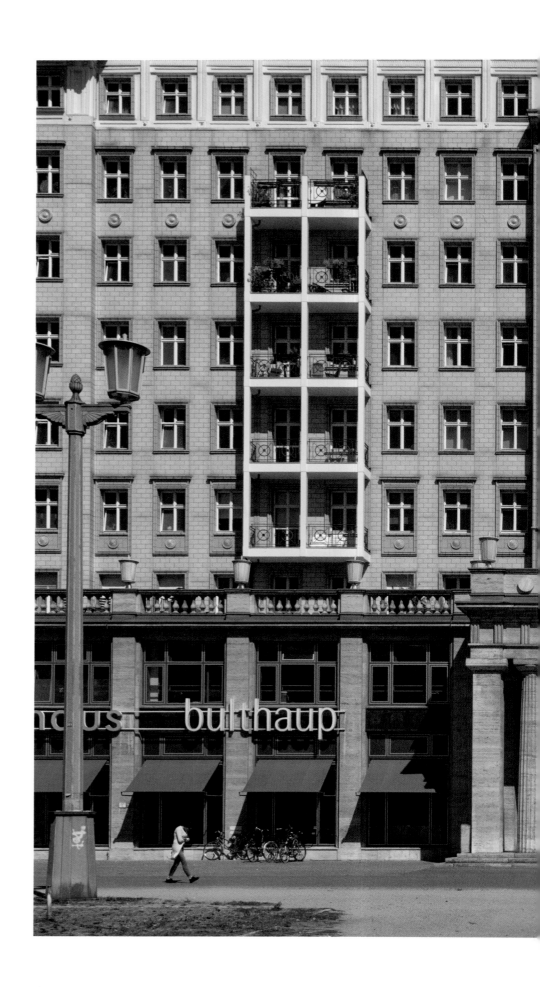

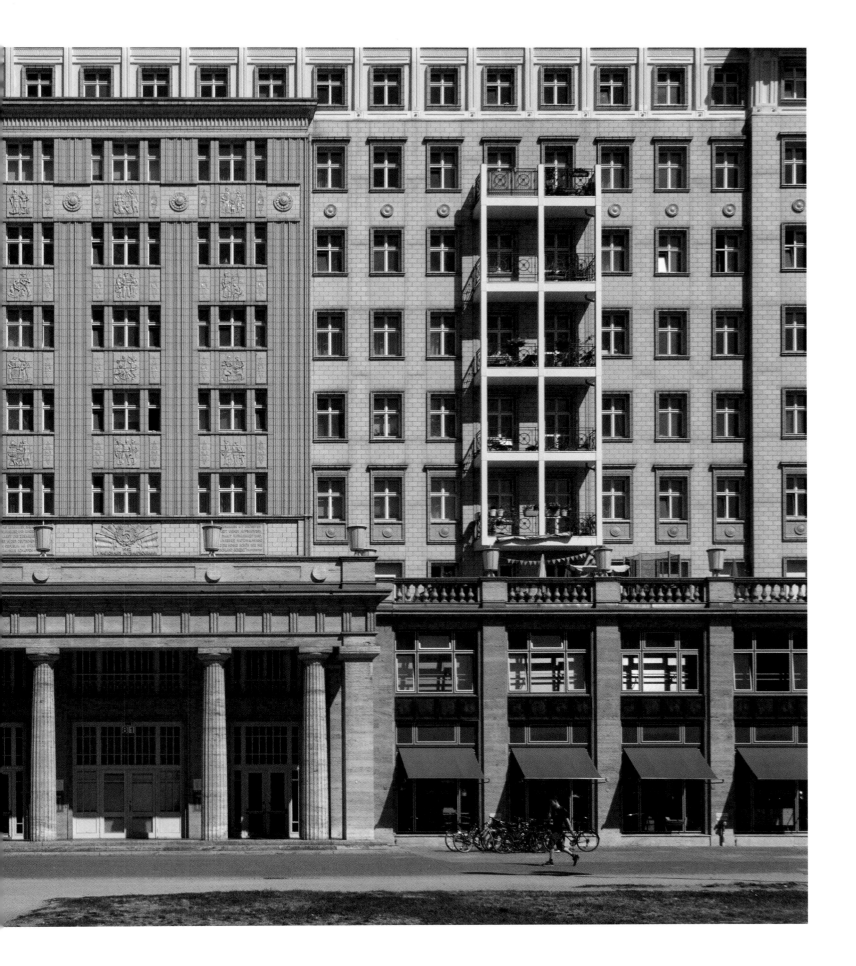

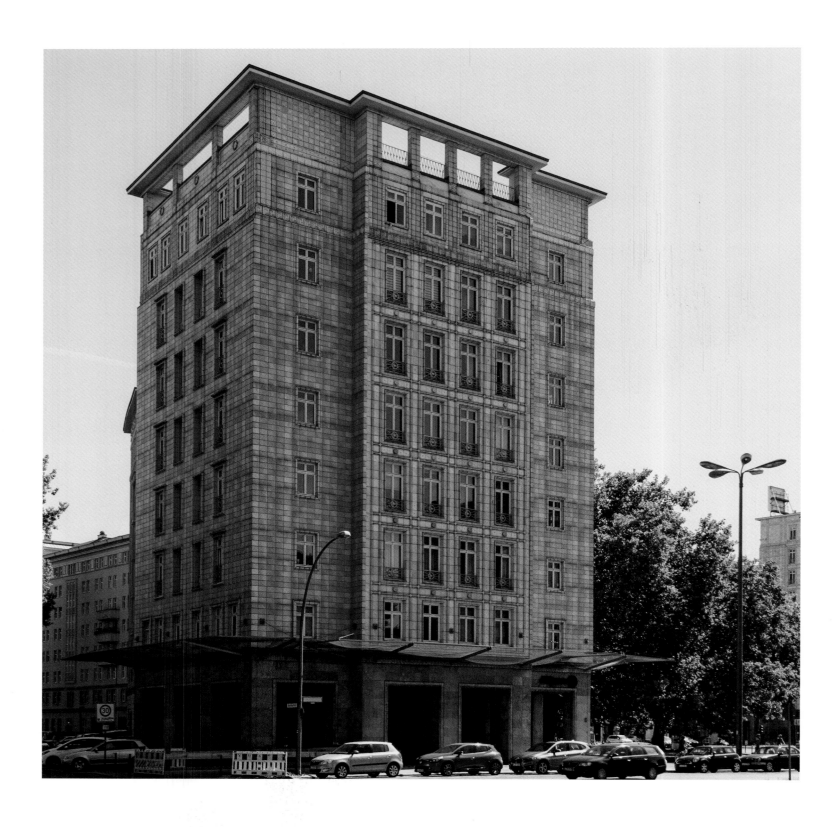

110 High-rise, Strausberger Platz, Berlin

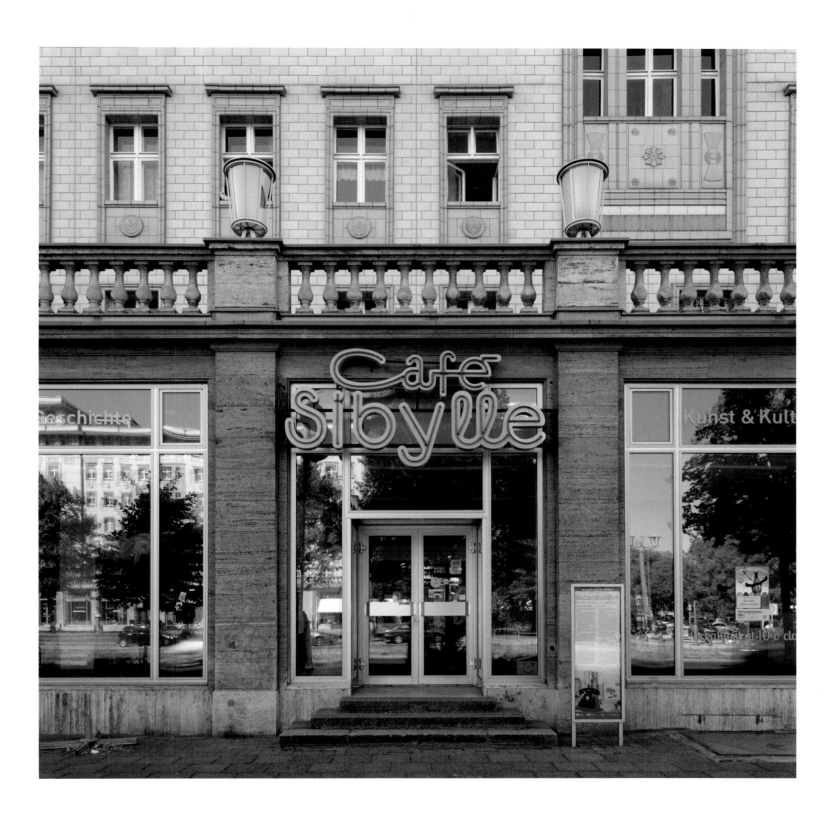

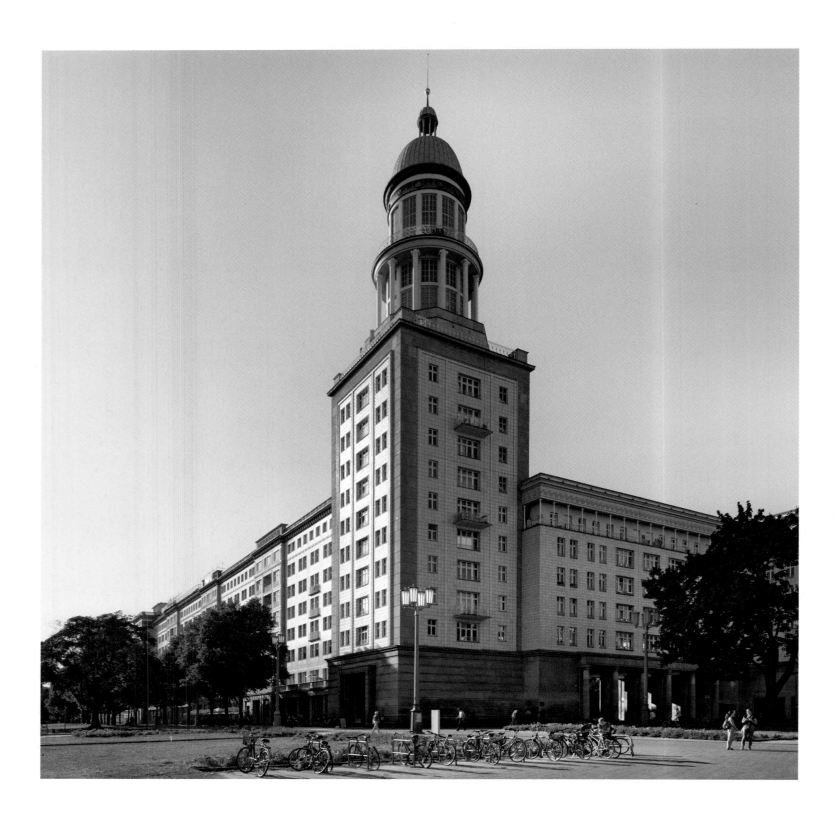

Balcony-access housing, Karl-Marx-Allee, Berlin **113**

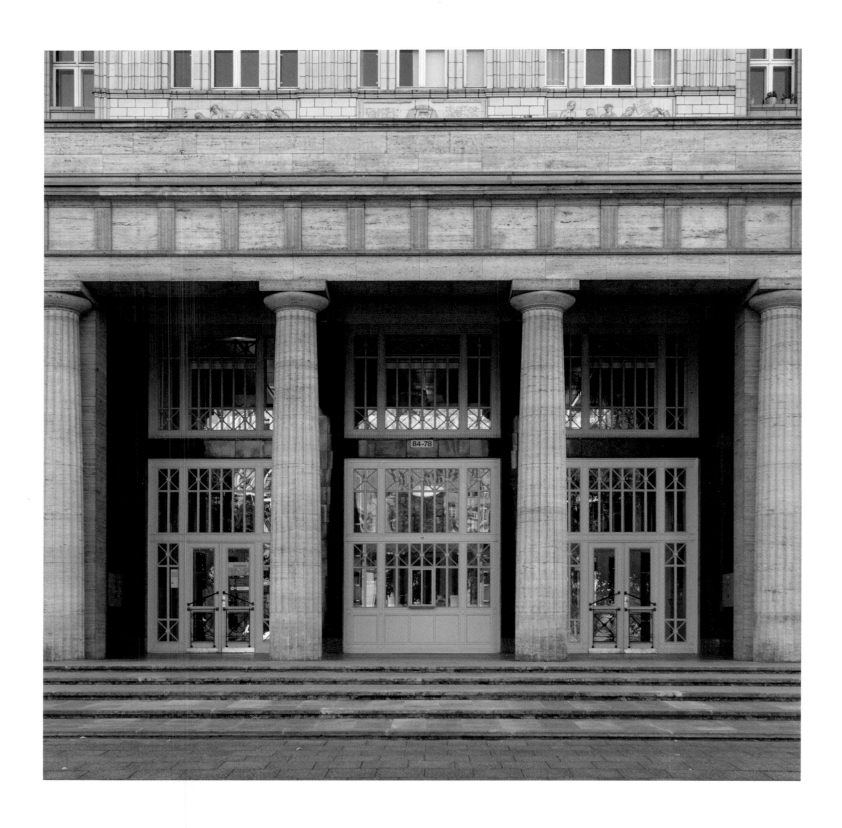

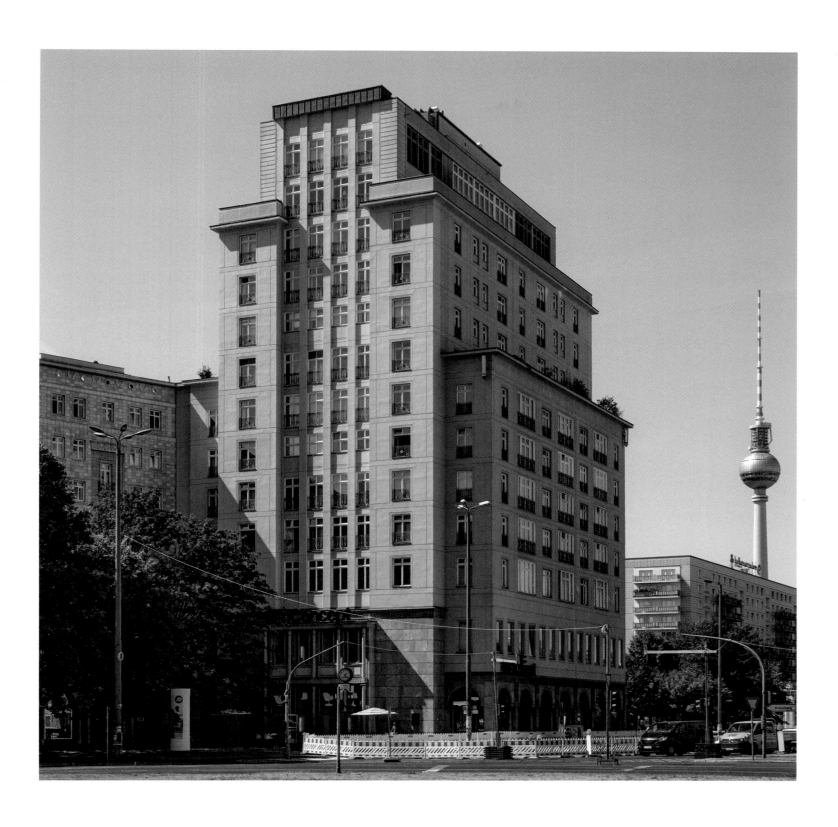

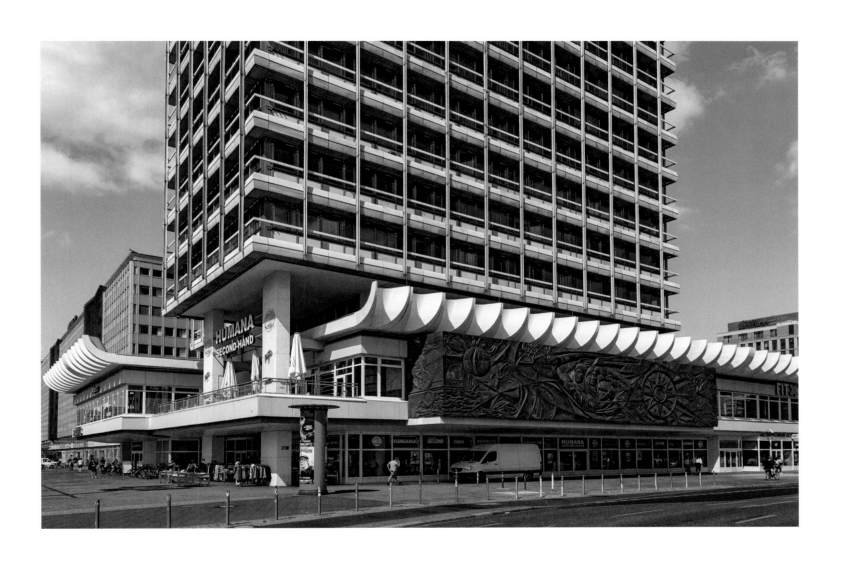

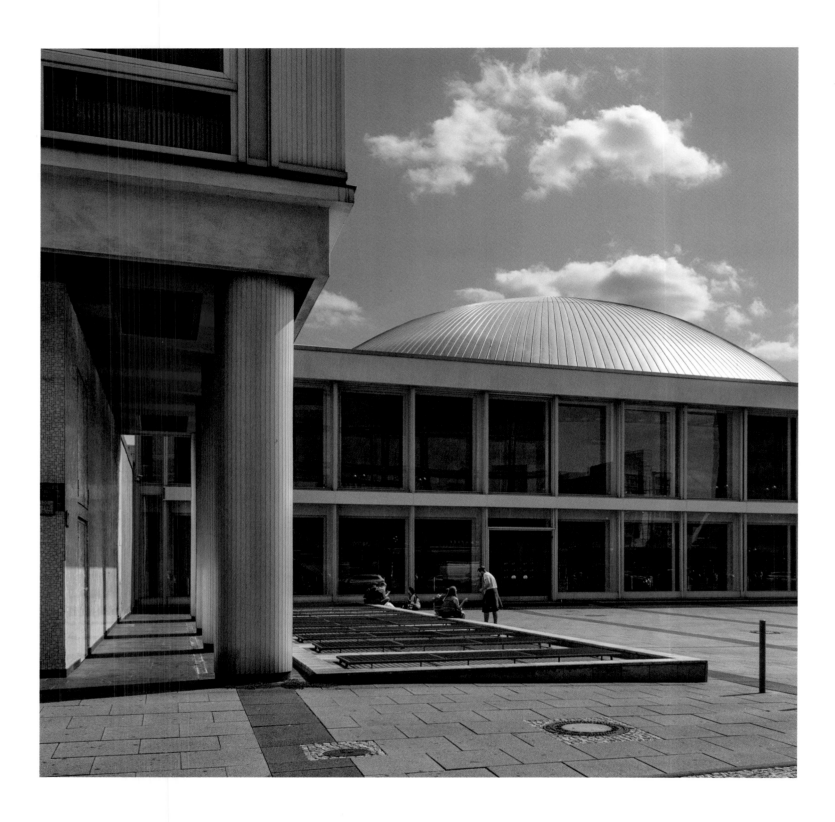

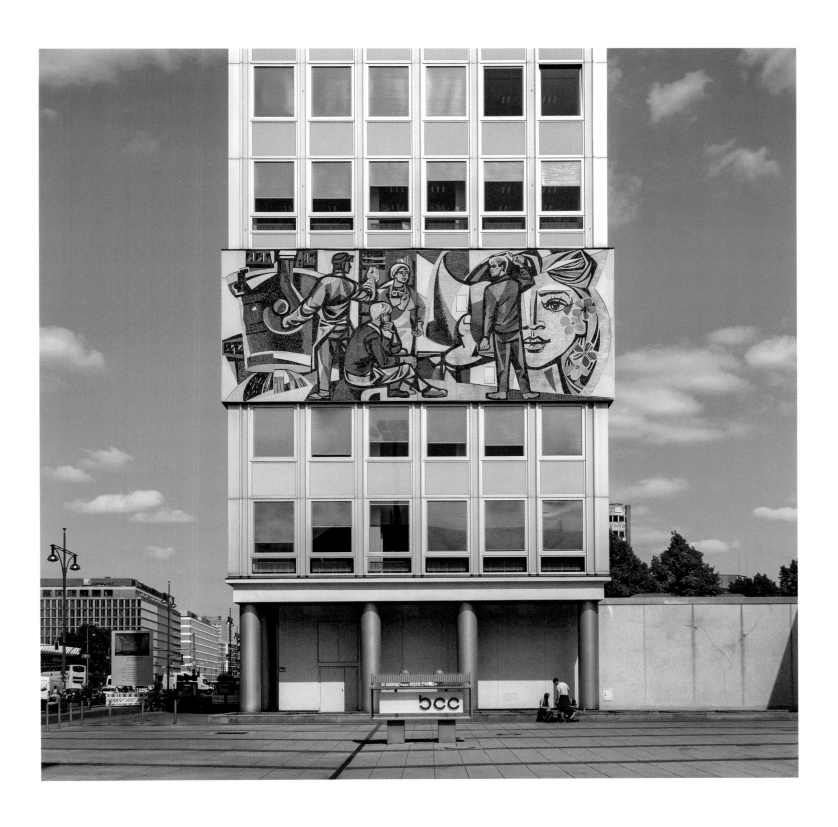

122 Kunst im Heim gallery pavilion, Berlin

right: Interflor florist, Berlin

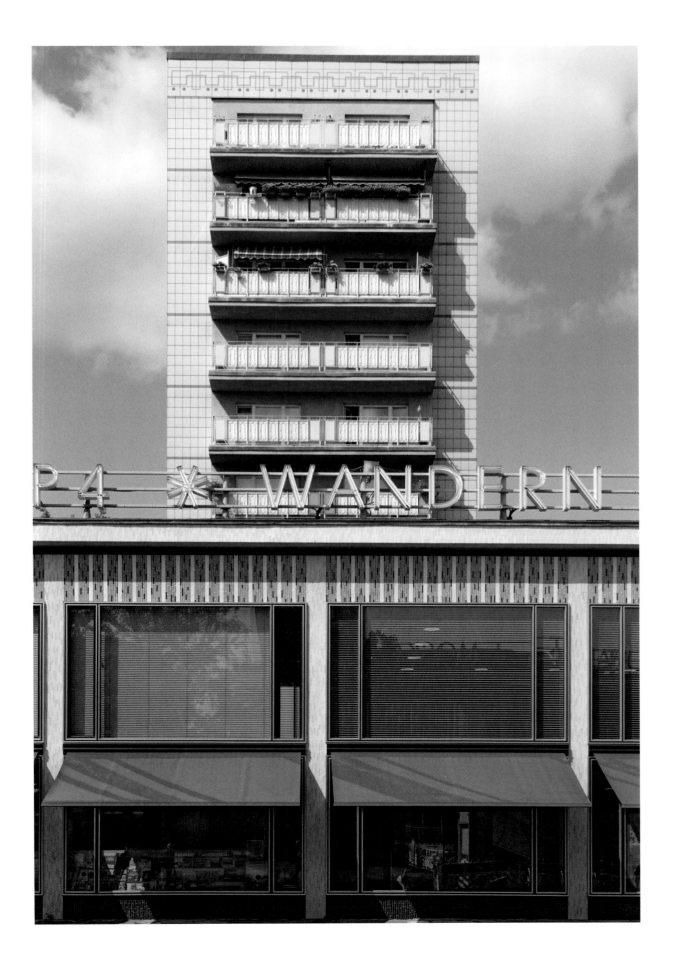

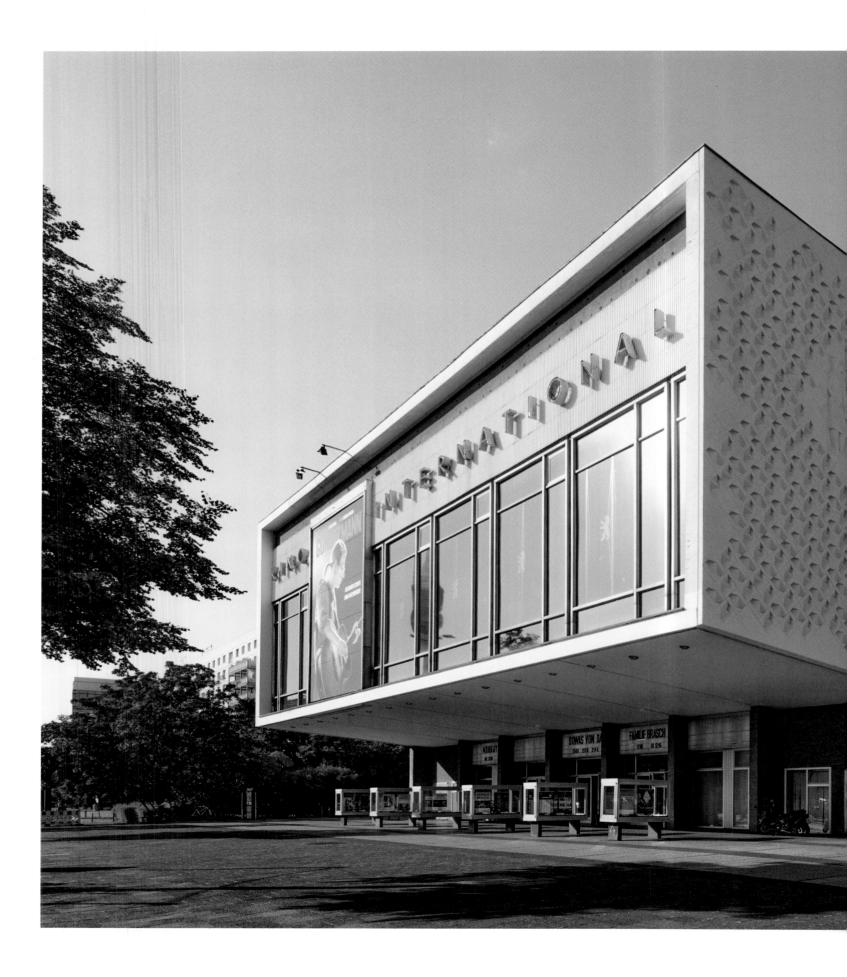

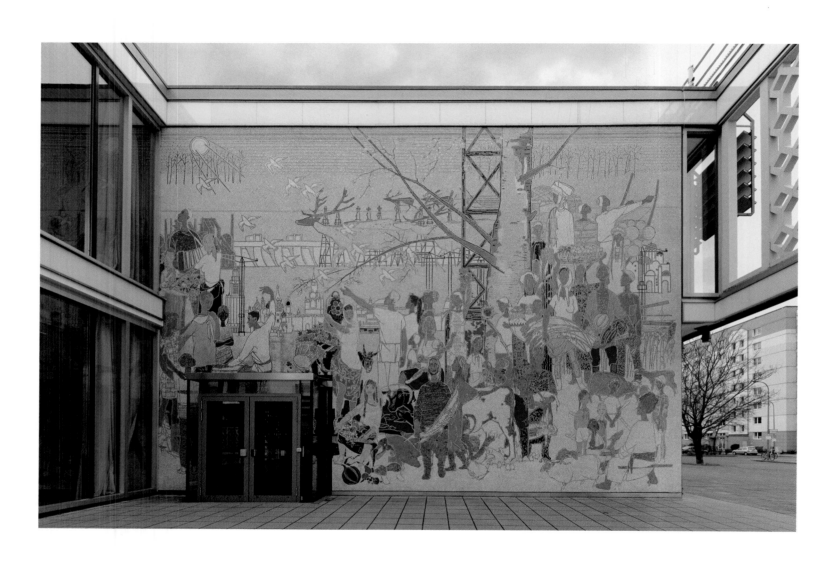

126 *Aus dem Leben der Völker der Sowjetunion* mural, by Bert Heller, Restaurant Moskau, Berlin

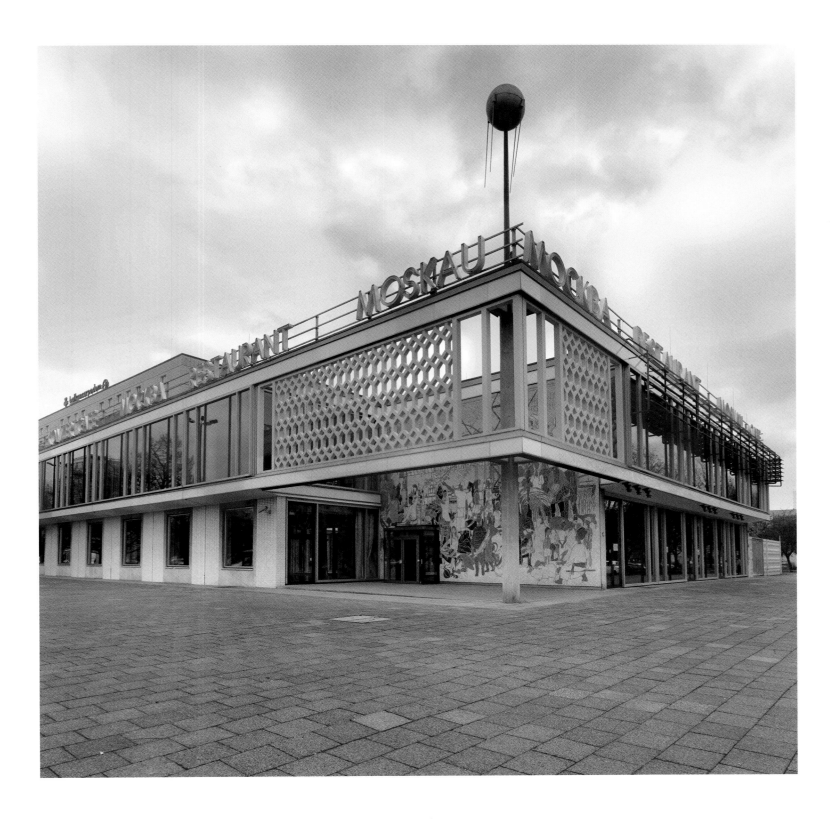

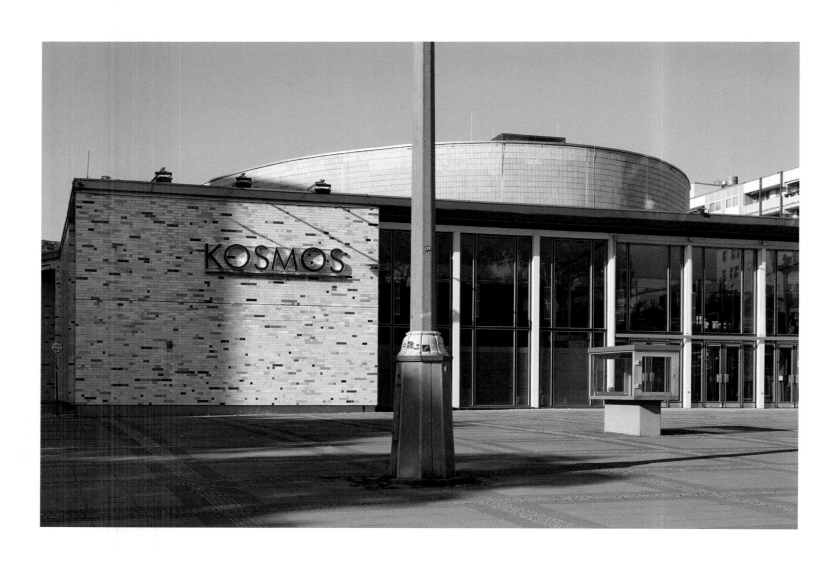

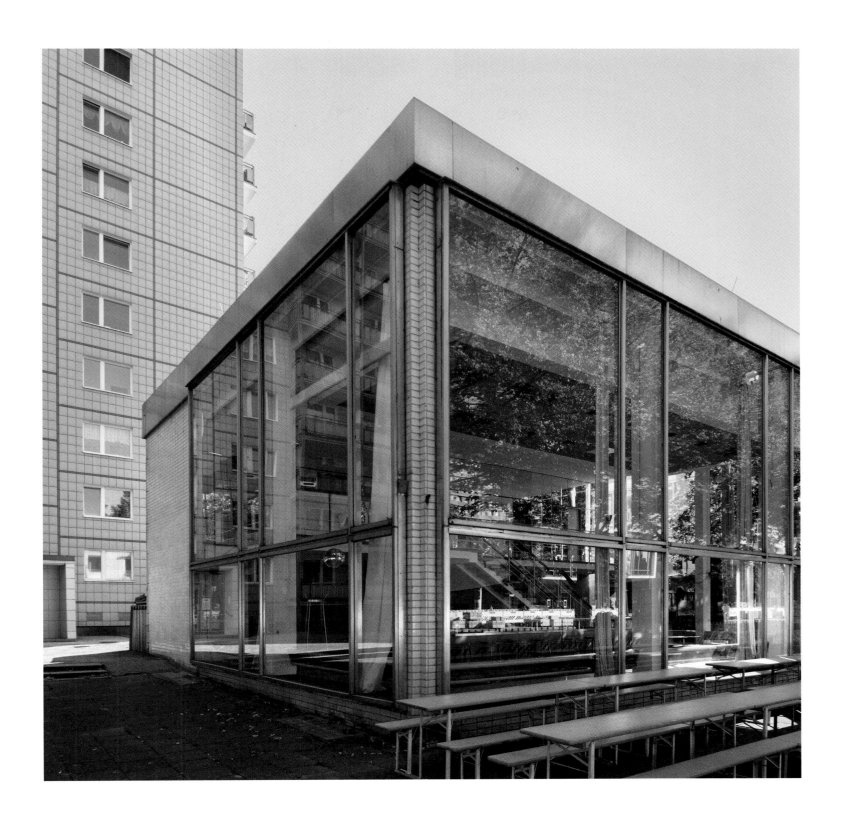

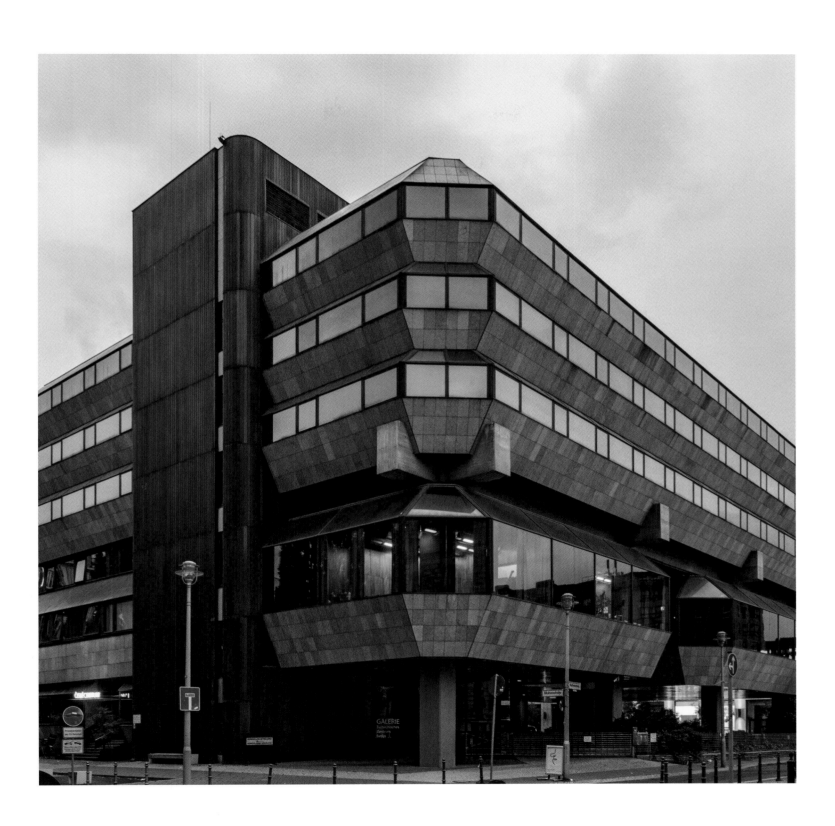

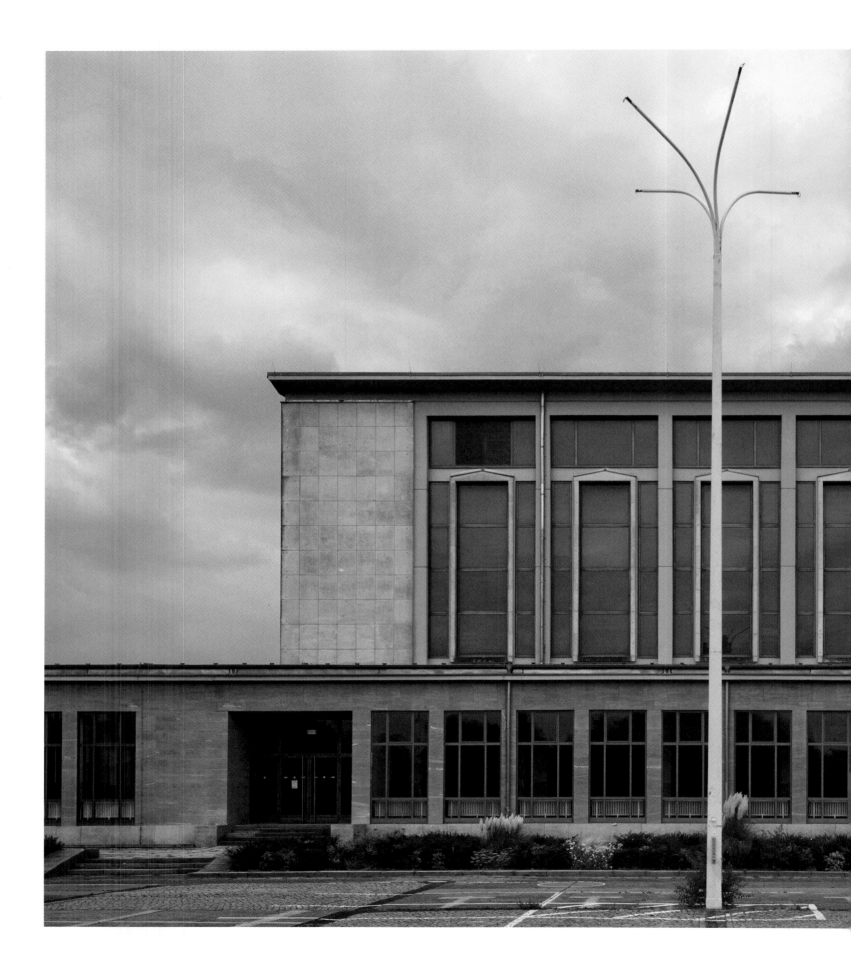

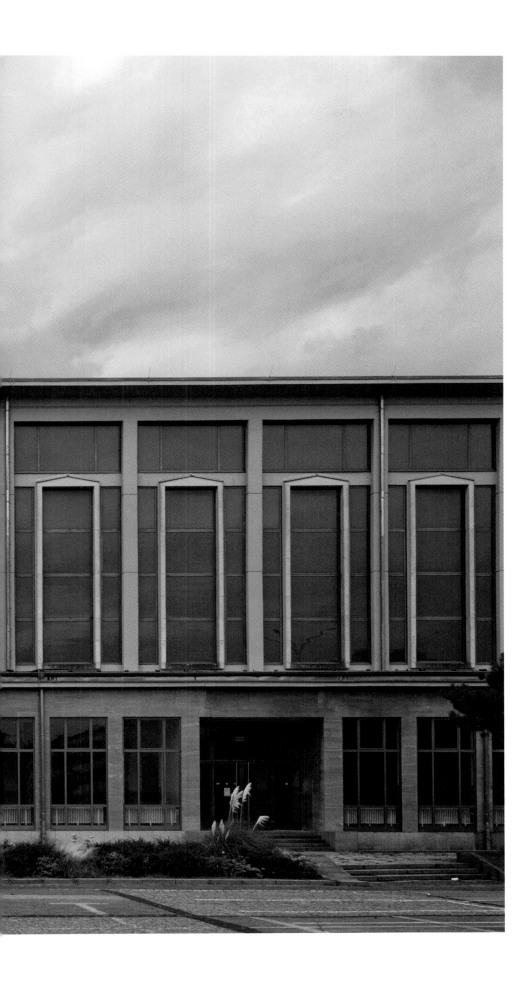

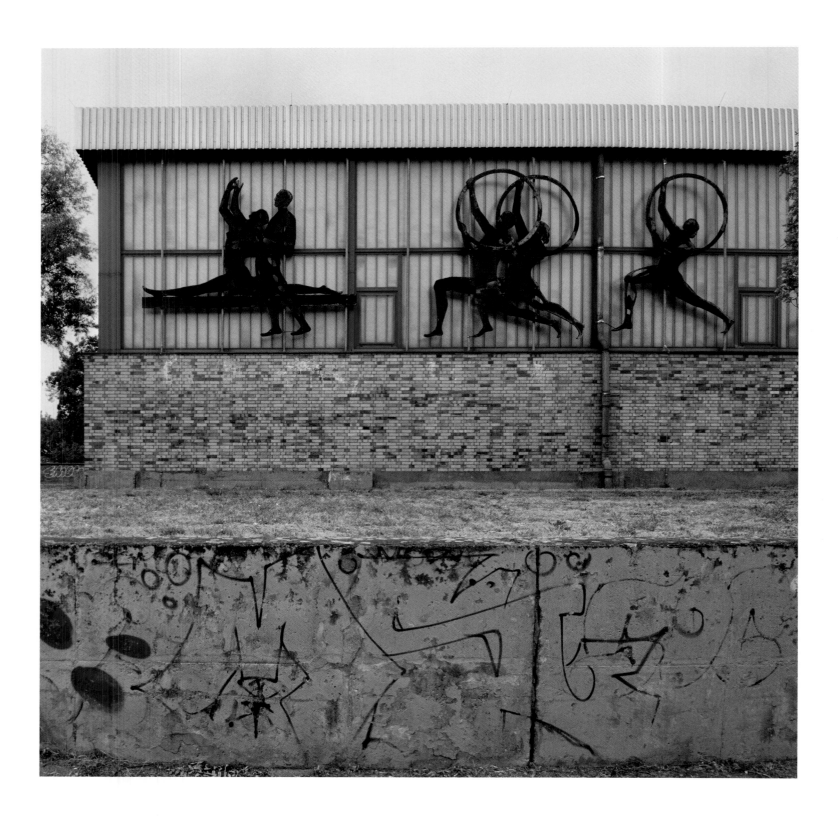

134 Training halls, Sportforum Berlin

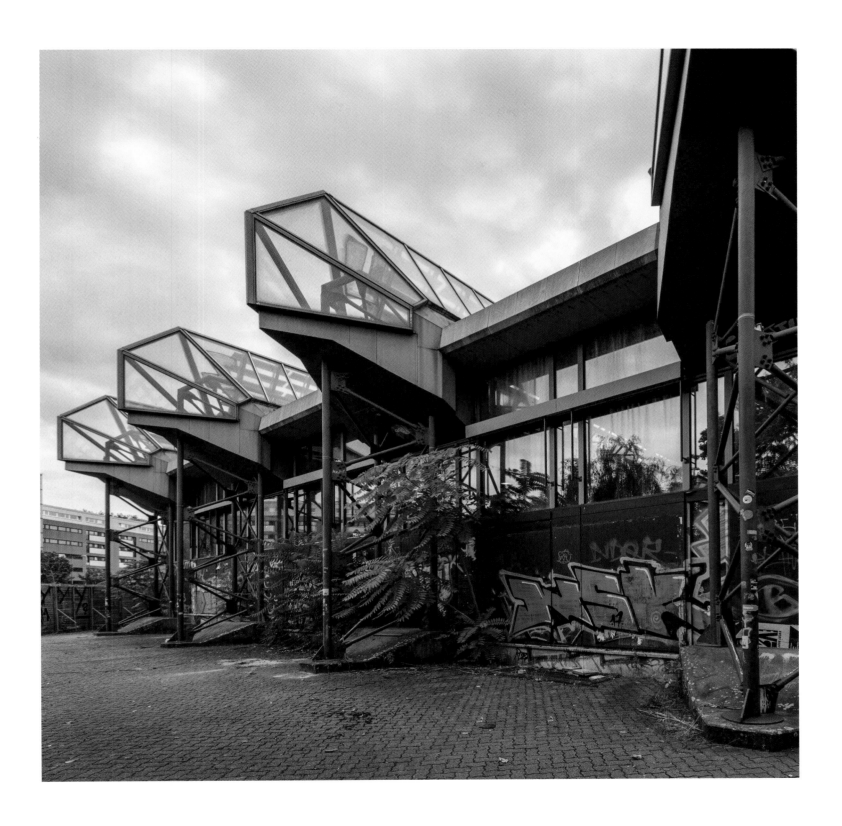

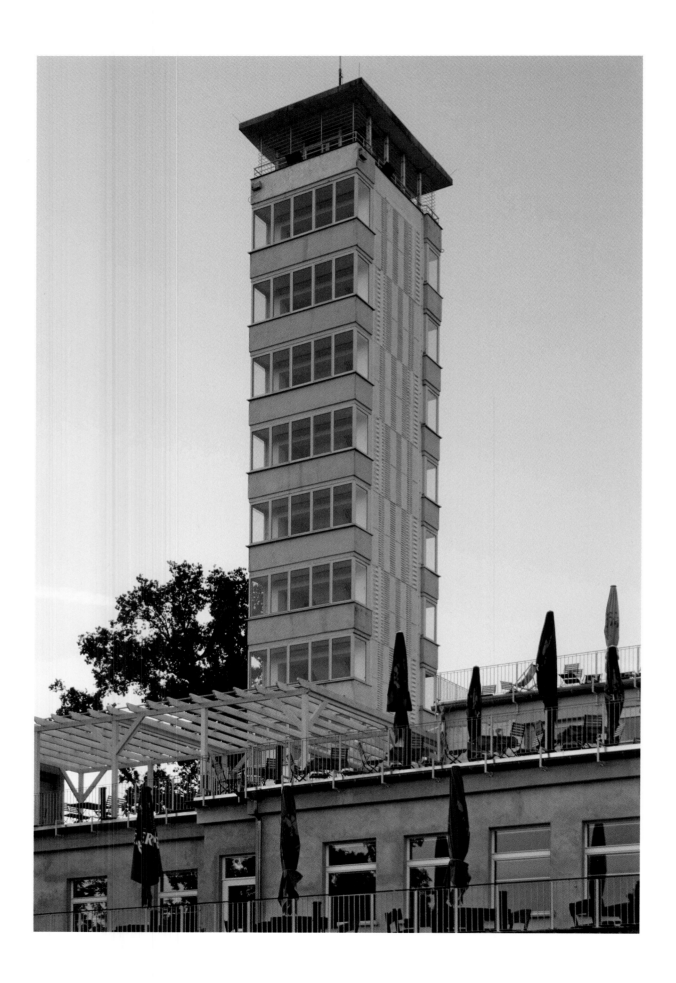

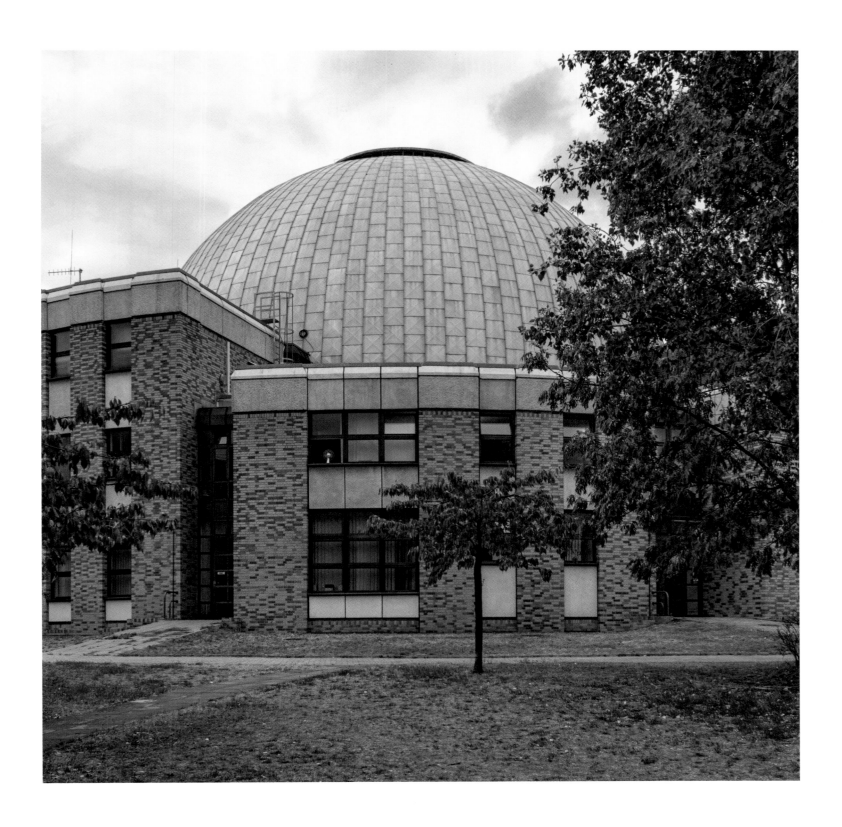

Zeiss-Grossplanetarium Prenzlauer Berg, Berlin **137**

left: Müggelturm, Berlin

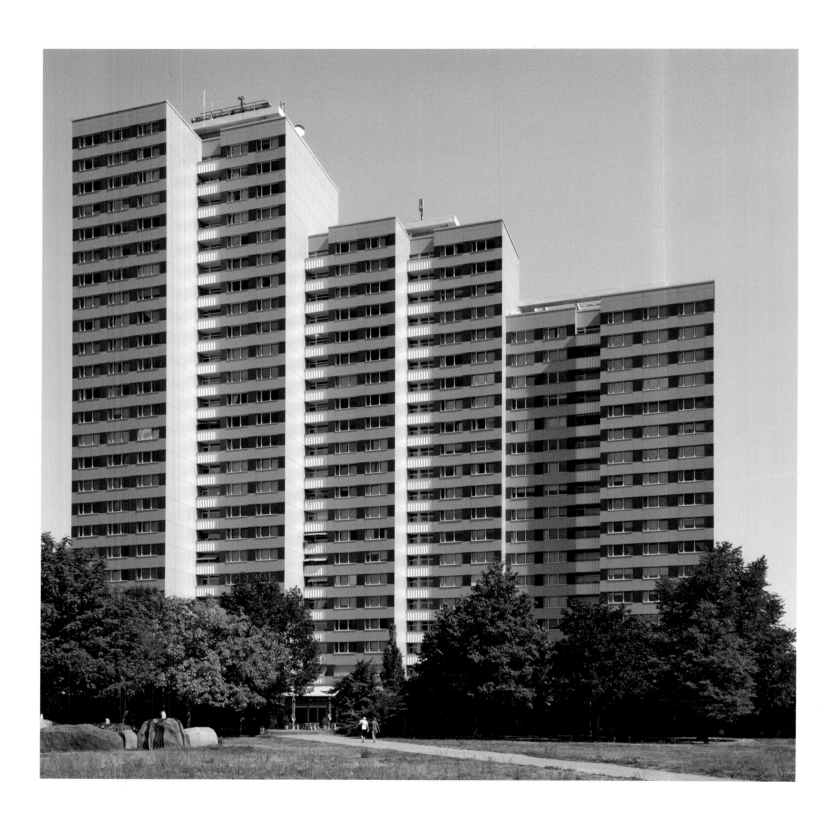

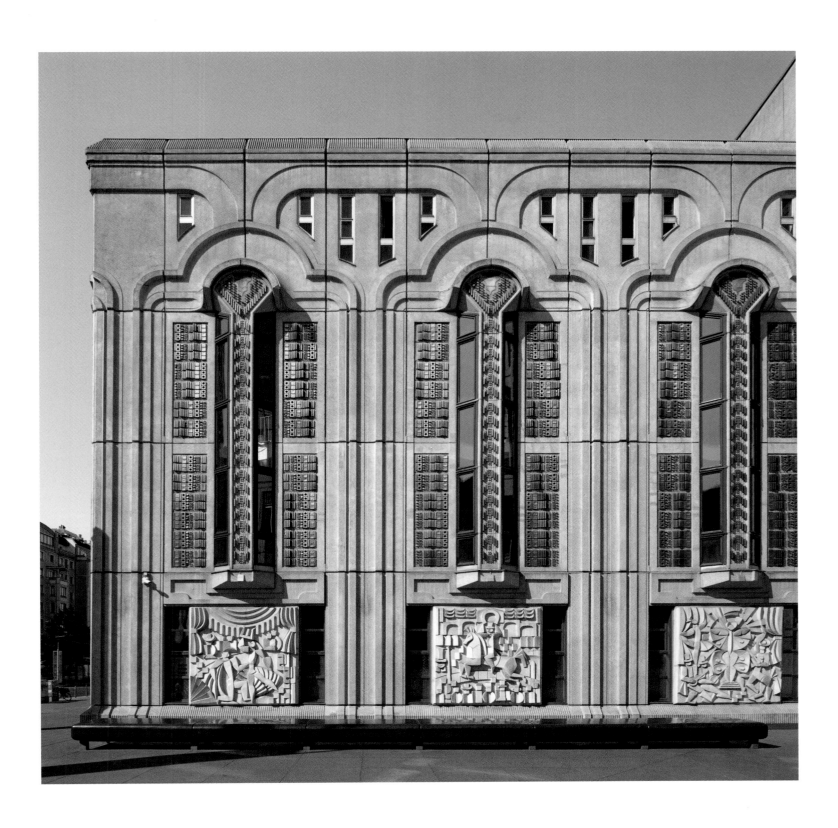

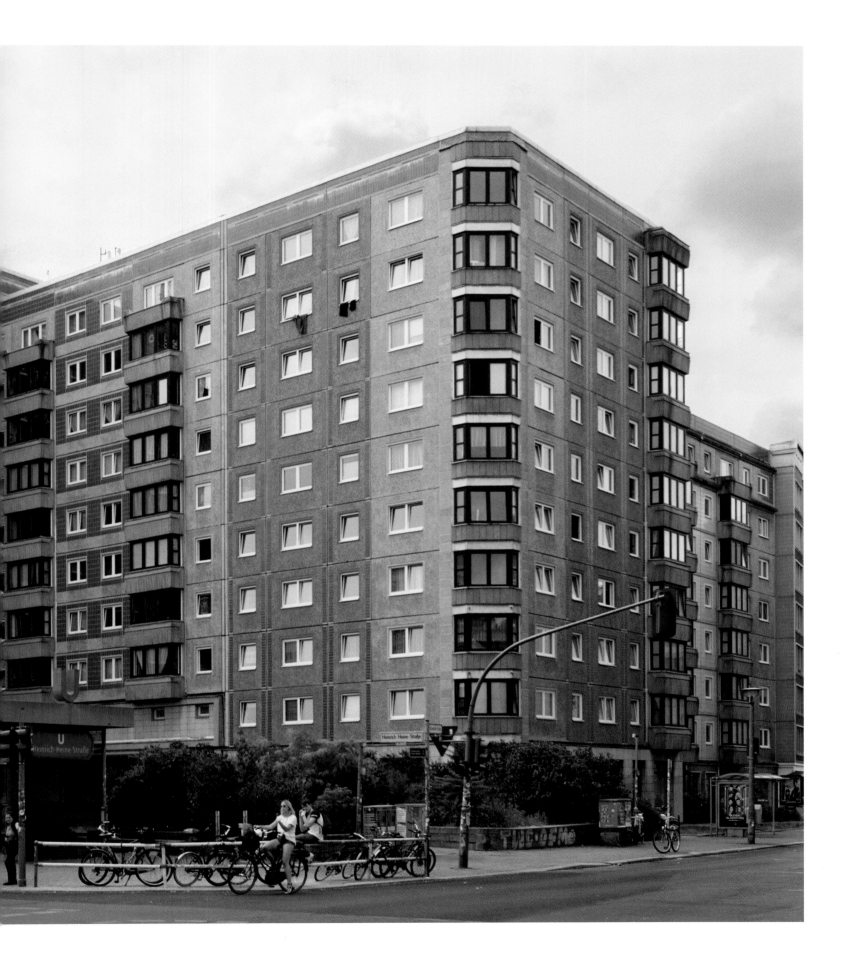

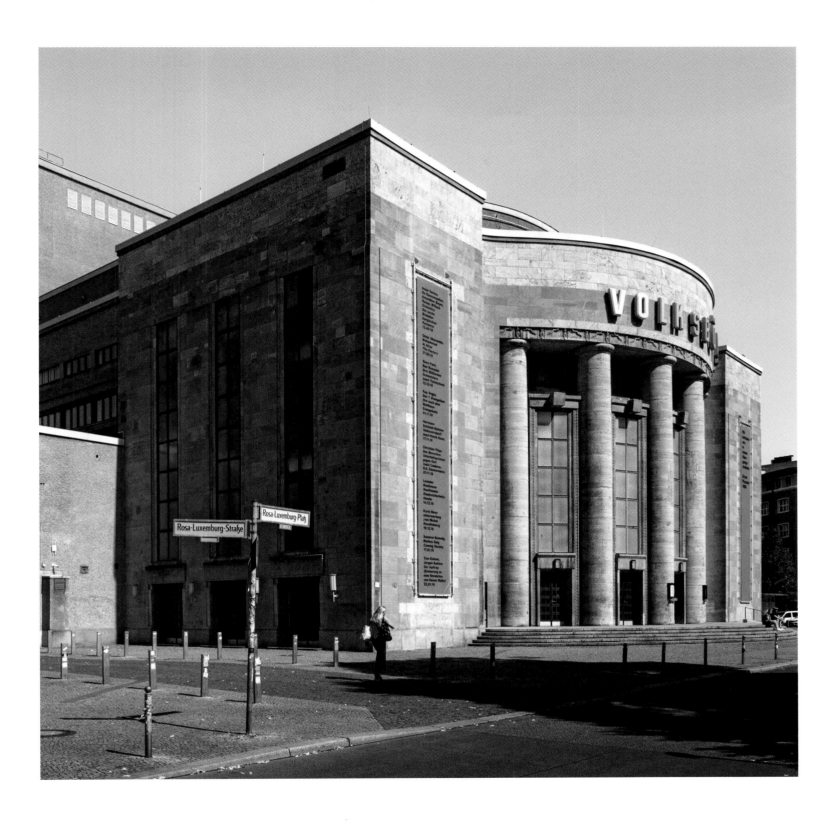

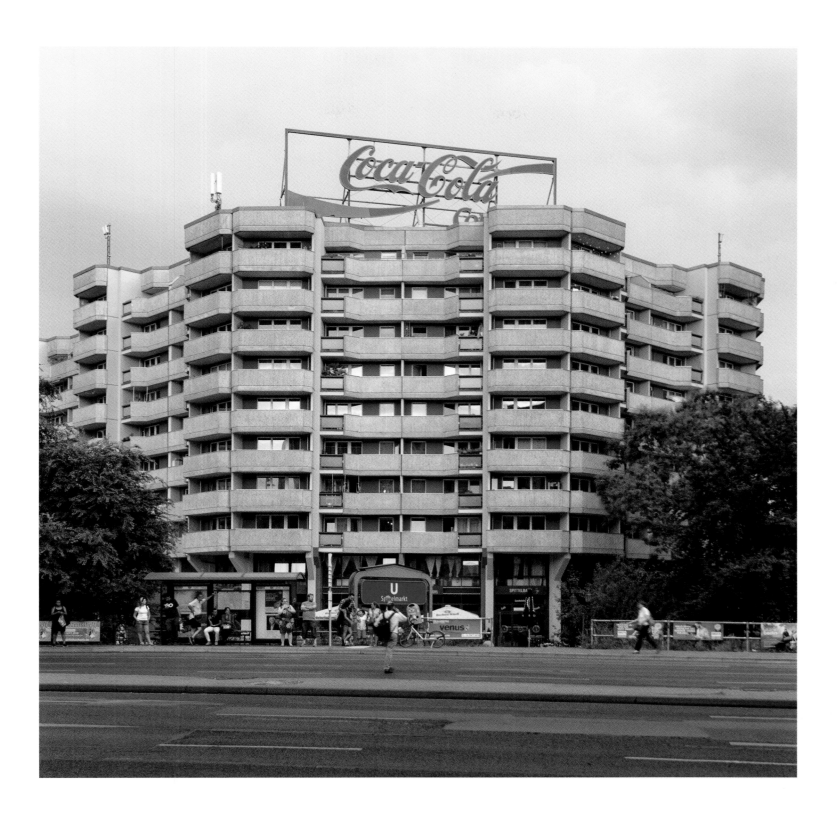

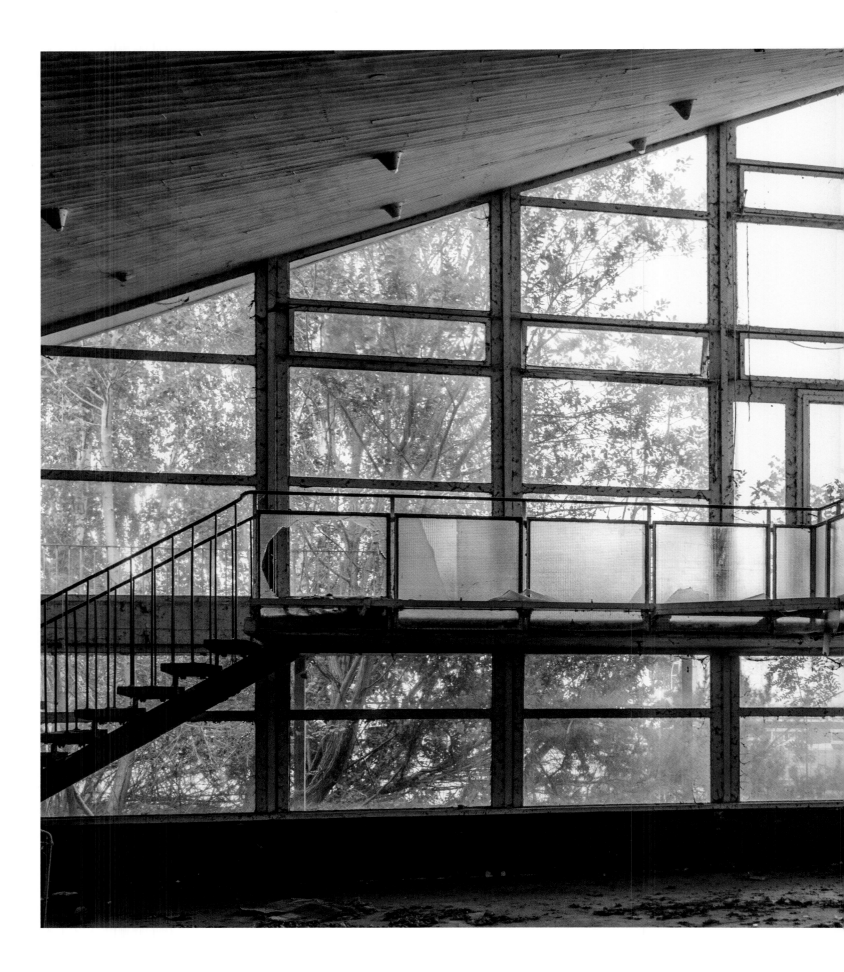

150 Housing on Domplatz, Halle (Saale)

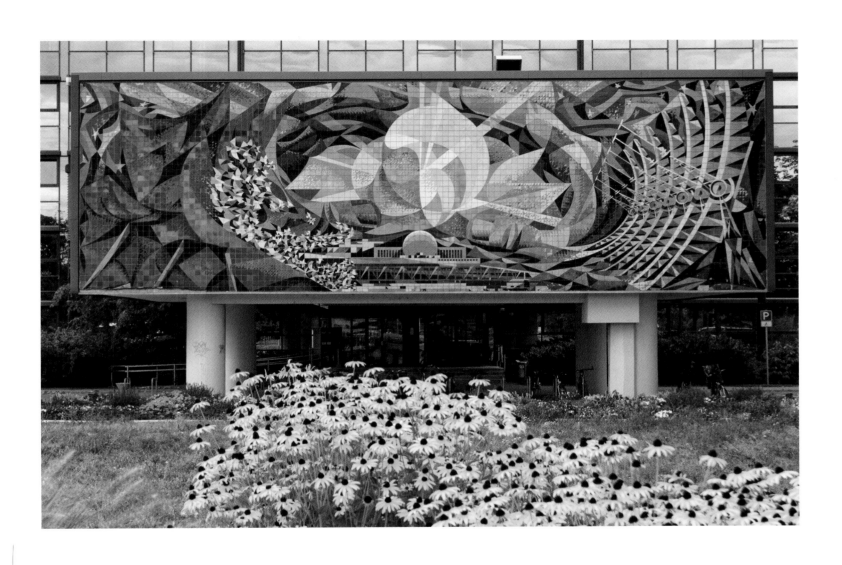

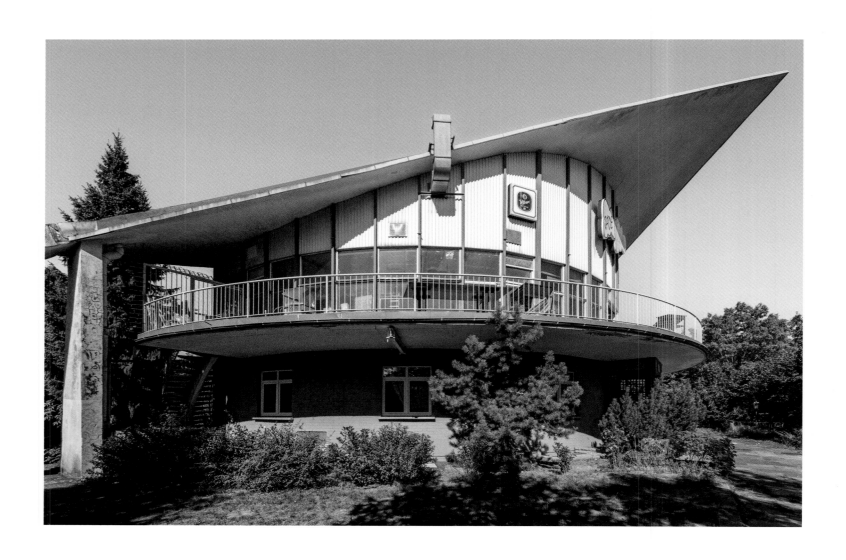

152 Panorama restaurant, Schwerin

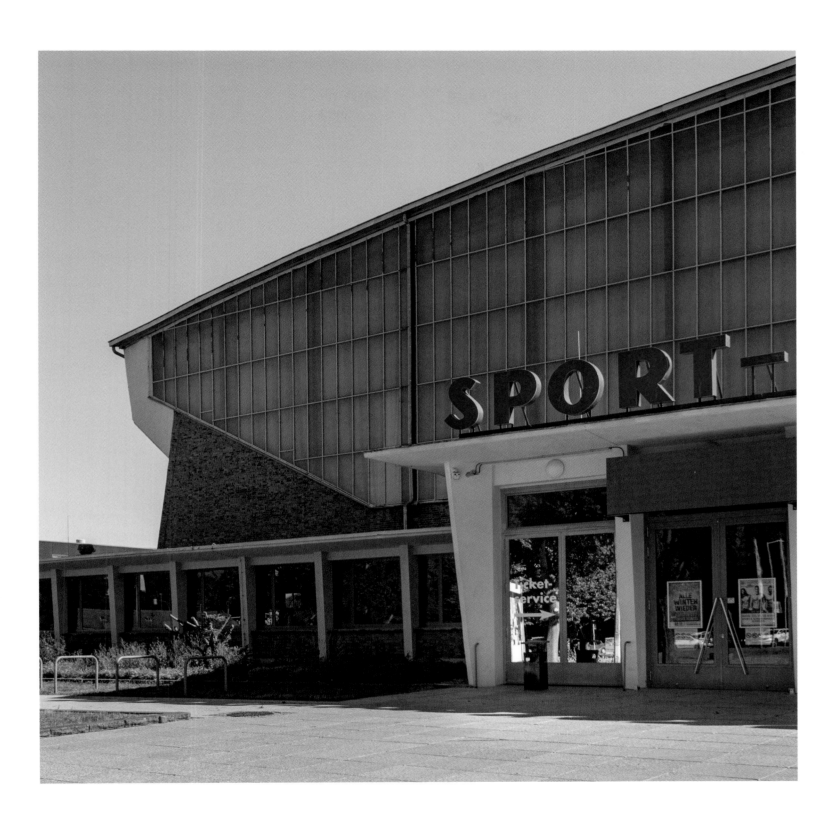

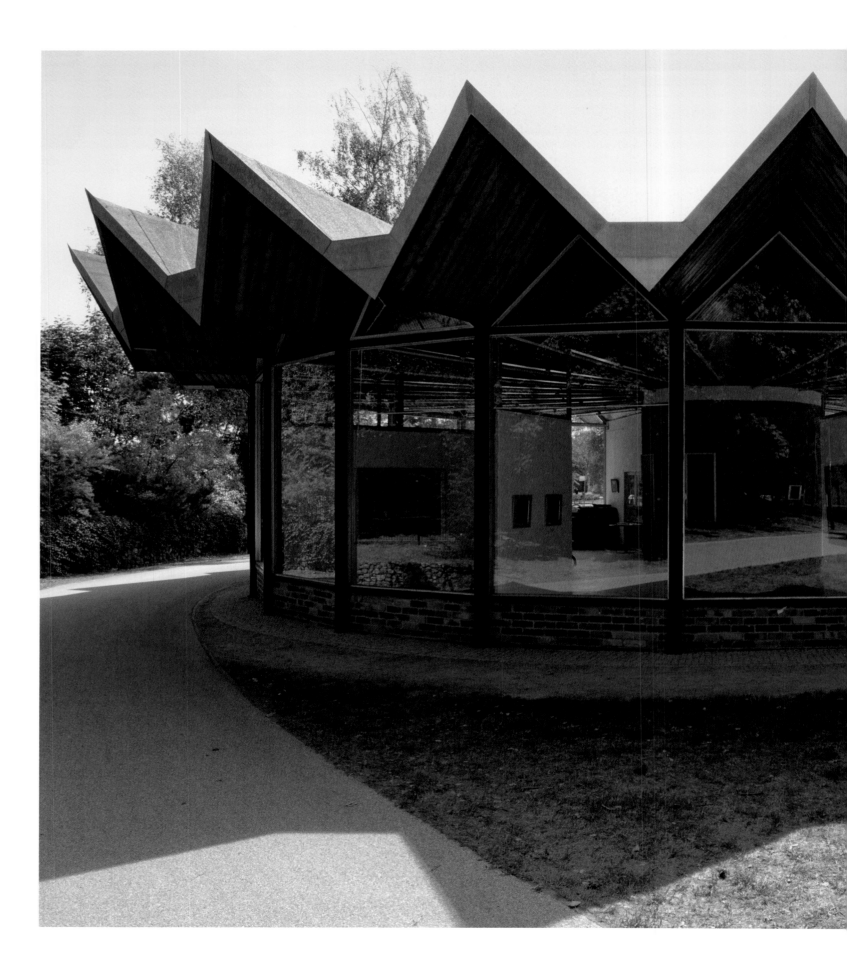

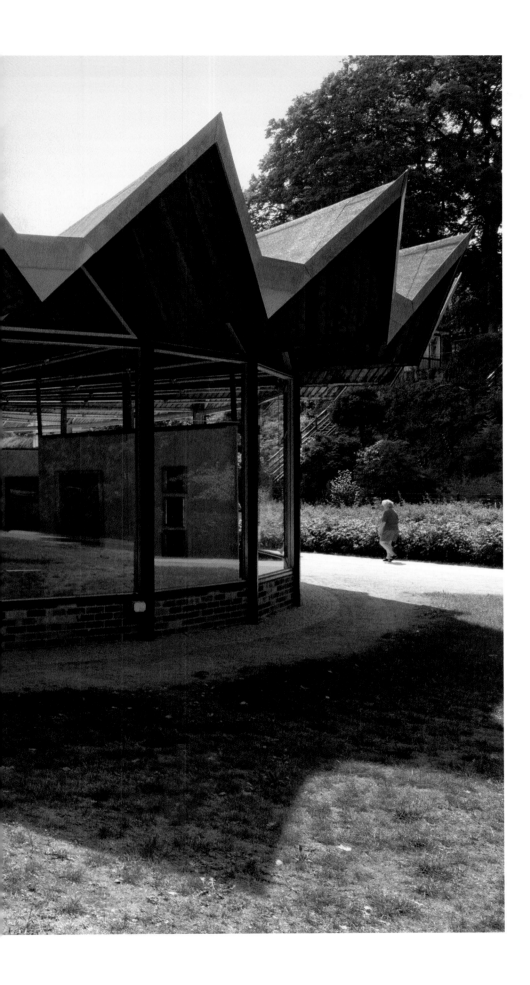

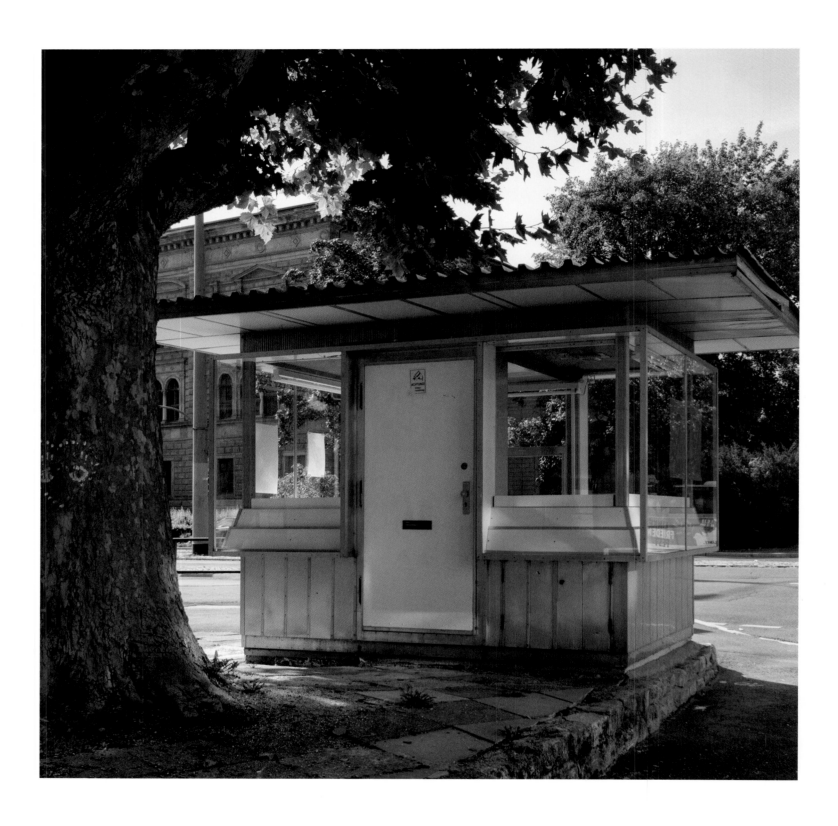

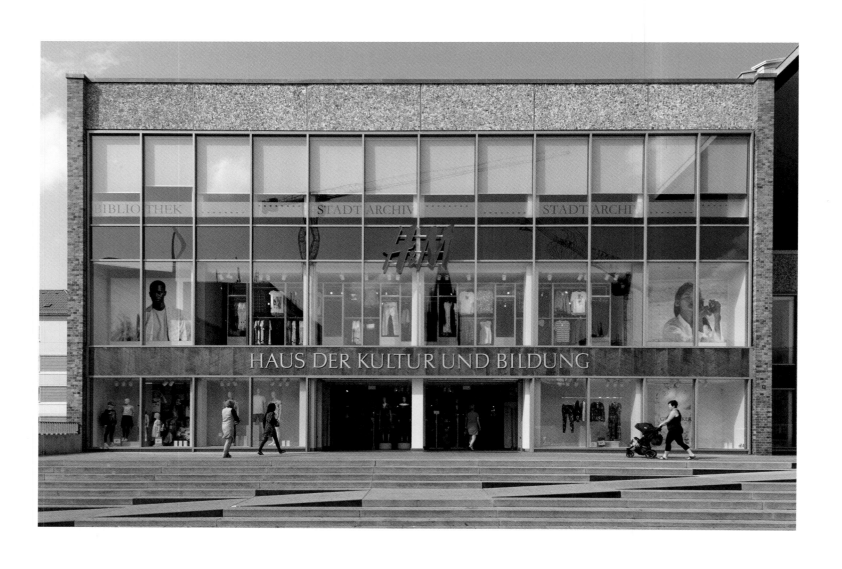

here and opposite: Haus der Kultur und Bildung, Neubrandenburg

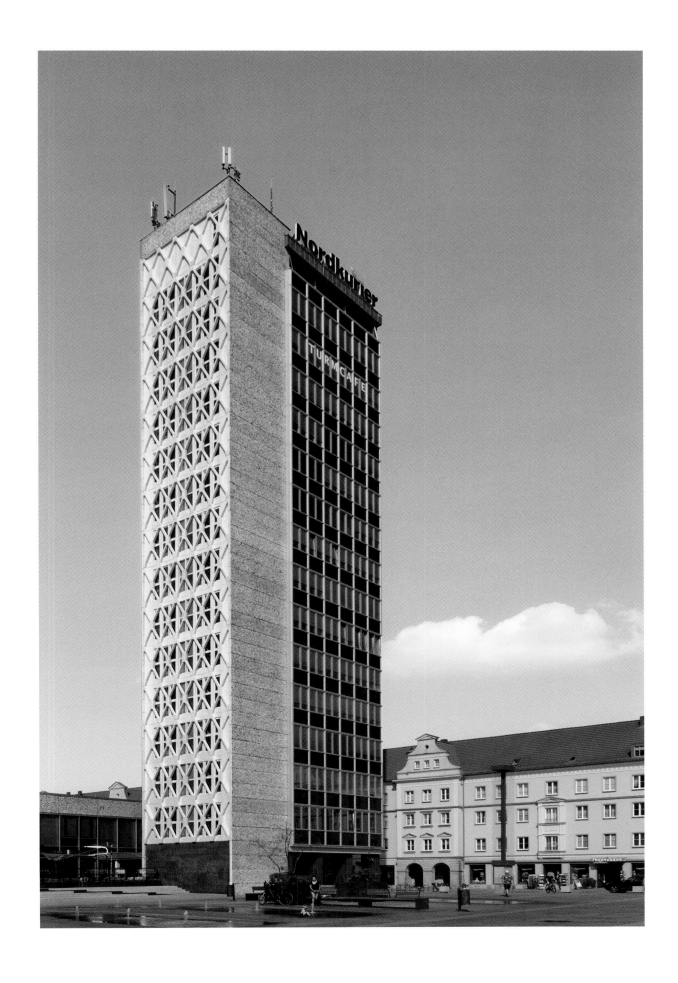

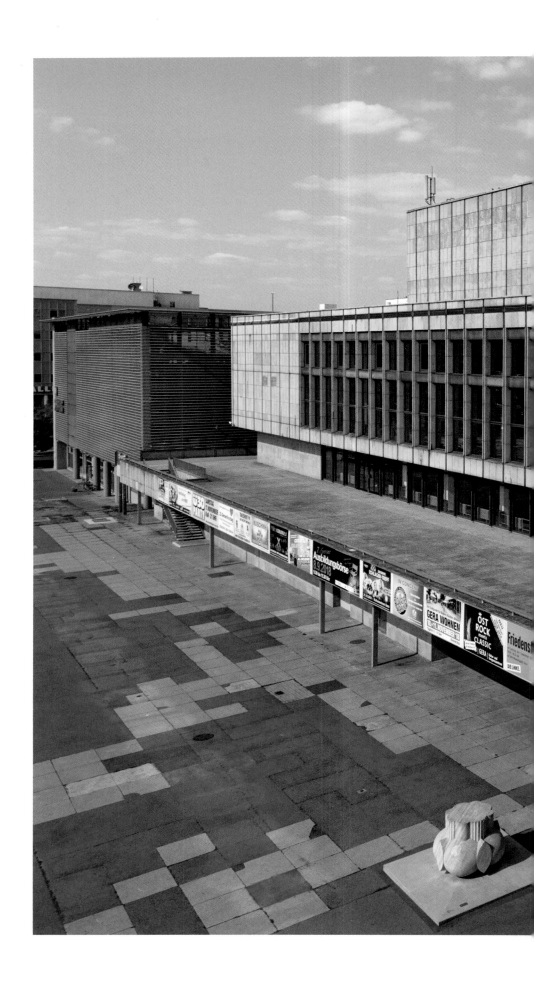

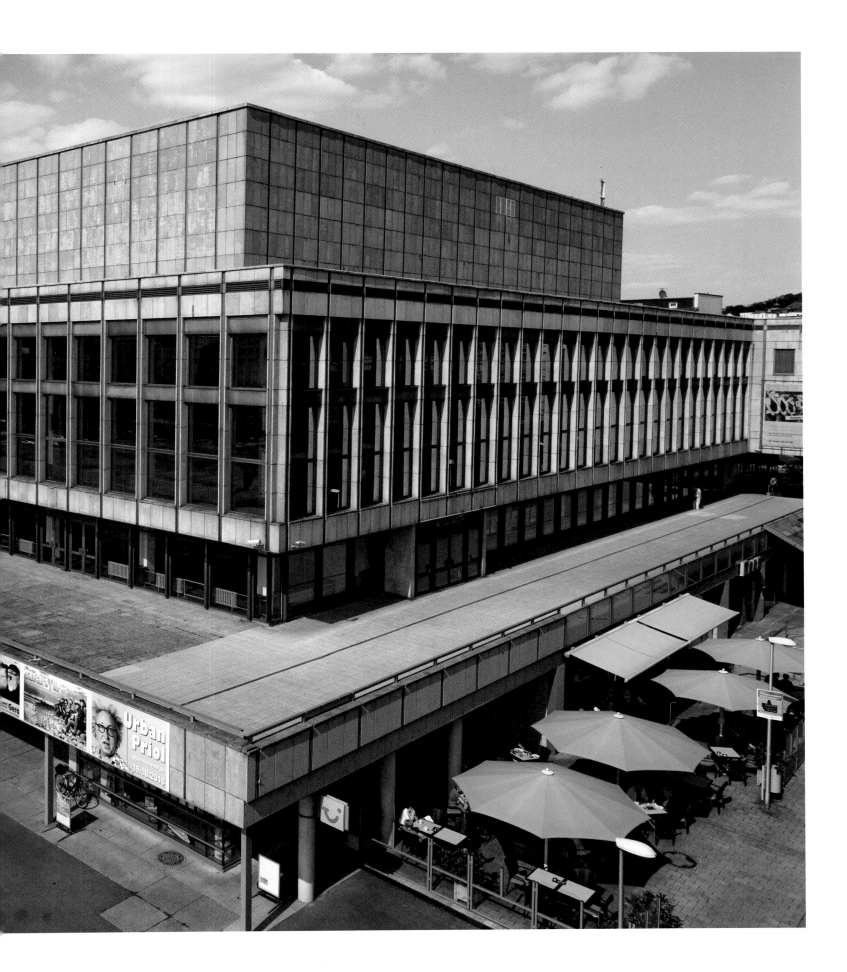

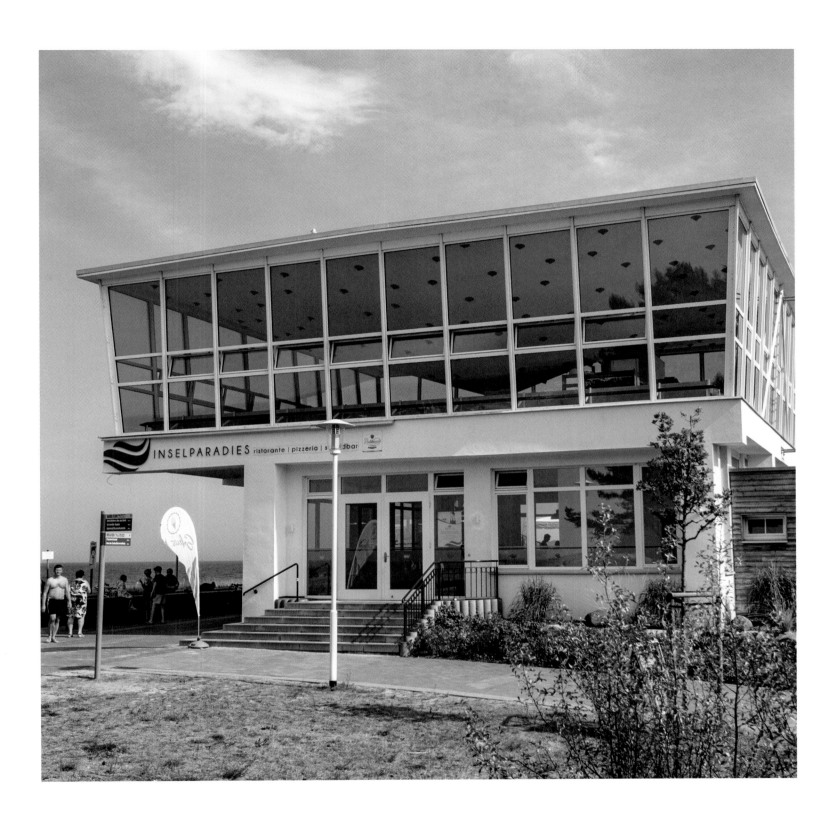

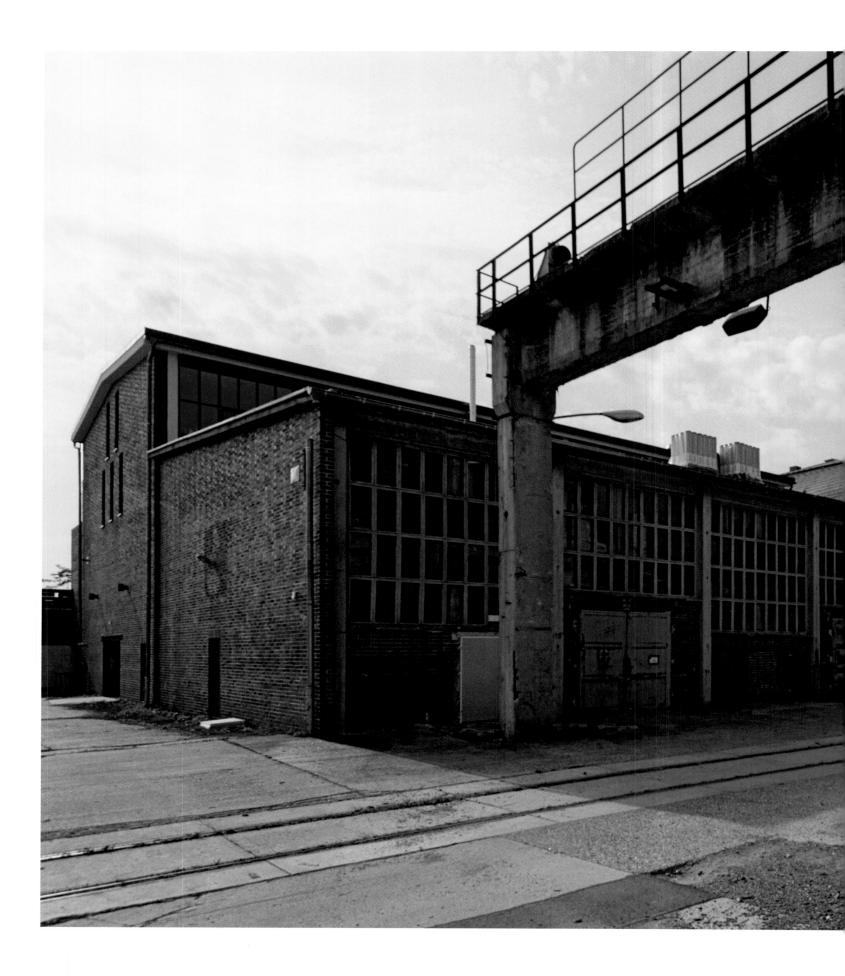

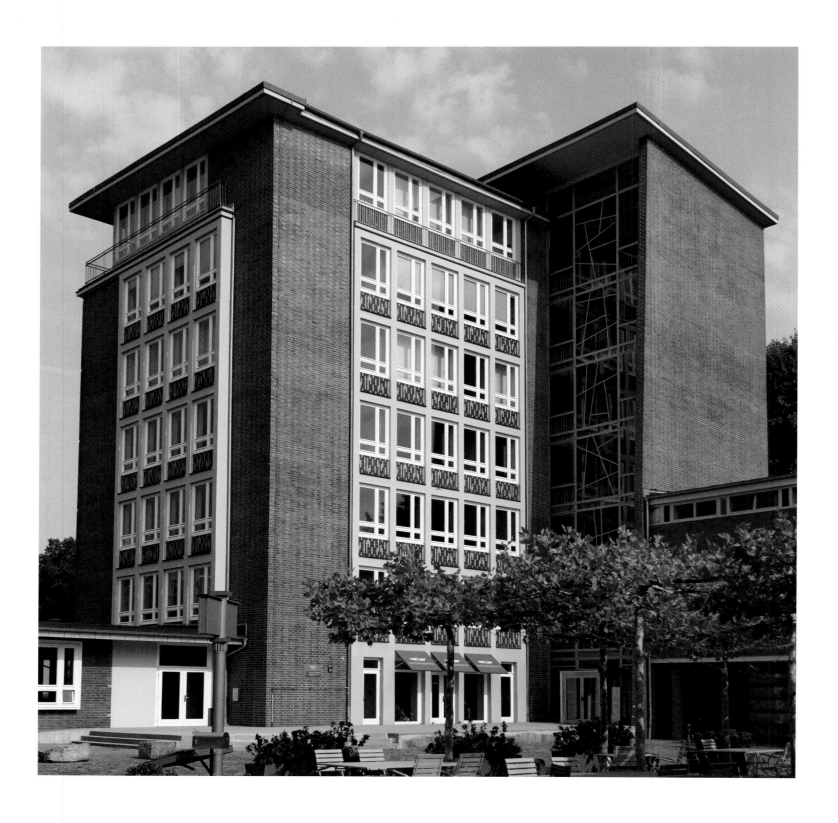

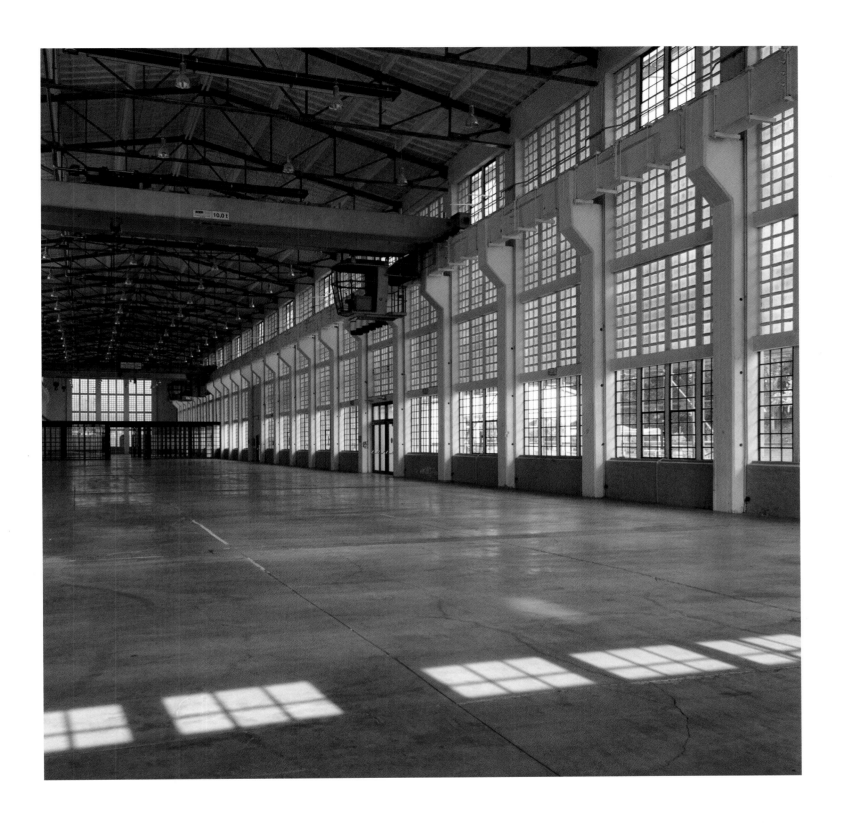

here and opposite: VEB Strömungsmaschinen Dresden **167**

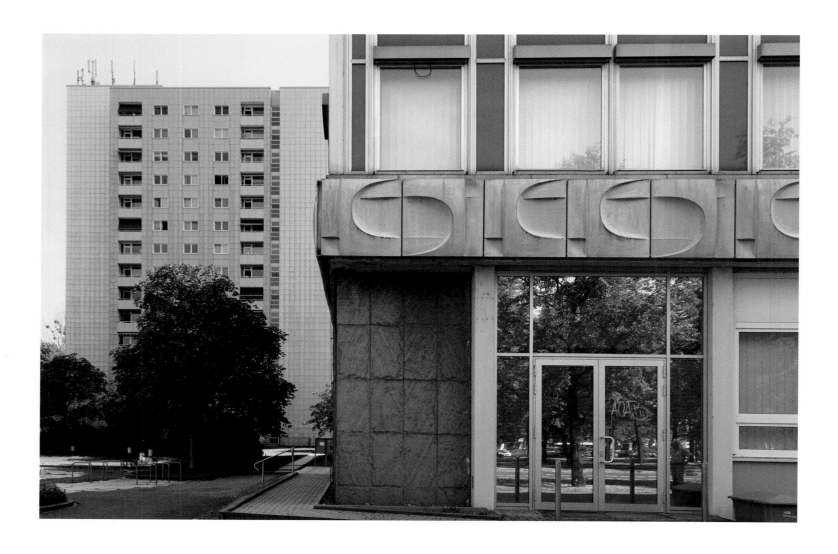

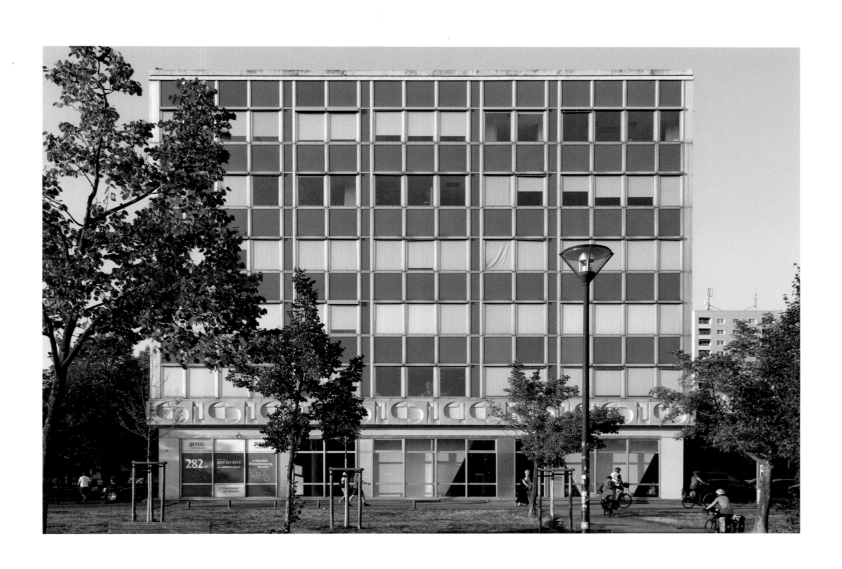

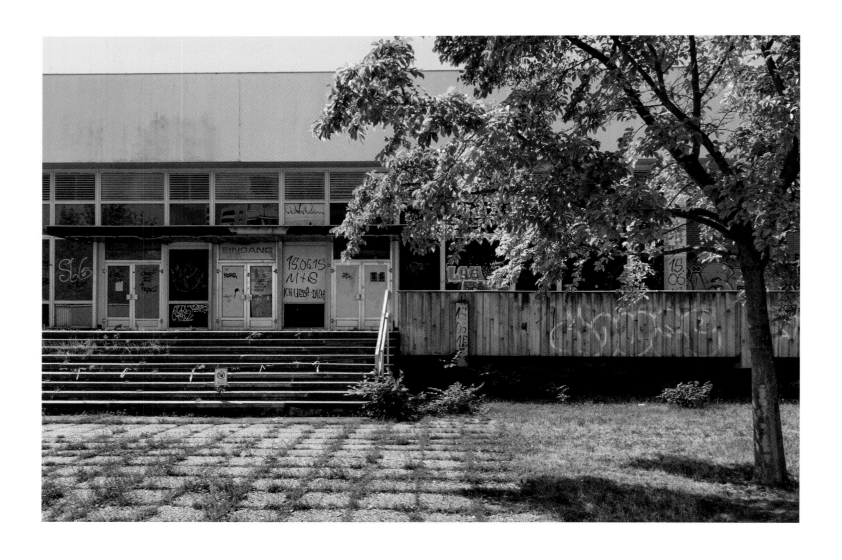

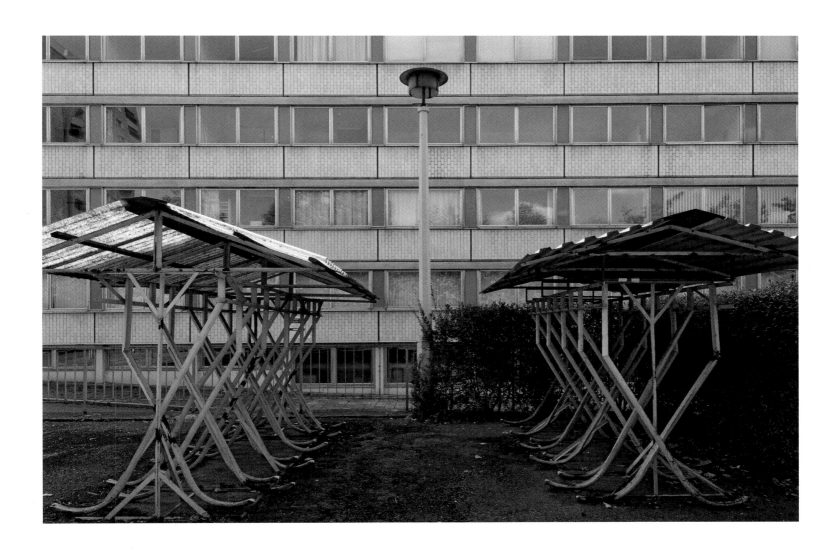

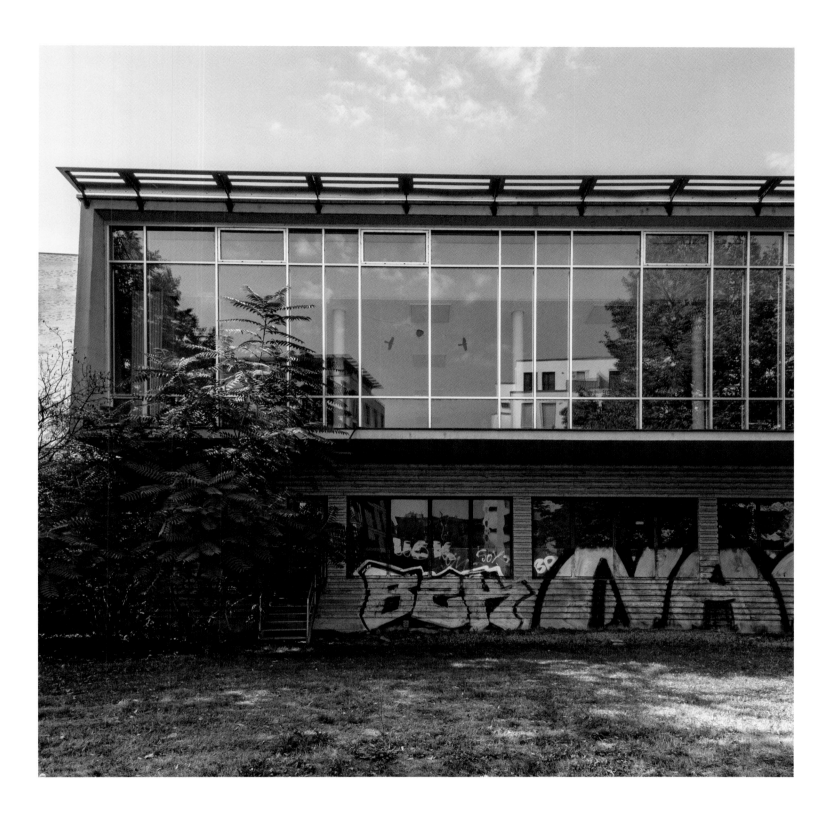

176 Neustadt main post office, Dresden

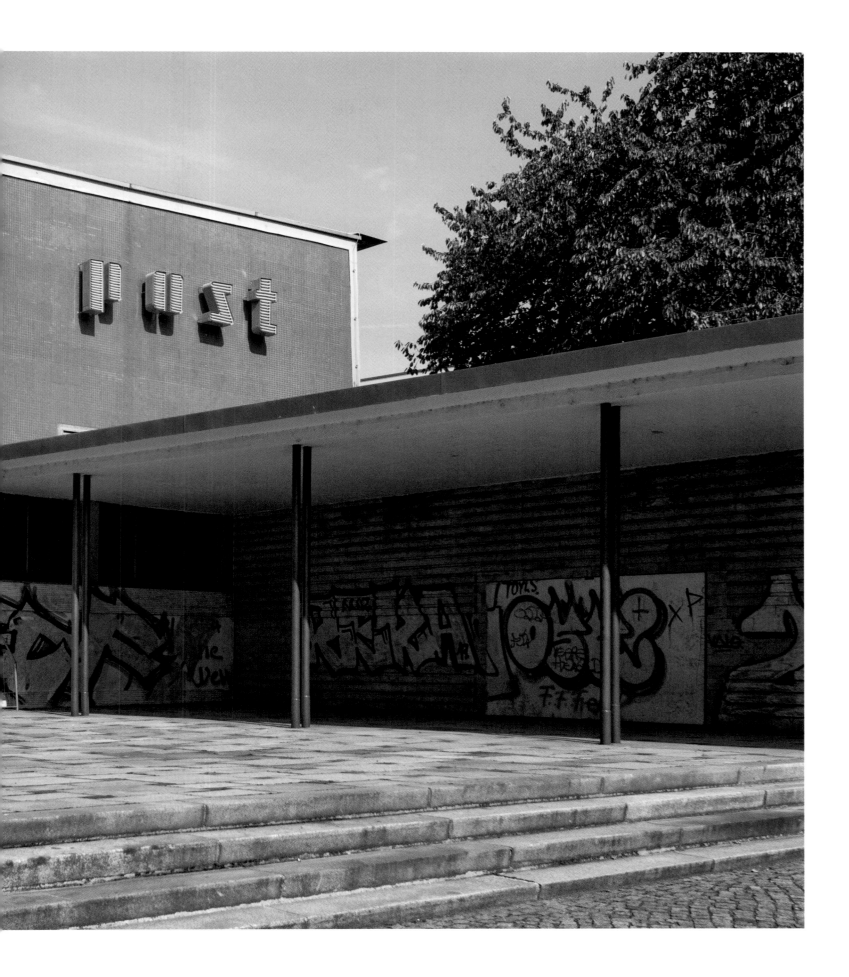

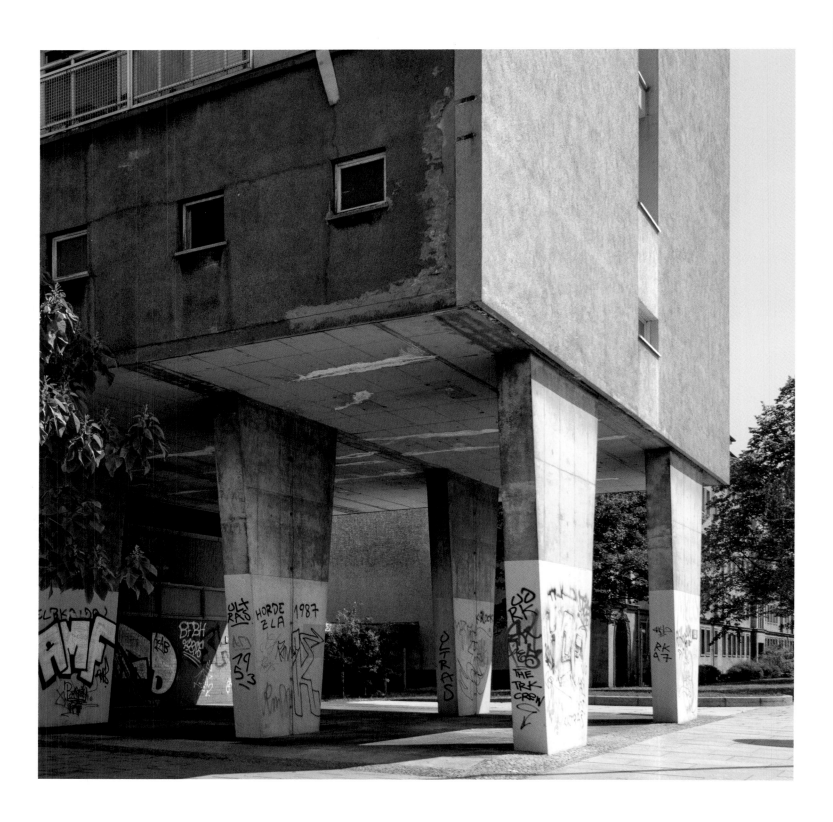

178 Residential high-rise, Dresden

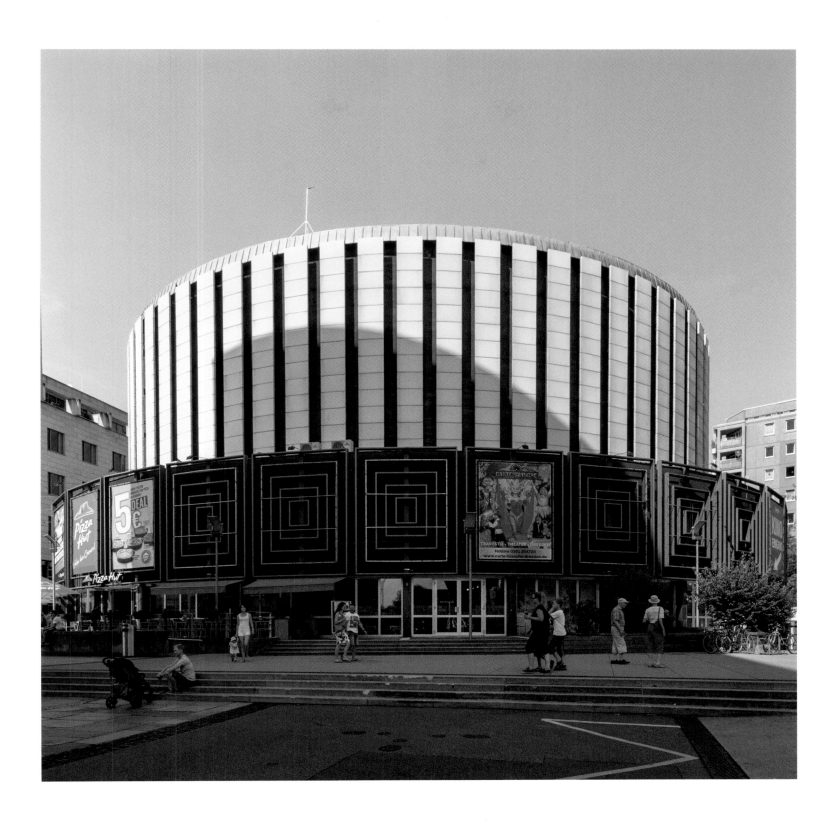

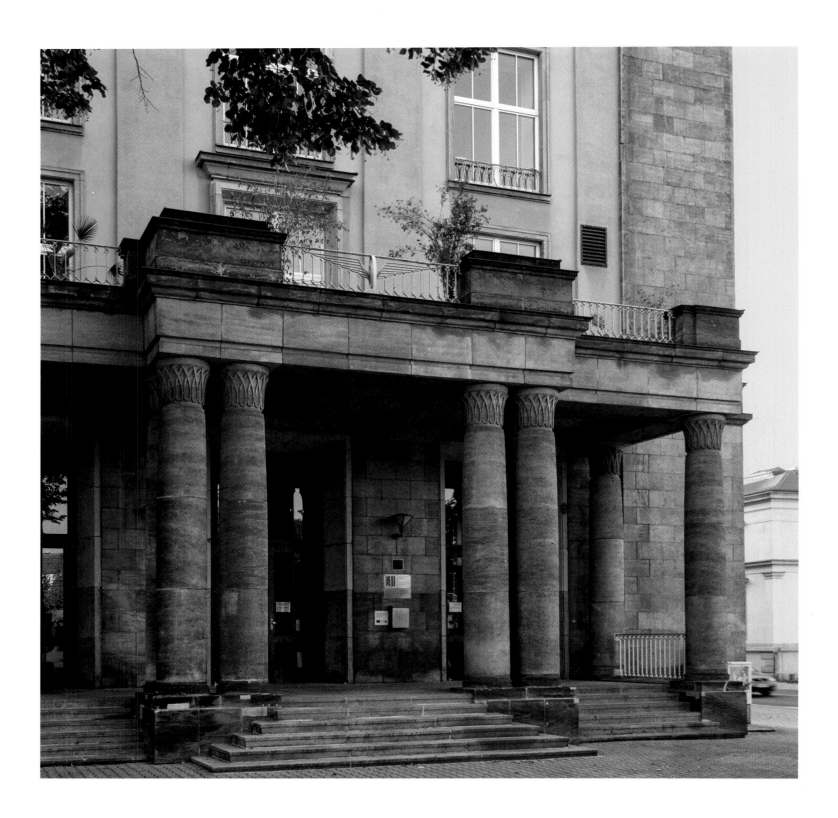

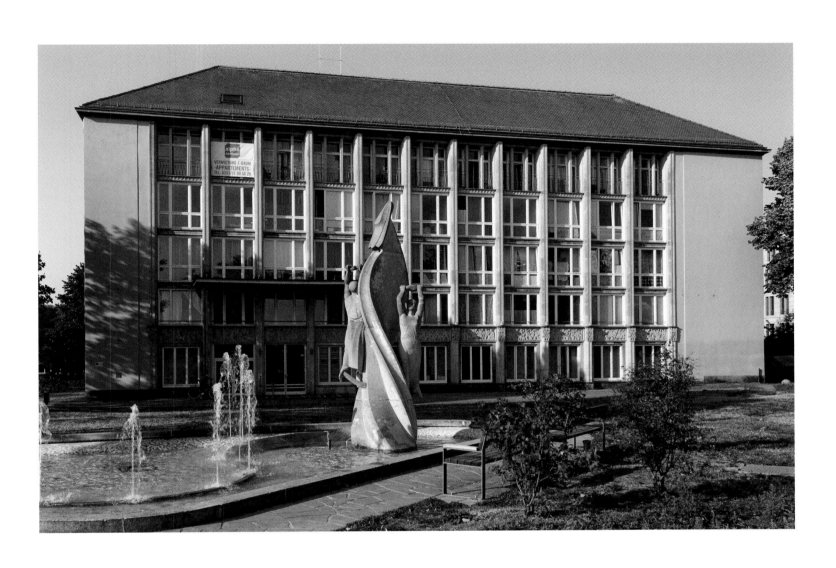

Student residence for the Technische Universität, Dresden **183**

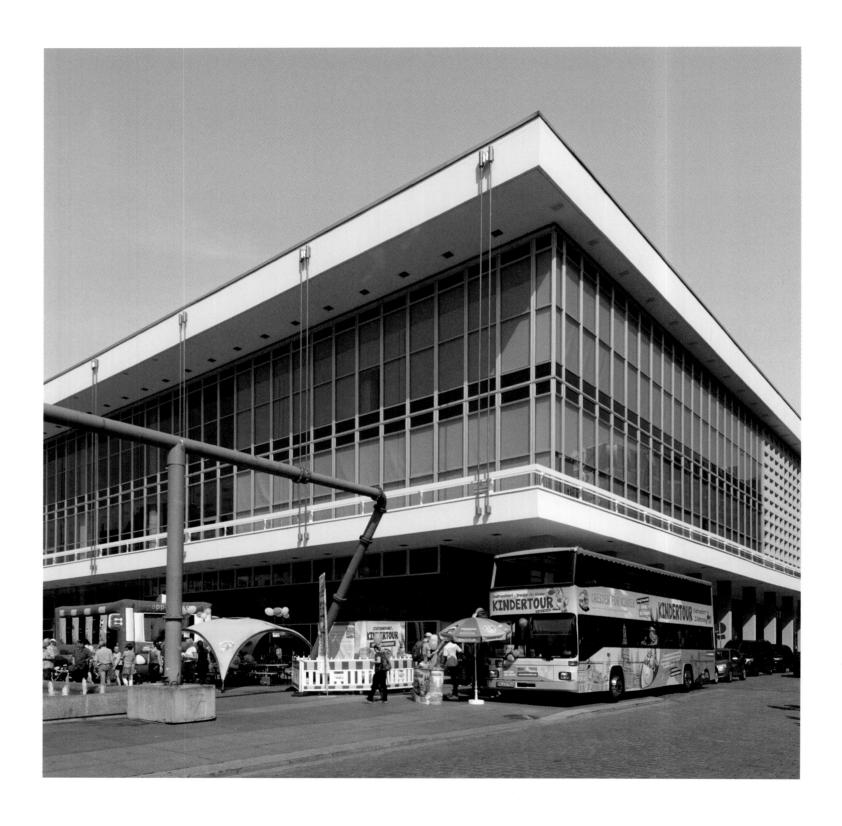

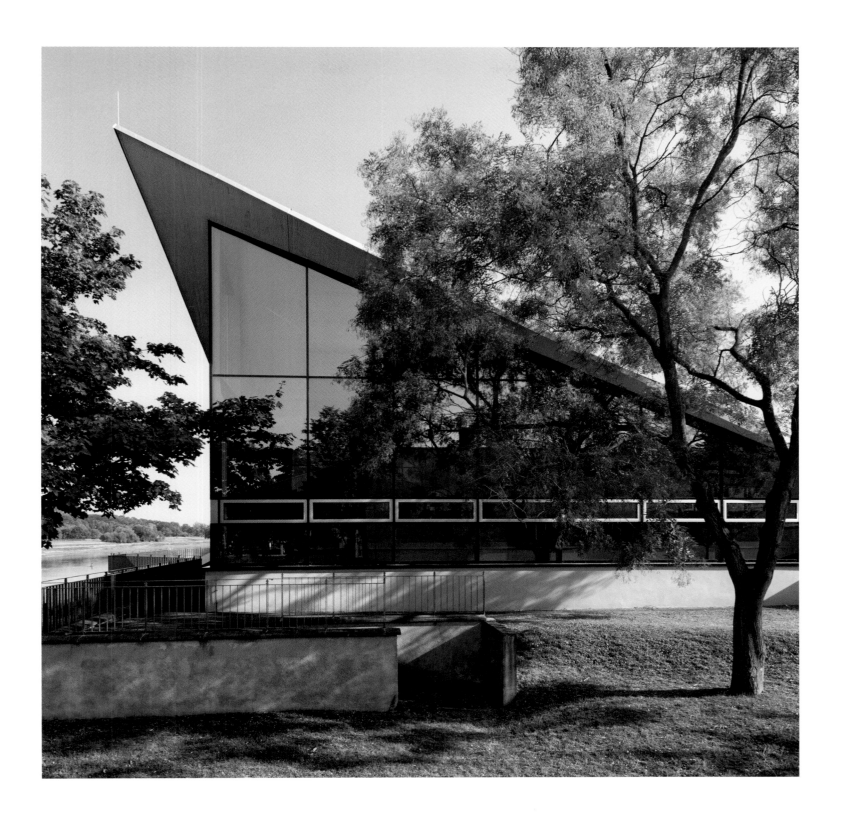

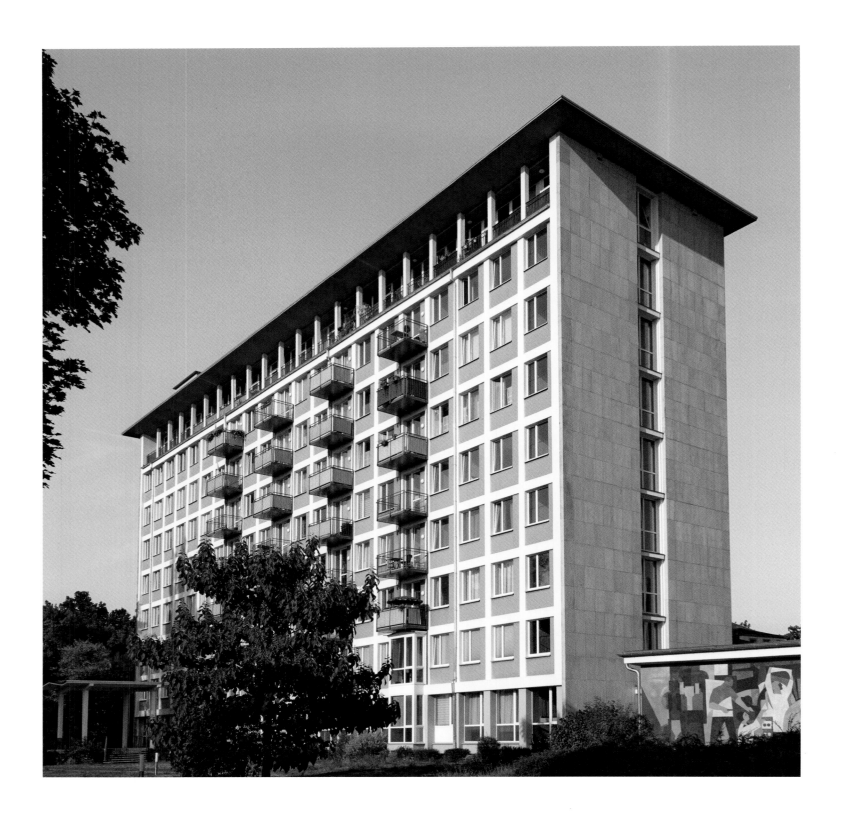

17

18–19

20

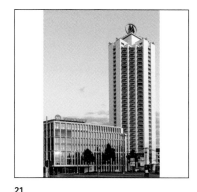

21

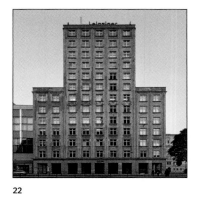

22

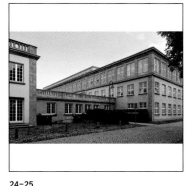

23

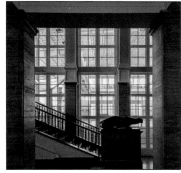

24–25

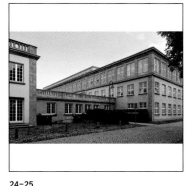

27

17
Bad Frankenhausen, Panorama Museum
for the Peasants' War Panorama
1974–80
Herbert Müller

To commemorate the Peasants' War, the
artist Werner Tübke was commissioned to
paint a panorama, *Early Bourgeois Revolution*
in Germany, which to this day is one of the
largest paintings in the world. Herbert Müller
was tasked with constructing the building at
the Schlachtberg near Bad Frankenhausen,
which takes its name from a decisive battle
in the war. The museum was completed for
the 450th anniversary of the Peasants' War,
but the painting of the battle was not on view
until 1989, for the 500th anniversary of the
birth of the peasants' leader Thomas Müntzer.

18–19
Leipzig, Neues Gewandhaus
1977–81
Rudolf Skoda, Horst Siegel,
Eberhard Göschel, Volker Sieg,
Winfried Sziegoleit

With a long delay and in place of a main
auditorium for the university, the Neues
Gewandhaus was built in Leipzig on the
square then known as Karl-Marx-Platz. The
impressive building costing 83 million marks
was inaugurated on the 200th anniversary
of the first Gewandhaus concert. Orchestra
director Kurt Masur gained not only a new

performance venue but also a hall he helped
design. The foyer ceiling is adorned with a
painting by Sighard Gille, *Gesang vom Leben*
(Song of Life), measuring 712 square metres.

20
Leipzig, Opera house
1956–60
Kunz Nierade and Collective,
Kurt Hemmerling

Starting in the mid-1950s, on the site of
Carl Ferdinand Langhans' Neues Theater,
destroyed in the war, the first new theatre
in the GDR was built, clearly influenced by
classical models. The Elbe sandstone façade
also reveals a shift from the preponderance
of architectural ornament in socialist classi-
cism towards formal reduction. There are,
however, some works in relief, for example
by Walter Arnold. The theatre's overall form
is reminiscent of the previous building, while
the gold anodised aluminium window frames
point towards Ostmoderne.

21
Leipzig, Wintergartenhochhaus
1970–72
Georg Eichhorn, Frieder Gebhardt
and Collective

The "Winter Garden Tower" was the first
and, ultimately, only one of eight high-
rises planned as dominant features of the
Promenadenring in Leipzig. A symbol of

the modern city visible from afar, with its
thirty-two storeys it fulfils the concept from
the general plan of the 1920s. The original
two-storey building for a nursery and restau-
rant that surrounded its base, now removed,
underlined its status as a machine for living.

22
Leipzig, Europahochhaus
1928–29 Otto Paul Burghardt
1965 Frieder Gebhardt and
Hans-Joachim Dressler

The "Europe Tower" was constructed in
1928–29 as part of Hubert Ritter's general
plan for the Stadtring ring road. When the
Hotel Deutschland (Helmut Ullmann, Wolf-
gang Scheibe) was built next to it in plain
modernist style in 1964–65, the Europahoch-
haus was thoroughly remodelled. Since then
it has provided an extremely coherent urban
link between the buildings on Rossplatz
(1953–55) – built by Rudolf Rohrer in the
National Tradition style – and the modern
redevelopment towards Georgiring.

23
Leipzig, Bowlingtreff
1985–87
Winfried Sziegoleit

On the site and in the physical structures of
a former electrical substation at the heart
of Leipzig, a unique "bowling rendezvous"
conceived for a maximum of 2,800 visitors

was built, largely underground, for the 8th
Gymnastics and Sports Festival of the GDR.
Two halls with fourteen bowling alleys,
gymnasia, pool tables, Poly Play arcade games
and catering facilities made it an immediate
attraction. Though closed in 1997, today it is
a designated monument and awaits a new
use plan.

24–25
Leipzig, Deutsche Hochschule
für Körperkultur (DHfK),
first construction phase
1952–57
Hanns Hopp, Kunz Nierade

The high status of sports in the GDR led to
the establishment of Leipzig as a city of sport.
The first construction phase of the DHfK
with pilasters, lattice windows and balus-
trades was in keeping with the neo-baroque
and neoclassical architectural vocabulary of
the National Tradition and was intended for
representational purposes, as the interior
fittings also show. In the second of a total of
four building phases (1961–64, Wolfgang
Assmann, Eitel Jackowski) the architectural
language became more modern, and later
considerably more functional.

27
Leipzig, DHfK, Ernst-Grube-Halle
1953–57
Hanns Hopp, Kunz Nierade

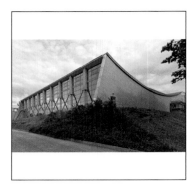

28–29

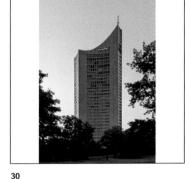

30

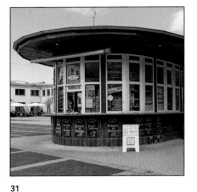

31

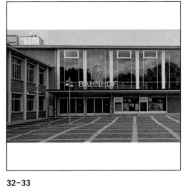

32–33

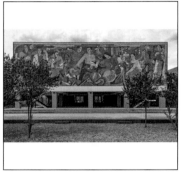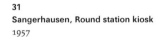

34

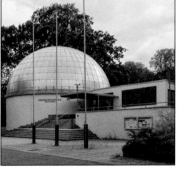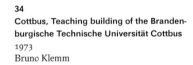

35

36

37

28–29
Leipzig, DHfK, Swimming pool complex
1967–71
Eitel Jackowski

In the third building phase of the DHfK (1967–71), on the southern part of the campus, the swimming pool complex was built in lightweight steel construction and significantly more modern than the halls of the first phase. It housed a learners' pool, Germany's first counter-current pool and an indoor pool for competitions and diving. In 1976 the building was the motif on an Olympic postage stamp of the GDR.

30
Leipzig, Universitätshochhaus
1968–72
Hermann Henselmann, Helmut Ullmann, Horst Siegel, Ambros G. Gross

The "University Tower" (today: City-Hochhaus Leipzig) for Karl-Marx-Universität Leipzig is a principal example of Hermann Henselmann's so-called symbolic architecture. With a height of more than 140 metres, it dominates the cityscape of Leipzig. In the manner of a large-scale sculpture, the building was intended to speak through its form, in this case the shape of a slightly opened book – a reference to the cultural significance of Leipzig as a university city and a centre of publishing.

31
Sangerhausen, Round station kiosk
1957

From 1957 a round kiosk of the Handelsorganisation (HO, Trade Organisation) supplied the needs of train passengers on the space in front of Sangerhausen station. In 1963 a Mitropa restaurant opened in the station's new concourse, but the kiosk stayed in business – and has remained to this day. Like the station building, the almost uniquely shaped kiosk is a designated monument as part of the ensemble.

32–33
Sangerhausen, Train station building
1963
Karl Seidler, Harald Ulbrich, Fred Pietzsch

In April 1945 the explosion of an ammunition train destroyed the old station of the town of Sangerhausen. Almost twenty years were to pass before the town received its new station building in 1963, but to compensate it was not only the first newly built rail station of the GDR but also a showpiece of the Ostmoderne style. The large-format wall mosaic *Landwirtschaft und Industrie* (Agriculture and Industry) in the entrance lobby was made by Wilhelm Schmied in the spirit of Socialist Realism – and thanks to the glass façade is visible from the square in front of the station.

34
Cottbus, Teaching building of the Brandenburgische Technische Universität Cottbus
1973
Bruno Klemm

In the early 1970s the Hochschule für Bauwesen was given new teaching facilities that were adorned with art-for-architecture in the manner of the period. At the transition between buildings 2A and 2B Gerhard Bondzin created the monumental mural *Mensch und Bildung* (Humanity and Education) in the style of Socialist Realism. As his painting material Bondzin used pulverised coloured glass. This process, an invention of the GDR, was widely exported. Unfortunately it is hardly possible today to restore works made by this method.

35
Cottbus, 32nd Polytechnische Oberschule Cottbus
(today: Regine-Hildebrandt-Grundschule)
1980–81

The Cottbus Wohnungsbaukombinat for housing construction was particularly active in building schools and produced a series of building types for multiple use. The Cottbus type of school building was used some one hundred times. It is striking for its multipurpose hall on stilts, beneath which there is space for breaks and the entrance to the building.

36
Cottbus, Raumflugplanetarium Juri Gagarin
1972–74
Gerhart Müller

The general euphoria for space travel in the GDR resulted in the construction of numerous planetariums. The "Yuri Gagarin Space Travel Planetarium" on Lindenplatz in Cottbus is unusual in that it simulates an extraterrestrial perspective for 160 visitors at a time, allowing them to view the Earth from the Moon or Venus. The technology for this experience of space, unique at the time, was provided by VEB Carl Zeiss Jena – not only for Cottbus but also for the Planetário de Brasília.

37
Cottbus, Stadthalle Cottbus
1975
Eberhard Kühn

This multipurpose hall with seating for up to 2,700 persons closed off the north-west side of the city centre and was the largest theatre in the GDR when it opened – in what was described as the youngest city of the GDR. One of the first events here on Berliner Platz was a programme called "Midnight Party" by the highly popular GDR pop stars Frank Schöbel and Aurora Lacasa.

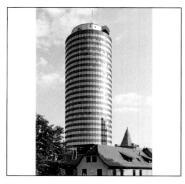

39

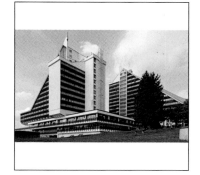

40–41

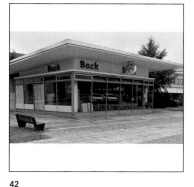

42

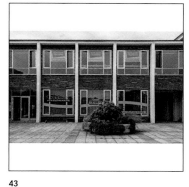

43

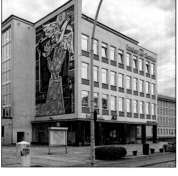

44

45

47

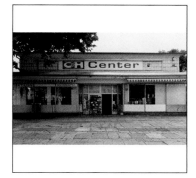

48

39
Jena, Universitätshochhaus
1970–72
Collective of Hermann Henselmann,
Heinz Rauch, Ulrich Balke, Friedrich Riehl

This "University Tower" has in common with
the one in Leipzig its vertical dominance of
the city and its symbolic shape: planned as
a research centre for VEB Carl Zeiss, its cylin-
drical form plays on the idea of a telescope.
For cost reasons, the execution was much less
ambitious than the designs. Numerous historic
buildings were razed for its construction.

40–41
Oberhof, Interhotel Panorama
1967–69
Krešimir Martinković and Arhitektura
i urbanizam Collective

The form of this building, was conceived in
symbolic terms and, in accordance with the
character of Oberhof as a resort for winter
sports, could be interpreted as either a ski
jump or mountain peaks. Like the Interhotel
Neptun in Warnemünde, this hotel aroused
an almost mythical longing in the GDR. The
swimming pool, "hunter's tavern" and hall
with open fireplace represented the pinnacle
of luxury tourism in the popular imagina-
tion. A restaurant named Beograd served
as a reminder of the architect's origins in
Yugoslavia. From 1972 GDR citizens from
the FDGB (Federation of Free German Trade

Unions) were admitted, and holidays in Ober-
hof were granted as a special distinction.

42
Eisenhüttenstadt, Autopavillon
1958–59
Collective of Gerhard Wollner,
Wolfgang Timme, Herbert Hoffmann

To own a car in the GDR was a highlight in
life and in status, not least because of the long
wait for delivery of a car also regarded as a
symbol of modern life. The "Car Pavilion" in
the main axis of Eisenhüttenstadt, deliberately
shifted out towards the road from the line of
shops, expressed this spirit of the age in for-
mal terms and in the showroom for the object
of desire – usually a car of the Wartburg or
Trabant marque.

43
Eisenhüttenstadt, Spowa retail building
1958–59
Collective of Gerhard Wollner,
Wolfgang Timme, Herbert Hoffmann

Designed in the National Tradition style,
the municipal theatre had already been
constructed between 1953 and 1955 (Peter
Schweizer, Hermann Enders, Hans Klein)
and later had to be integrated into the more
modern style of the subsequent architecture
on the main axis of the town. This was
achieved by means of two-storey wings that
framed the theatre and emphasised its height.

The wing on the right contained the town
library and a shop for arts and crafts, the one
on the left a sales outlet for sports equipment.

44
Eisenhüttenstadt,
Magnet department store
1958–60
Otto Lopp, Otto Schnabel

Together with the former Hotel Lunik, the
department store building is the midpoint of
the main street of Eisenhüttenstadt. In this
planned new town, a "house of culture" was
originally to have occupied the Zentraler
Platz, the central square, which still remains
empty. As a modest substitute for that, the top
floor of the department store with its pleasant
viewing terrace was retained as a club for
the intelligentsia. Today this is the municipal
library. In 1965, on the side of the building
facing the main axis, Walter Womacka
created the mosaic *Produktion in Frieden* (Pro-
duction in Peace) with the key socialist motifs
of the worker's hand and the dove of peace.

45
Eisenhüttenstadt, Beauty salon
1958–59
Collective of Gerhard Wollner,
Wolfgang Timme, Herbert Hoffmann

This beauty salon, which is often photo-
graphed thanks to its largely unchanged
exterior, is a reminder that modernism was

associated with the idea that a well-groomed
appearance was expected of the socialist
woman. Here she was given a place to go in
her everyday life, even though the execution is
not as spectacular as that of the beauty salon
on Karl-Marx-Allee in Berlin.

47
Eisenhüttenstadt, Magistral pharmacy
1958–59
Collective of Gerhard Wollner,
Wolfgang Timme, Herbert Hoffmann

Two bronze cranes by sculptor Heinz Beber-
niss have always greeted customers to Magis-
tral pharmacy. The two-storey corner building
is unique both for its architectural restraint
and its harmonious control of the urban
space, expressed in its site between the line of
shops and the residential area behind it.

48
Eisenhüttenstadt, Kaufhalle Fix
1959–62
Walter Pallocks Collective

In the planned new town of Eisenhüttenstadt
every residential complex had its own Kauf-
halle (small department store). The one on
the main street, called Fix, was a special place
to shop, however, not only on account of its
central location directly on the route to work
for many employees of the steel plant, but also
because its late opening hours were adapted
to the rhythm of the workers' shifts.

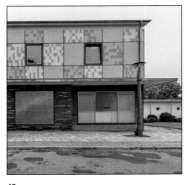

49

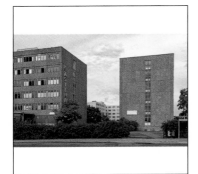

50–51

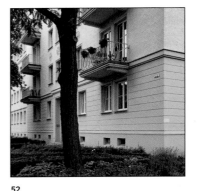

52

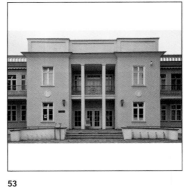

53

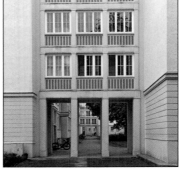

54

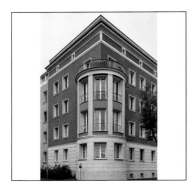

55

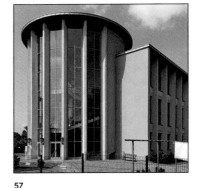

57

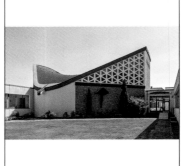

58–59

49

Eisenhüttenstadt, Furniture store
1960–61
Erwin Rösel, Hans Klein

This two-storey furniture shop is taller
and considerably larger in volume than the
adjacent rows of shops, also of two floors.
Thus, as a corner building, it forms a tran-
sition from Housing Complex I to the main
street. Towards the residential buildings, in
the shadow of the furniture store, is a small
urban square which once had a fountain.
Next to the store is the only pine tree remain-
ing from the period before trees were felled
to construct the planned new town.

50–51

**Eisenhüttenstadt, Guesthouse at
Karl-Marx-Strasse / Strasse der Republik**
1982

Constant expansion of the town and
steelworks meant that a large amount of
temporary accommodation was always
required in Eisenhüttenstadt. Initially there
were barracks, later a hostel for unmarried
persons and a *Mittelganghaus* (building with
a central passageway), about which reports
appeared in national media in 1998 when it
was the first such block in eastern Germany
to be demolished. Later workers' hostels
were built (1979) of prefabricated concrete
using the Plattenbau system, with finally in
1982 the centrally located guesthouse, which

today is decaying, unloved and unused, in a
town clearly marked by the dismantling of
its buildings.

52

**Eisenhüttenstadt, Housing Complex II
buildings**
From 1953
Josef Kaiser, Friedel Schmidt, Kurt Gierke,
Rudolf Nitschke, Herbert Schiweck

In Housing Complex II, the National Tradi-
tion reached its zenith in terms of architecture
and urban planning. Although many towns
of the GDR possess comparable streets, this
complex is unique in its size and logic, and
remains to this day an impressive interpreta-
tion of the idea of an ideal socialist town.

53

**Eisenhüttenstadt, Nursery school on
Erich-Weinert-Allee**
1952
Makarenko Youth Brigade, Ludwig Deiters,
Hans Grotewohl, Horst Kutzat

In the first socialist town, special efforts
were devoted to facilities for children due to
their symbolic potential. For the first nursery
school of Housing Complex II, Walter Wom-
acka designed a work of art in glass for the
stairwell window. Today the building, which
is often used as a film set, houses a centre doc-
umenting the everyday culture of the GDR.

54

**Eisenhüttenstadt, Housing Complex II
building, Pawlowallee**
1952–54
Josef Kaiser, Peter Schweizer

55

**Eisenhüttenstadt, Housing Complex II
building, Block 51/53**
1952–53
Josef Kaiser

A noticeable differentiation of façade design
can be seen, especially in the housing blocks
on Strasse der Jugend (Street of Youth,
today Saarlouiser Strasse) and Karl-Marx-
Strasse. Stucco ornamentation, balconies, bay
windows and other design features make
this residential quarter a kind of showroom
for the capabilities of architecture in the
early years of the GDR. These parts of the
town have consequently been designated as
monuments since the 1980s.

57

**Pirna, VEB Entwicklungsbau, after 1970
VEB Strömungsmaschinen, canteen**
1956–59
VEB Projektierungsbüro Süd Dresden

In the 1950s, in strict secrecy, the GDR built
a development complex for aircraft engines
in Pirna near Sonnenstein Castle. For the
employees, an impressive canteen was

designed in the style of post-war modernism
by a project office associated with the Defence
Ministry that otherwise specialised in build-
ing bunkers. In the bright, curving stairwell,
which is still in a good state of preservation,
a mural depicting the story of human flight
from Icarus to the Sputnik flanks the route
from the entrance and kitchen area to one of
the two dining halls. Following conversion
work, residential loft apartments are now
available in the building.

58–59

Rostock, Catholic Christuskirche
1971
Gisbert Wolf, Rudolf Lasch, Kurt Tauscher
and Collective, Ulrich Müther

In August 1971 the Catholic congregation
in Rostock moved into a replacement for the
brick-built Christuskirche (Church of Christ),
which was demolished in the course of the
remodelling of Rostock city centre when the
new church had been completed. Architec-
turally marked by the spirit of modernism,
the church was given a hyperbolic paraboloid
roof by Ulrich Müther.

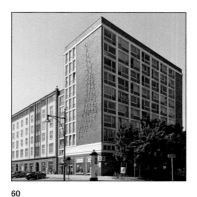

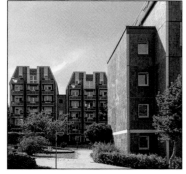

60

61

62–63

64

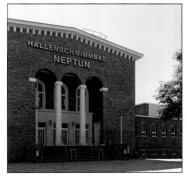

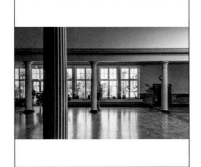

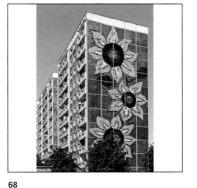

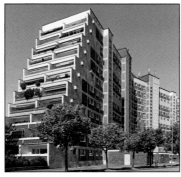

65

65–67

68

69

60
Rostock, Möwenhaus with Warnow pharmacy
1966–68
Dieter Jastram, Edith Fleischhauer
and Collective

This residential high-rise Möwenhaus (Gull House) was built from 1966 as a kind of afterthought for Lange Strasse, the showcase street which was laid out from 1953 in a north German version of the National Tradition style. It was constructed on the site of the demolished Waterways Office of 1951, fitted into the street remarkably inconspicuously, and possesses arcades on its courtyard side. In its details and in contrast to other buildings on Lange Strasse, the turn to a more modern style, here known as Nordmoderne (Northern modernism) is recognisable. The façade relief by Reinhard Dietrich, *Vogelzug* (Migrating Birds), is particularly striking.

61
Rostock, Housing in the Old Town North
1983–87
Wohnungsbaukombinat Rostock,
Erich Kaufmann and Collective

To the north of Lange Strasse in a designated reconstruction zone, a far-reaching pro-gramme of new building began in 1983 using the Type 83 series inner-city prefabricated housing block. It took its cue from historical volumes and forms, especially from north

German brick architecture with gables and eaves. The intention, in a link to reconstructed historic buildings, was to reproduce the small scale and variety of the structures that once stood there, a project that was successful in its own way.

62–63
Rostock, Kosmos café-bar
1968–70
Wolfgang Reinhard, Robert Waterstraat,
Kurt Tauscher, Ulrich Müther

In typical GDR manner, a service building with four different culinary facilities (restaur-ant, beer parlour, café, mocha milk-bar) and a library was constructed for the Südstadt residential district according to the standards for a low-density, green urban area. Ulrich Müther's hyperbolic paraboloid roof lends quality to the building to this day and makes it a landmark of the district.

64
Rostock, Kunsthalle
1967–69
Erich Kaufmann, Hans Fleischhauer,
Martin Halwas

Idyllically situated in a park and surrounded by sculptures, the Rostock Kunsthalle was the definitive, indeed the only, newly built art museum in the GDR. The striking aspect of this two-storey building is white cladding of the façade with relief tiles. This

highly popular structure is still used as an art museum, regularly exhibiting art from the GDR.

65–67
Rostock, Neptun swimming pool complex
1950–55
Karl Krüger, Max Krüger

Like almost all provincial capitals of the GDR, Rostock was given a large sports forum with a swimming pool complex. It has generous dimensions and, with its diving tower, stands for spectators and underwater illumination, was purposely equipped for competitions. At the time of its construction it met high standards. The interior with marble cladding was, of course, designed to impress. The complex closed in 1988 due to its poor structural condition, was renovated a few years ago and is in operation again today.

68
Rostock-Lichtenhagen, Sonnenblumenhaus
1979
Reinhard Dietrich (design of sunflowers)

The new quarter of Lichtenhagen was built from 1974 onwards in the north of Rostock near Warnemünde. It was based on a concept that was ambitious in its time: without through traffic and with a green central axis, gardens for tenants and shopping facilities. In the early 1980s several high-rise buildings with a wide, narrow ground plan were added,

including the "Sunflower House", which received unfavourable headlines nationally in 1992 when riots by extreme right-wing demonstrators took place there.

69
Rostock-Evershagen, Terraced high-rise
1980
Peter Baumbach

The stepped terraced buildings of Wohnungs-bauserie 70 (WBS 70; Housing series 70), were an innovation of the industrial archi-tecture of the GDR and are a hallmark of the so-called Nordmoderne (Northern mod-ernism). They can be found in Evershagen, in the Rostock district of Schmarl, and also, as a contribution to the expansion of East Berlin by the Rostock housing construction combine, in the Berlin residential area of Kaulsdorf-Nord.

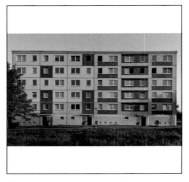

71

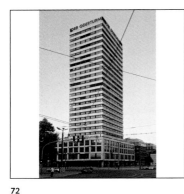

72

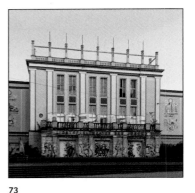

73

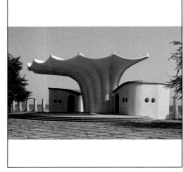

74–75

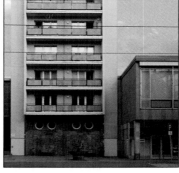

76

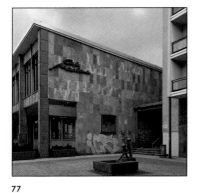

77

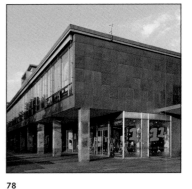

78

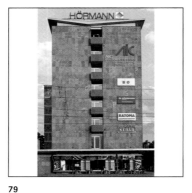

79

71

Frankfurt (Oder), Plattenbau housing, Type P2
*c.*1980
Wilfried Stallknecht, Herbert Kuschny, Achim Felz

Industrial housing was designed to fundamentally and rapidly solve the housing shortage in the GDR. After the National Tradition style was abandoned, the first attempts at developing and applying the Plattenbau system took place in the early 1950s, and became from the middle of the 1960s the predominant urban construction system, particularly with the Type P2 and WBS 70. Almost every city in the GDR received similar city extensions. After 1990, these quarters were often stigmatized, and later razed.
The housing in Frankfurt (Oder) served as the backdrop to the hit film *Halbe Treppe* (Eng.: *Grill Point*) by Andreas Dresen (2002).

72

Frankfurt (Oder), Oderturm
1968–76
Hans Tulke, Paul Teichmann and Collective, Rudolf Krebs and Manfred Vogler

With twenty-four storeys and a height of almost ninety metres, the "Oder Tower" has an undisputed position as the dominant high-rise in Frankfurt (Oder). When it was opened, it housed a hotel run by the newly founded VEB Jugendtourist (Youth Tourist

People's Enterprise), a grill bar and a café on the twenty-third storey. On the ground floor were shops and an impressive wall frieze. Conversion and renovation in the 1990s largely destroyed the original appearance of the tower which remains the emblem of the city thanks to its size.

73

Frankfurt (Oder), Filmtheater der Jugend
1910–19, 1954–55
Wilhelm Flemming, Karl Irmler, Gerhard Osswald

The "Youth Cinema" rose literally from the rubble of an older UFA cinema in the mid-1950s and, later extended to be a multi-purpose building, became the main cultural venue in the city. The images of a *Trümmerfrau* ("rubble women" cleared ruins after the war) and a steelworker, along with sgraffiti on the façade, were links to the formation of local and social identity in this period. The cinema was in operation until 1998. Since the opening of a multiplex cinema in Frankfurt, the old movie theatre in its central location has decayed in full public view.

74–75

Sassnitz, Musikpavillon
1986–88
Ulrich Müther

The idea of the "concert seashell" is widespread in the architecture of seaside resorts,

but it was seldom taken so literally as by Ulrich Müther in his pre-stressed structure at the end of the beach promenade in Sassnitz. A more maritime look than this, in elegant and playful waves of concrete, can hardly be imagined. Since 2014 the Musikpavillon has been a designated monument, and in accordance with this status has now been restored with the help of a foundation.

76–79

Chemnitz, Buildings on Strasse der Nationen, first construction phase
1959–63
Werner Oehme

From the late 1950s onwards, in a clear formal departure from the National Tradition, the Strasse der Nationen was laid out as a main axis of the city and a new city centre. A central section is characterised by eight-storey residential blocks (1961–62, Johannes Gitschel Collective) with two-storey shops (1961–64, Gerhard Laake Collective) placed between them. Three small fountains lent an artistic enhancement to the ensemble: *Spielende Kinder* (Children Playing; Hanns Diettrich, 1965), *Jugend* (Youth; Johannes Belz, 1965) and *Völkerfreundschaft* (Friendship of Peoples; Gottfried Kohl, 1966).

80–81

Chemnitz, Haus der Staatsorgane and Haus der Partei
1968–70, 1977–79
Günter Schlegel, Wolfgang Seidel, Günter Arnold

This 280-metre-long office building (the House of State Organs and House of the Party) in the centre of Chemnitz catches the eye immediately thanks to its shape. It takes its nickname "Party saw" (Parteisäge) from the drastic angles in the façade. It was erected from the late 1960s as part of the monumental reshaping of the southern city centre, of which the Karl Marx Monument, the Stadthalle auditorium and the Interhotel are also part.

83

Chemnitz, Karl Marx Monument
1971
Lew Kerbel
(bronze sculpture on a granite base)
1969
Heinz Schumann, Volker Beier
(inscribed wall)

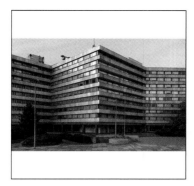

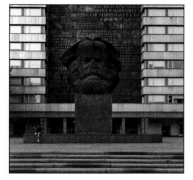

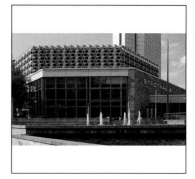

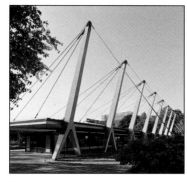

80–81 83 84 85

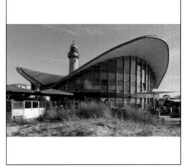

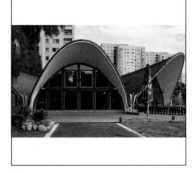

86–87 88 89 90

84
Chemnitz, Stadthalle and Interhotel Kongress
1968–74
Rudolf Weisser and Collective

The twenty-eight-storey Interhotel gave Karl-Marx-Stadt (now Chemnitz) its socialist vertical landmark and, with the Stadthalle, not only a further dominant building but also a structured concrete façade that shaped the urban space and was right up to date. It is the work of Hubert Schiefelbein, who also worked on the poured-concrete walls of the Kino International in Berlin. By way of contrast, a large expanse of local stone, Rochlitz porphyry, was used on the façade.

85
Chemnitz, Bus station
1967–68
Johannes Meyer

Principally thanks to its impressive roof construction by Christian Weise, a designated monument, the new bus station in Karl-Marx-Stadt was a building described in superlatives – at its inauguration it was nothing less than the most modern bus station in Europe. The roof is suspended on steel cables and supported by pylons of reinforced concrete. The bus platforms were roofed with arched plastic shells, unfortunately removed in 1997, that were otherwise used almost solely to build greenhouses.

86–87
Warnemünde, Seerestaurant Teepott
1968
Erich Kaufmann, Hans Fleischhauer, Carl-Heinz Pastor, Ulrich Müther

A further – perhaps the best-known – work by Ulrich Müther with a hyperbolic paraboloid shell is a landmark that stands right by the beach on the Baltic Sea at Warnemünde. Before 1990 the "Tea Mug Sea Restaurant" was also a place of yearning, as from here it was possible to watch the ferries heading for Denmark. After 1990 the prospects were not very good, even for this textbook example of GDR modernism. However, it was saved and restored in the first years of the new millennium. Today, visible from afar, it is a main attraction in the holiday season for people on the Baltic Sea promenade in Warnemünde.

88
Potsdam, Central station
1956–58
Wolfgang Dressler, Walter Mempel

Given the proximity of Potsdam to West Berlin, the political situation necessitated a reorganisation of rail links from the city to other parts of the GDR. The solution was to build a circular rail route in Berlin. In this way Potsdam gained a new multilevel station, opened in 1958 under the name Bahnhof Potsdam Süd (Potsdam South Station) with a bright concourse typical of the period, somewhat plain and functional inside. In 1961, before the Berlin Wall was built, it became the main station (Hauptbahnhof) and principal connecting point of the city for long-distance travel within the GDR. When the old Potsdam Stadt station became the main station again in 1993, it lost its importance and was renamed Bahnhof Potsdam Pirschheide.

89
Potsdam, Café Seerose
1980–83
Dieter Ahting, Ulrich Müther

This pavilion with its curving roof on a bay in the river Havel, the Neustädter Havelbucht, stands between a pumping station for Sanssouci Park built in the style of a mosque (1841–42, Reinhold Persius, Carl von Diebitsch) and an angular, seventeen-storey tower (1973–74, Hans Joachim Engmann). It is one of the smaller tours de force from Ulrich Müther's portfolio of concrete-shell construction. With this building, the architect also brought a cosmopolitan touch to the shores of the Havel, as it strongly resembles an architectural classic, the restaurant Los Manantiales (1958) by Félix Candela in Xochimilco in Mexico.

90
Potsdam, Datenverarbeitungszentrum
1969–71
Sepp Weber and Collective

The "Data Processing Centre" testifies in more than one way to the GDR's links to modernism. In addition to the attention paid to computerisation, as at the Dresden research centre of Robotron, here art-for-architecture symbolises the new age. A mosaic by Fritz Eisel runs all around the ground floor, though in a changed sequence following alterations, and proclaims that "Humankind conquers the cosmos".

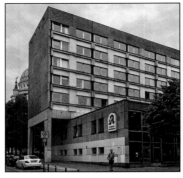

91

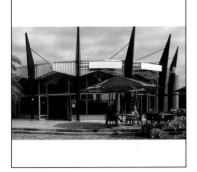

93

94

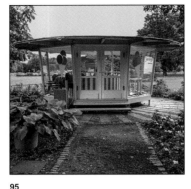

95

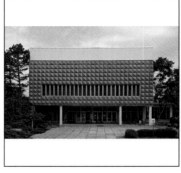

96–97

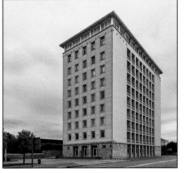

98

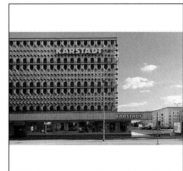

99

100–101

91

Potsdam, Residential building at the Staudenhof

1971–72

Hartwig Ebert, Peter Mylo, Fritz Neuendorf

As the emphasis in Potsdam at present lies on reinstating historic urban structures, the fact that this seven-storey residential building was part of the radical socialist remodelling of Potsdam is likely to determine its fate. Demolition is being considered. Much of the urban solution represented by the Staudenhof, which mediates between the river Havel and the city centre, has already disappeared completely, for example the former Institut für Lehrerbildung (Institute for Teacher Training; 1971–77, Sepp Weber et al.).

93

Erfurt, iga 61, Round pavilion

1974

Klaus Thiele

As an attraction at the iga 61 (Reinhold Lingner, Walter Funcke), a permanent garden show since 1961, a round pavilion was constructed next to the playground and roller-skating rink on the northern slope. With its crown-shaped roof it was intended to be reminiscent of a circus marquee and to take account of the atmosphere of playful leisure and recreation. Accordingly, the pavilion was at first a children's theatre, while today it houses a restaurant.

94

Erfurt, iga 61, *Aufbauhelfer* (Reconstruction Helper) sculpture

1953

Fritz Cremer

Like many major projects in the GDR, the iga site was built with the help of volunteers. In the early 1950s, the sculptor Fritz Cremer honoured the men and women of the Nationalen Aufbauwerkes (National Building Project) with two larger-than-life-size bronze sculptures placed in front of the Rotes Rathaus (Red City Hall) in Berlin. In 1961 the city of Erfurt had a second casting made of the male figure for the main entrance to the garden show.

95

Erfurt, iga 61, Pavilion on the Grosse Wiese

1961

On the flower meadow (1961, Alice Lingner) at the centre of the garden show stand six small pavilions, which, to complement the exhibition of the agricultural achievements of socialist countries in thirteen exhibition halls, was mainly devoted to shows of arts and crafts.

96–97

Erfurt, SED-Bezirksparteischule

1969–72

Heinz Gebauer, Walter Schönfelder, Erich Neumann, Gottfried Mempel, Hannelore Henze

The "SED Party District School" is a perfect demonstration of how the architecturally ambitious design of a site was intended to convey a feeling of being appreciated and honoured to participants at party training courses. The closed-off character and function of the building led to its being known as the "Red Monastery". The complex survived the post-unification period largely untouched, astonishingly, and has had the status of a cultural monument since 2007.

98

Erfurt-Rieth, Vilniuspassage residential district centre

1976

Helmut Weingart

In the north of Erfurt the second large zone of new construction for the city was built from 1969, and within it a residential district centre named after Vilnius, Erfurt's twin city. It housed an outpatient clinic, services, retail outlets, a restaurant and a children's library, around whose façade ran a maxim by Marx in the shape of a huge mural by Erich Enge. To this new urban space was added a clock with chimes, standing on a clock tower

encircled by external steps – clearly signalling that there was no church in this newly built district.

99

Erfurt, Administration building

1950–51

Egon Hartmann, Hartmut Schaub and Heinrich Weiss

From 1948 Erfurt was the capital of the state of Thuringia and required suitable space for administrative offices. In the Löbervorstadt suburb a tower was built with 110 offices, the seat of the state prime minister and a roof garden. Constructed before architectural policy turned to the National Tradition style, it was subjected to severe criticism when it opened. Egon Hartmann then moved on to work on Stalinallee in Berlin, where he provided impressive proof of his abilities in the new style.

100–101

Magdeburg, Centrum department store

1970–73

Karl-Ernst Zorn, Anne-Monika Zorn

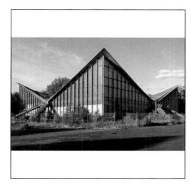

102–103

105

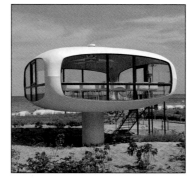

106

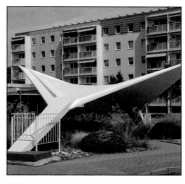

107

108–109

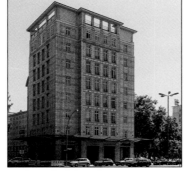

110

111

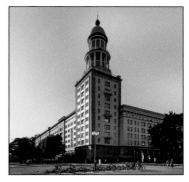

112

102–103
Magdeburg, Rotehornpark multipurpose hall
1969
Ulrich Müther, Horst Freytag, Fritz Retzloff

The purpose of this concrete-shell building on the Elbe island relates to a local exhibition tradition from the 1920s. Like all buildings of this type, the hall requires no supporting pillars and was thus highly flexible, serving as a trade-fair hall, a dance hall and a television studio. In its form and lightness it represented a clear counterpoint to the Stadthalle opposite. Following years of uncertainty, in 2018 the prospect for renovating the hall emerged.

105
Hoyerswerda, Centrum department store
1965
G. Walter, H. Fellmann

Hoyerswerda new town, built from 1957 onwards, was the second planned town in the GDR after Eisenhüttenstadt. The National Tradition style is not to be found there; plain structures built to type are predominant. In the department store, too, a fundamental change in architectural vocabulary can be observed in comparison to the clothes store in Eisenhüttenstadt. The building was the first of a total of fourteen Centrum department stores. Almost all of them were given a façade with ornamental metal cladding.

106
Binz, Coastguard tower
1981–82
Ulrich Müther

Seenotrettungsturm 1 (Coastguard Tower 1) in Binz is one of the best-known and most photogenic examples of Ostmoderne. There were originally two of them, but the older, somewhat more complex twin of this one dating from 1975 was torn down in 1993 in order to reconstruct the pier. The surviving tower, by contrast, has now been restored to the standards of a designated monument. It is used as a registry office for weddings.

107
Binz, Bus shelter, Proraer Chaussee/Dollahner Strasse
1967
Ulrich Müther

Bus shelters rarely attain the status of architectural icons, unless they were built by Ulrich Müther with his typical curving verve as a hyperbolic paraboloid shell. (A second, somewhat less well-known example exists nearby in the village of Buschvitz.) The cult status of this designated monument was certainly aided by the fact that it stands in Müther's home town.

108–109
Berlin, Karl-Marx-Allee, Block C North
1952
Richard Paulick

Karl-Marx-Allee, named Stalinallee when it was built, is the best-known manifestation of the two principal architectural periods of GDR architecture, the National Tradition (first construction phase) and Ostmoderne (second phase). Richard Paulick's Block C belongs to the first phase, and is extraordinarily opulent even by these standards of form and ornamentation.

110
Berlin, Strausberger Platz, High-rise
1951–53
Hermann Henselmann, Rolf Göpfert, Emil Leibold

With the presentation of his designs for Strausberger Platz in the competition for Stalinallee, Hermann Henselmann established his supremacy in interpreting and to an extent shaping the appearance of this new main axis in the city. In addition to the Haus des Kindes (House of the Child) and Haus Berlin, the square, in the middle of which a splashing fountain by the metal artist Fritz Kühn was placed in 1967, is framed by seven- to nine-storey residential buildings with shops and restaurants on the ground floor.

111
Berlin, Karl-Marx-Allee, Café Sibylle
Opened in 1953

After a short delay, in October 1953 a milk bar, later also a sales point for ice cream, began to serve honey, cherry and malt-beer milk in Block C South on Stalinallee. It is in a way the discreet preliminary version of the famous Mokka-Milch-Eisbar (Mocha Milk Ice Cream Bar) of the second, Ostmoderne section of the boulevard. After its opening, the milk bar became a rendezvous for the East Berlin fashion scene and soon changed its name to that of the GDR fashion magazine *Sibylle*.

112
Berlin, Frankfurter Tor
1957–60
Hermann Henselmann

The towers of the Frankfurter Tor (Frankfurt Gate), visible far and wide, are a final highlight of the National Tradition and an unmistakable reference to Berlin's Gendarmenmarkt. Despite its role as a traffic hub, the square as a whole is a notable sight. In the former Warenhaus für Sport und Freizeit (department store for sports and leisure) there is also a mural by Gabriele Mucchi, which was hidden shortly after its completion following strong official criticism. After 1989 it was restored by the artist himself, then almost 90 years old.

113

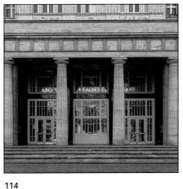

114

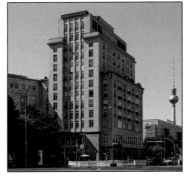

115

116–117

118

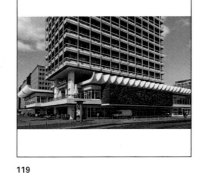

119

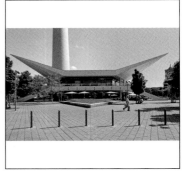

120

121

113
Berlin, Karl-Marx-Allee,
Balcony-access housing
1949–50
Hans Scharoun, Ludmilla Herzenstein,
Karl Brockschmidt

The urban reconstruction of Berlin was
intended to begin in Friedrichshain. The
approach developed by Hans Scharoun and
his team, adopting the "reform architecture"
of the 1920s, was called the Wohnzelle
("dwelling cell") Friedrichshain. The first
blocks were built on Graudenzer Strasse, and
two buildings with balcony access (*Lauben-
ganghäuser*) on Stalinallee. Then, heralded by
the high-rise on Weberwiese, began the move
to the National Tradition style, which lent
the boulevard between Strausberger Platz
and Frankfurter Tor its character as a kind of
built antithesis to the idea of the dwelling cell.

114
Berlin, Karl-Marx-Allee, Portal of
Block C South
1952
Richard Paulick

115
Berlin, Haus des Kindes
1951–53
Hermann Henselmann, Rolf Göpfert,
Emil Leibold

Along with the Haus Berlin, the "House of
the Child" was the architectural conclusion
at the west end of Stalinallee and one of the
main attractions of the avenue. The interior
was elaborately decorated, for example with
fairy-tale figures by Fritz Kühn on the stair
balustrades and a mural by Bert Heller. The
thirteenth floor housed a puppet theatre and a
children's café with a roof terrace. Hermann
Henselmann himself moved into the fifth
floor.

116–117
Berlin, Fernsehturm, Base building
1969–72
Walter Herzog, Heinz Aust,
Manfred Prasser

The striking building around the foot of
the television tower extended its vertical
expressiveness into the lateral dimension.
The two-storey complex with outdoor steps
leading to the fountain housed the leading
exhibition space for contemporary art in
Berlin, the central tourist information office,
restaurants and a dance café. The intention
was that the Ostmoderne style should be a
palpable way of life here.

118
Berlin, Haus der Statistik
1968–70
Manfred Hörner, Peter Senf, Joachim Härter
and Collective

This massive building for officialdom in the
city centre was to underline East Berlin's
role as a capital city. At the same time it
largely concluded the remodelling of the area
between Alexanderplatz and Karl-Marx-
Allee. The pavilion that was fitted in between
the Haus der Statistik and the Haus der
Gesundheit (House of Health; 1913, altered
in 1966–70) only partially succeeds, however,
in mediating this caesura in the urban scene.
Following use as a bicycle shop, it is now
home to a workshop on the future of the city
development.

119
Berlin, Haus des Reisens
1969–70
Roland Korn, Johannes Brieske,
Roland Steiger, Hans-Erich Bogatzky

The eighteen-storey "House of Travel" occu-
pies a dominant position on the lines of view
between the second phase of Karl-Marx-Allee
and the new form, reworked in the Ostmod-
erne style, of Alexanderplatz. The ground
floor housed a registration office for travellers
from abroad and a currency exchange bureau.
For travellers from the GDR there was a
sales counter for flights and train journeys.
On the façade, a work in copper by Walter
Womacka, *Der Mensch überwindet Zeit und
Raum* (Humanity Overcomes Time and
Space), presents an extraterrestrial outlook.

120
Berlin, Kongresshalle at the Haus des
Lehrers
1961–64
Hermann Henselmann, Bernhard Geyer,
Jörg Streitparth and Collective

In the 1960s, next to the "House of the
Teacher", the growing city of East Berlin
gained this elegant, low, two-storey congress
centre with a thousand-seat congress hall, an
aluminium-clad concrete dome and impres-
sive stairways. Its purpose fit the tradition of
the Lehrervereinshauses (Teachers' Associa-
tion House; 1908, Hans Toebelmann, Henry
Gross) which occupied this site until 1945.

121
Berlin, Haus des Lehrers
1961–64
Hermann Henselmann, Bernhard Geyer,
Jörg Streitparth and Collective

A central location, the period of its construc-
tion and a famous pictorial frieze by Walter
Womacka make this thirteen-storey edifice
one of the best-known buildings in the Ost-
moderne style. Behind the frieze program-
matically named *Unser Leben* (Our Life) were
the holdings of the central teaching library of
the GDR. Until 1990 the Haus des Lehrers
was a centre for education, information and
events, with a restaurant and café.

122

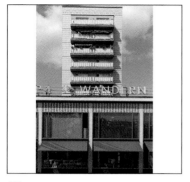

123

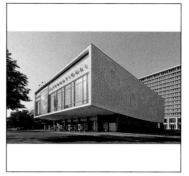

124–125

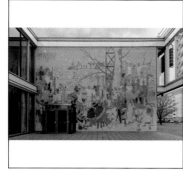

126

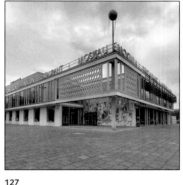

127

128

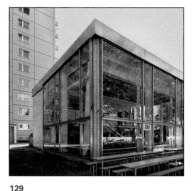

129

130

122
Berlin, Kunst im Heim gallery pavilion
1960–63
Josef Kaiser, Walter Franek

Of the gallery named Kunst im Heim (Art for the Home), only the architectural shell and memories remain. Even the cheerful neon lettering by Klaus Wittkugel proclaiming the purpose of the salon has been lost. The opening of the shop was truly an event, as small furniture items and craftwork that were otherwise hard to find in the GDR were displayed for sale on its high-class floor of travertine stone. Today the building houses a fashionable gallery for contemporary art.

123
Berlin, Interflor florist/Madeleine fashion salon/Schillingstrasse subway station
1961–64
Josef Kaiser, Walter Franek

With the sales pavilions in the Karl-Marx-Allee, the GDR progressed towards a more upscale consumer culture. The florist was the largest of twelve sales outlets of the newly founded VEB Gartenbau. In the fashion salon, the GDR's latest fashions were presented in displays. The underground access integrated into the building ensured optimum accessibility and, at first, a surprised public.

124–125
Berlin, Kino International
1961–63
Josef Kaiser, Heinz Aust Collective

This highly photogenic cinema is *the* icon of the Ostmoderne style. Built for premieres, it also houses the district library and thus became the cultural centre of the new residential area to the west of Strausberger Platz. At the same time it sent a signal to West Berlin, where the Zoopalast (1956–57, Paul Schwebes et al.) had made cinema architectural history. Largely preserved in its original condition on the inside too, the cinema allows visitors to immerse themselves in the elegance of the years when GDR architecture set out on a modern course.

126–127
Berlin, Restaurant Moskau
1961–64
Josef Kaiser, Horst Bauer Collective

A further showpiece of Ostmoderne is the Restaurant Moskau on the second section of Karl-Marx-Allee, opposite the Kino International. The impressive mosaic at the entrance, *Aus dem Leben der Völker der Sowjetunion* (From the Life of the Peoples of the Soviet Union), by Bert Heller splendidly makes the link between Socialist Realism and the age of space travel. The Sputnik floating above the entrance is a further reminder of the euphoria about the future in those years.

128
Berlin, Filmtheater Kosmos
1961–62
Josef Kaiser, Heinz Aust

The cinema that was initially called Kino 1000 – this was the number of seats inside – is somewhat more restrained but no less impressive than the Kino International. It was built, in visibly changed circumstances, to replace a house for the arts that had been conceived in 1951 but was never realised. Its style is a radical break with the neighbouring blocks of Karl-Marx-Allee. Today it is used as an event venue.

129
Berlin, Babette beauty salon
Opened in 1964
Josef Kaiser, Horst Bauer

As befitted the location, the beauty salon on Karl-Marx-Allee was the largest and most elegant of its kind in East Berlin – and probably in the whole of the GDR. The Ostmoderne style was a broadly based attempt to catch up with international standards, and beauty consultations for the modern urban woman was part of this. Some large enterprises even employed in-house beauticians. Salon Babette was long regarded as a place of expertise for the benefit of normal citizens. After 1990 it became a gallery, later a bar, and since 2018 has been unoccupied.

130
Berlin, Funkhaus
1951, 1952–56
Franz Ehrlich and Collective

On the site of a factory for wood veneer, making use of existing structures, a building for radio transmissions and subsequently rooms for recording, production and studios for the GDR broadcasting service were built in 1951. Brick-clad façades, walls of stone and marble (taken from the Reich Chancellery) in the foyer and fittings made by the Deutsche Werkstätten in Hellerau underlined the character of the broadcasting centre as a showpiece. At the same time, the buildings, especially the hall for recordings, still meet the highest functional standards and are used accordingly to this day.

131

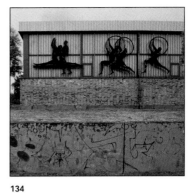

132–133

134

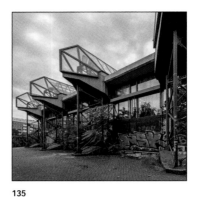

135

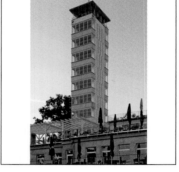

136

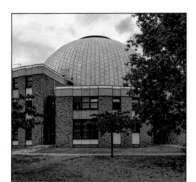

137

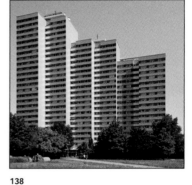

138

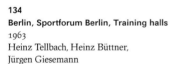

139

131
Berlin, Czech Embassy
1974–78
Věra Machoninová, Vladimír Machonin,
Klaus Pätzmann and Collective

This highly representational edifice is an
example of the extremely sophisticated and
playful modern architecture of Czechoslo-
vakia in the 1970s. In keeping with this, it
breaks with the formally much less elaborate
architecture of its surroundings. This can be
seen in, for example, the contrast with the
directly adjacent embassy of North Korea
(1972–74, Manfred Jäkel, Gerhard Schubring
and Collective).

132–133
Berlin, Sportforum Berlin, Sporthalle
Dynamo
1955–58
Walter Schmidt

As Berlin, too, was intended to be a city of
sport, construction of the Sportforum started
in 1954, in the rather out-of-the-way location
of Hohenschönhausen. One area of focus was
sport on ice. The Sporthalle Dynamo, named
after the police sports club, was also used for
large-scale events of a non-sporting nature,
however. It was the third venue of its kind in
East Berlin after the Werner-Seelenbinder-
Halle (1950) and the Deutsche Sporthalle on
Stalinallee (1951, Richard Paulick).

134
Berlin, Sportforum Berlin, Training halls
1963
Heinz Tellbach, Heinz Büttner,
Jürgen Giesemann

135
Berlin, Sport- und Erholungszentrum (SEZ)
1978–81
Erhardt Gisske, Bernd Fundel, Günter Reiss,
Klaus Trödel

At the intersection of two main arteries, close
to the Volkspark Friedrichshain, a sports and
recreation centre that was exceptional in the
GDR included an indoor swimming pool and
a water park with a counter-current pool, an
ice-skating rink, a bowling alley, sports halls
and facilities for sports medicine. The halls
are deliberately open to the city by means of
extensive areas of glazing. The bowling cen-
tre was regularly open for midnight sports,
and in other ways, too, evening events were
held for the working population.

136
Berlin, Müggelturm
1959–61
Jörg Streitparth, Siegfried Wagner,
Klaus Weisshaupt

After the extremely well-loved previous
building burned down in 1958 during
renovation work, planning for a new

Müggelturm on the same site began due to
popular demand. The competition winners
were a students' collective from the Weis-
sensee Kunsthochschule (Arts University) in
Berlin who proposed a tower of reinforced
concrete based on a modern architectural
vocabulary. After 1990, various plans for its
use failed, and currently a new alternative
with an additional tower is under discussion.

137
Berlin, Zeiss-Grossplanetarium
Prenzlauer Berg
1985–87
Gottfried Hein, Gertrud Schille,
Hubert Schlotter, Ulrich Müther

The Zeiss major planetarium at the boundary
between the old and newly built quarters of
Prenzlauer Berg is the architectural climax of
the Ernst-Thälmann-Park residential quarter
(Erhardt Gisske). One of the highlights in the
celebrations of the 750th city jubilee in East
Berlin is – to this day – the domed room in
which up to 9,000 stars shine. A stone's throw
away, the cosmonaut playground, designed in
1986 by Stephanie Bluhm, is in keeping with
this theme.

138
Berlin, Platz der Vereinten Nationen
(United Nations Plaza; formerly Leninplatz)
1968–70
Egon Kreissl, Erwin Kussat, Heinz Mehlan

The building type WHH-GT, already
tried on Fischerinsel, was ambitiously
given exceptional form on Leninplatz: the
residential high-rise, stepped in twenty-four,
twenty-one and seventeen storeys, was meant
to unfold like a flag behind the monumental
Lenin Memorial by Nikolai Tomsky. This
relationship no longer exists: the memorial
disappeared in 1991.

139
Berlin, Immigration and emigration hall
at Friedrichstrasse Station/Tränenpalast
(Palace of Tears)
1961–62
Horst Lüderitz

This building is surprising, as such light,
permeable architecture is unexpected in, of
all places, a border installation. However, the
decision was clearly made consciously: para-
doxically, the hall, which broadens and opens
to the east, was indeed intended to symbolise
freedom, while its narrowing towards the
north-south rail route, in other words, to the
West, symbolised the opposite. Restored with
comparative care, today the building harbours
an exhibition on the partition of Berlin.

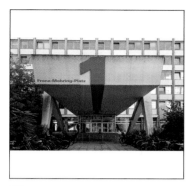

140

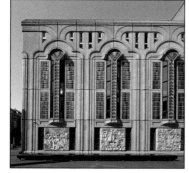

141

142–143

144

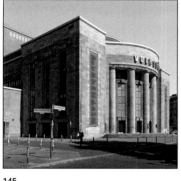

145

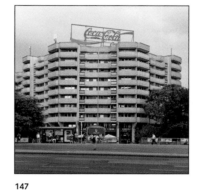

146

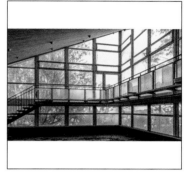

147

148–149

140

Berlin, Verlag Neues Deutschland
1969–74
Edgar Hofmann, Eberhard Just
and Collective

On the site of a rail station building destroyed in the Second World War, a production complex for the *Neues Deutschland* daily newspaper was built. As the principal organ of the SED party it was omnipresent, the newspaper with the largest circulation in the GDR. For the design of this building, too, the partition of Germany played its part: the seven-storey structure with its impressive lobby was erected in response to the Axel Springer Tower, built for the press in the West a few years earlier.

141

Berlin, Friedrichstadtpalast
1980–84
Walter Schwarz, Manfred Prasser,
Dieter Bankert

The Friedrichstadtpalast, like Gendarmenmarkt and the Nikolaiviertel (St Nicholas Quarter), marks a step towards a more playful, postmodern language of architecture in the GDR. This theatre replaced the Grosses Schauspielhaus (Hans Poelzig), which had been sacrificed, though indirectly, to the major construction project of the Charité hospital. Ornamental concrete elements and coloured glass prisms characterise the façade and point

to its function as a revue theatre, a unique building that serves its purpose extremely well to this day.

142–143

Berlin, Heinrich-Heine-Viertel, second construction phase
1968–69
Werner Dutschke, Edith Diehl,
Günther Piesker

144

Berlin, Transportable space extension hall, Kopenhagener Strasse
1966
Helmuth Both, VEB Metallbau Boizenburg

This hall for extending a space, also called "Variant", is a curiosity of GDR architecture and at the same time represents the pinnacle of efforts towards modular, low-cost solutions for building. Some 3,000 of them were made in serial production, and could be extended almost at will by means of modules, including a bathroom and kitchen. The Variant was used in ways ranging from a holiday home to a shop. Originally it was clad in a shell of anodised aluminium sheeting, later in corrugated steel sheets.

145

Berlin, Volksbühne (reconstruction)
1948–51, interior from 1952 onwards
Hermann Fehling, Gustav Müller,
Franz-Heinrich Sobotka, Hans Richter

After 1945 only a ruin remained of the old Volksbühne, a theatre dating from 1913. It was accorded special importance as a place for conveying the values of working-class culture, and rapid rebuilding was therefore necessary. The columned façade was retained, and emphasised more strongly through new functional elements and an altered roof. The move towards the National Tradition style was especially apparent in the interior.

146

Berlin, Leipziger Strasse residential district
1972–77
Joachim Näther, Peter Schweizer,
Dorothea Tscheschner, Dieter Schulze, Werner Strassenmeier Collective

The housing area on Leipziger Strasse, a main traffic artery, has massive dimensions, with twenty-two- to twenty-five-storey residential blocks and more than 1,300 apartments. It filled wasteland resulting from the Second World War and showed a firm rejection of the idea of perimeter block construction. For the six high-rises of the Fischerinsel, also newly erected, demolition took place – even of building fabric with designated monument status at the first settled site in Berlin.

Attempts were later made to compensate for these losses in the Nikolaiviertel.

147

Berlin, Spitteleck
1983–85
Eckart Schmidt, BMK Ingenieurhochbau
Berlin

Even more than the bulky, horseshoe-shaped new building at Spitteleck, Berliners appreciated the pub of the same name. In terms of urban development, the eight- to ten-storey complex was intended to link older buildings in Wallstrasse with the tower blocks in Leipziger Strasse. Tenants of this sought-after residential location benefited from two furniture stores on the ground floor, one of them specialising in children's furnishings. There was also a nursery school and a police registration office. As late as 1989 this complex was the motif on a special-issue postage stamp for the fortieth anniversary of the GDR. After 1990 Coca-Cola brought the new era to the building in a highly photogenic manner by placing a neon advertisement on the roof.

148–149

Oschatz, Lonnewitz service area
1968
Ulrich Müther, Ingo Schönrock

Lonnewitz, a district of Oschatz, Saxony, showed how the emerging automobile culture

150

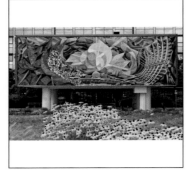

151

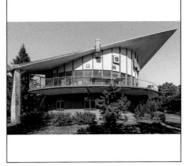

152

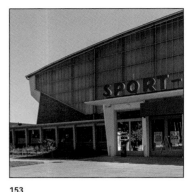

153

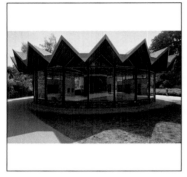

154–155

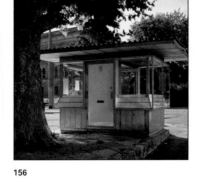

156

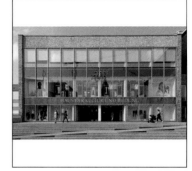

157

158

of the GDR could be combined with the guiding star of the Ostmoderne style: by means of Ulrich Müther's concrete shell structures. On the overland route between Dresden and Leipzig, food and drink was now available for travellers between 6 a.m. and midnight thanks to this building. At lunchtime, however, they had to share the dining room: the service area was also used for feeding pupils of the local secondary school. Today the property, a designated monument, belongs to a recycling company and is unused.

150
Halle (Saale), Housing on Domplatz
1986
Wulf Brandstädter, Peter Weeck,
Andreas Bollmann and Wolf-Rüdiger Thäder

In the 1980s the GDR rediscovered its historic city centres and began to rebuilt them. This often led to massive alterations, as industrial construction methods were employed in this field too. However, efforts were usually made to preserve the structures that had evolved there. In the Domplatz (Cathedral Square) reconstruction zone, bevelled elements of exposed concrete confronted brick masonry, and panels of reinforced concrete above roof terraces simulated lost pitched roofs.

151
Halle (Saale), *Die friedliche Nutzung der Atomenergie* (The Peaceful Use of Nuclear Energy) mural
1967–70
Josep Renau

The Spanish artist Josep Renau moved to the GDR in 1958, bringing the modern, colourful and international visual language of *muralismo* with him. Ten years later he was able to present his art – whose theme was the quest for the new human being – in public with architecture-related commissions in Halle, Halle-Neustadt and Erfurt, as on the administration building of an energy utility, VEB Energieversorgung Halle (1965–66, Alfred Möller, Walter Funkat, Ulrich Tielsch). Humans are not to be seen on this majolica painting, but a swarm of doves of peace, red flags and parabolic mirrors.

152
Schwerin, Panorama restaurant
1969–73
Ulrich Müther, Georg Schneider

From 1959 the town of Schwerin was significantly extended towards the Lankower See lake through construction of the Weststadt residential area. To provide facilities for the newly built district, the Panorama restaurant of the state retail enterprise HO was built using a shell of pre-stressed concrete. In terms of urban planning it acted as a landmark

and was related architecturally to the nearby sports and congress hall as well as to a housing high-rise (1963, Heinrich Handorf). An indoor swimming pool, also planned with a hyperbolic paraboloid shell, was not built.

153
Schwerin, Sport- und Kongresshalle
1958–62
Hans Fröhlich, Paul Peters,
Erwin Beckmann, Fritz Breuer

154–155
Heringsdorf, Usedom Kunstpavillon
1970
Ulrich Müther

The Baltic Sea coast was naturally a place for escapism, leisure and art. It therefore comes as no surprise to discover the Usedom art pavilion on the seaside promenade in Heringsdorf. This bright, architecturally convincing circular structure by Ulrich Müther was intended as the prototype for a series which was not, however, carried out.

156
Weimar, Kiosk
*c.*1970

The GDR kiosks were, alongside subscriptions, the main channel of sales for press publications. In view of the importance of the ready availability of especially daily

newspapers for the public, an extremely dense network of these sales points developed. Most of them have now disappeared. This example in Weimar of Type K 600 has been preserved as testimony to contemporary design, and is regularly used under the name kiosk.6 for holding exhibitions.

157
Weimar, Mensa am Park
1979–82
Anita Bach, Peter Klaus Kiefer

This Mensa (student canteen) by the park is the only one in the GDR that was not constructed according to a type. One reason for this may be that it occupies the site of an unrealized auditorium building for the Hochschule für Architektur und Bauwesen (today: Bauhaus-Universität). The line of the façade and the glazing are logically oriented to the specific site next to the Ilmpark. The fittings, which have been preserved to a large extent, were of very high quality. The lighting plan, for example, made use of the famous spherical lamps with lattices that were also installed in Berlin's Palast der Republik.

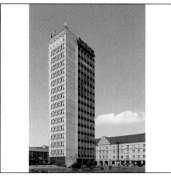

159

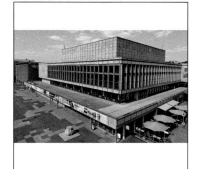

160–161

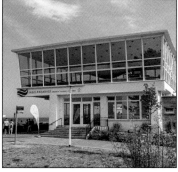

163

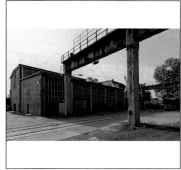

164–165

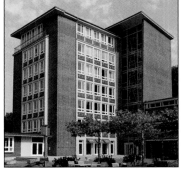

166

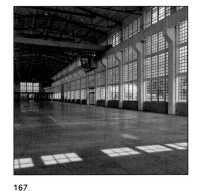

167

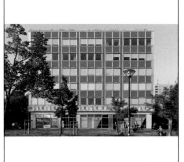

168

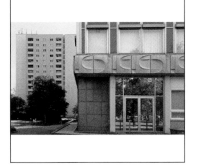

169

158–159
Neubrandenburg, Haus der Kultur und Bildung
1963–65
Iris Grund

The "House of Culture and Education" opened in summer 1965, purposely rising to the sky as a counter to the tower of the Church of St Mary. The sixteen-storey tower of this cultural ensemble provided the people of Neubrandenburg with a music library, rooms for leisure and education, and catering services (a mocha bar, tea parlour and wine restaurant) with a wonderful view of the town. The Haus der Kultur contained an open-shelf library, an exhibition space, a concert hall and a theatre stage.

160–161
Gera, Kultur- und Kongresszentrum
1977–81
Lothar Bortenreuter, Manfred Metzner, Günther Ignaczak, Günther Gerhardt, Karlheinz Günther, Gerd Kellner, Günter Meissgeier

In the late 1950s almost all provincial capitals of the GDR had their centres successively remodelled to make them into socialist cities. The "Culture and Congress Centre" in Gera was built relatively late on the Zentraler Platz. It possesses a large multipurpose hall seating 1,680 persons and the impressive wall relief *Lied des Lebens* (Song of Life), covering

450 square metres and produced by more than twenty sculptors. This is one of the outstanding works of art-for-architecture in the GDR.

163
Baabe, Inselparadies
1966
Ulrich Müther Collective

An early work by Ulrich Müther, the "Island Paradise" was inaugurated at Whitsun 1966 in the holiday resort of Baabe on the island of Rügen. A feature that was unusual (for the GDR) and in keeping with the times (for architectural modernism) was the roof, built as a canopy shell, making it possible to leave the interior open, except for a single support. In this way its gastronomic use could switch easily between self-service in the afternoon, table service in the evening and dancing at night. Thanks to its all-round glazing and location right by the beach, the Inselparadies was an eye-catching attraction.

164–167
Dresden, VEB Strömungsmaschinen Dresden
1952–57
Axel Magdeburg

In the early years of the GDR, Dresden with its Klotzsche Airport was a centre of the aeronautical industry. The plant at Dresden belonged to the VEB Strömungsmaschinen Pirna (People's Enterprise for Jet Engines in Pirna) until 1961, when plans to make its own aircraft were abandoned and work was confined to maintenance and locomotive technology. Architecturally, the office building (1957) in particular shows that in industrial construction it was possible at an early stage to eschew the demands of the National Tradition and to realise buildings that were soberly functional and at the same time of high quality.

168–173
Dresden, Robotron research centre, Dresden
1968–74
Collective of Axel Magdeburg, Werner Schmidt

In the GDR, Robotron was synonymous with the futuristic science of information technology. With its cybernetics concept it was regarded from the 1960s onwards as a guiding light for the organisation and establishment of the socialist state. Its campus-like

site was built with modern functional architecture and extensively furnished with art-for-architecture. Particularly well known are its variations on shaped masonry by Friedrich Kracht and Karl-Heinz Adler, and relief bands of Meissen porcelain. Since 2016 investors have been engaged in largely clearing the site.

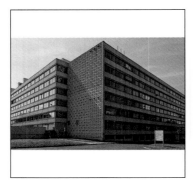

170–171

172

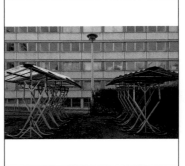

173

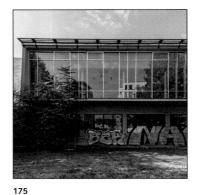

175

176–177

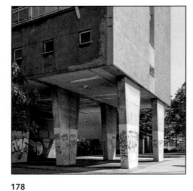

178

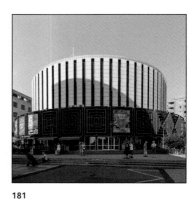

179

181

175–177
Dresden, Neustadt main post office
1962–64
Wolfram Starke, Kurt Nowotny,
Günter Biermann

The post office on Königsbrücker Strasse is considered a key work of Ostmoderne in Dresden. The unusually large investment that was made here in its architectural concept and in carrying out the construction were intended to underline the high status of the postal system. The elaborate work in tiles by E. G. Clauss and the design of the open areas are worthy of mention. Furthermore, the typographically unique design of the illuminated lettering "post", by the architect Wolfram Starke himself, is notable. At present the property is unoccupied and in poor condition.

178
Dresden, P27 residential high-rise
1963–67
Peter Sniegon, Herbert Löschau Collective,
Hans Kriesche, Gerhard Landgraf

In a central location with a view of the Old Town and the Elbe Valley, for a long time this dominant block proclaimed the motto that "Socialism triumphs". Owing to its prominent position in the urban landscape, on socialist public holidays it served, fully decked out with flags, as a kind of canvas for propaganda, and it was unpopular with citizens despite

its visibly ambitious architecture. It was constructed as a special development using components of a programme of building types.

179
Dresden, Office and commercial building
1959–61
Heinz Mersiowsky, Gerhard Hermsdorf

Between the National Tradition and the boldness of Ostmoderne there was a turn to the stylistic elements of Neue Sachlichkeit (New Objectivity), exemplified in this eight-storey commercial building on Wilsdruffer Strasse. The tiled roof and sandstone cladding of the façade emphasise the traditional manner of building, but the soberness of the composition already points clearly in another direction. Its dominant place in the urban environment is achieved in masterly fashion by means of a slight increase in height in relation to the adjacent housing.

181
Dresden, Rundkino
1970–72
Manfred Fasold, Winfried Sziegoleit,
Waltraud Heischkel, Gerhard Landgraf
and Collective, Theo Wagenführ

To emphasise the remodelling of the centre of Dresden on Prager Strasse, the Rundkino (round cinema), which bears a slight resemblance to the Stadthalle in Suhl, was

erected. It has two auditoriums, one seating 1,000 persons and the other about 130. It was a conscious break with the angular character of the surrounding buildings. In the 1990s its intended effect in the urban space was seriously impaired by the construction of another cinema nearby.

182

183

184

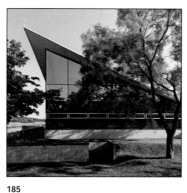

185

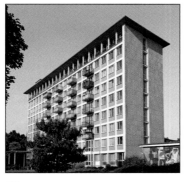

186

182
Dresden, Ingenieurschule für Verkehrstechnik
1954–58
Richard Paulick, Friedrich Wilhelm Wurm Collective

The new "Engineering School for Transportation Technology" demonstrates very clearly that the National Tradition in GDR architecture displayed diverse regional characteristics. Whereas Stalinallee in Berlin was designed with an eye to Karl Friedrich Schinkel, this example was guided by the baroque style typical of Dresden. Undoubtedly a dominant presence inserted into the urban surroundings, yet scaled down considerably in comparison to the preliminary designs, the engineering school possessed a significant symbolic function. Inside it has an impressive stairway.

183
Dresden, Student residence for the Technische Universität
1954–58
Wolfgang Rauda

This residence hall stands between different styles. In the composition of its façade it leans towards modernism, but parallel to this it was fitted with capitals and an extensive relief on the history of Dresden by Reinhold Langner. The sandstone sculpture *Der Flugwille des Menschen* (The Human Will to Fly; Max

Lachnit, 1956) and the fountain in front of the building are also caught stylistically and thematically between Socialist Realism and a more open approach to form. The age of flight and a move to the lightness of modernism are perceptible in the sculpture and architecture.

184
Dresden, Kulturpalast
1966–69
Wolfgang Hänsch, Herbert Löschau, Heinz Zimmermann, Dieter Schölzel, VEB Dresden Projekt

The Kulturpalast in Dresden, a lodestar of the Ostmoderne style, was opened punctually for the twentieth anniversary of the GDR as a prestige building. Gerhard Bondzin's mural *Der Weg der Roten Fahne* (The Way of the Red Flag) remains one of the most quoted works of architecturally related art in the GDR, a masterpiece of materials technology with its electrostatic coating and coloured glass on concrete, and a textbook example of the requirements of art policy in those years. Thoroughly restored between 2013 and 2017, the building can once again be experienced as an architectural legacy, although in the form of a new concert hall, modified by Gerkan, Marg and Partners.

185
Dresden, Ruderzentrum Blasewitz
1970–72
Ingo Schönrock and Collective, Ulrich Müther

In Blasewitz, a suburb of villas with a fine location on the river Elbe, close to the bridge known as the "Blue Wonder", a further building shows the characteristic style of Ulrich Müther: a "rowing centre" or boathouse. It is generally similar to the exhibition hall in Magdeburg, but in contrast to the latter has been renovated and is in excellent condition.

186
Dresden, Zentrales Forschungsinstitut für Arbeitsschutz und Arbeitsökonomie/ Blaues Haus
1958–60
Alfred Gottfried, Georg Wolf Collective

The so-called Blue House of the "Central Research Institute for Occupational Safety and Efficiency", an office building placed between two main roads, is an example of the shift towards modernism in the desired architectural vocabulary. It was to serve as a model and was regarded as a reutilisation project. Its free-standing, folded porch roof above the entrance and the sgraffito by Dietmar Gubsch, unusual in its formal language and not added until 1967, are worthy of mention.

Picture credits

Front Cover: Haus der Staatsorgane and Haus der Partei,
Chemnitz, see pp. 80–81

Prestel Publishing Ltd.
14–17 Wells Street
London W1T 3PD

Prestel Publishing
900 Broadway, Suite 603
New York, NY 10003

Library of Congress Control Number is available; British Library
Cataloguing-in-Publication Data: a catalogue record for this book is
available from the British Library.

Editorial direction: Curt Holtz & Stella Sämann
Translated from the German: John Sykes
Copy-editing: Jonathan Fox
Design and layout Hannah Feldmeier
Production management: Corinna Pickart
Separations: Reproline Mediateam, Munich
Printing and binding: TBB, a.s., Banská Bystrica
Paper: Profibulk

Verlagsgruppe Random House FSC® N001967
Printed in the Slovak Republic

ISBN 978-3-7913-8535-8
www.prestel.com